THE INVISIBLE SEX

ABOUT THE AUTHORS

J. M. Adovasio, Ph.D., is the founder and director of the Mercyhurst Archaeological Institute and Provost of Mercyhurst College in Erie, Pennsylvania. He is author, with Jake Page, of The First Americans.

Olga Soffer, formerly a fashion industy insider, is emerita professor of anthropology at the University of Illinois, Urbana-Champaign and research associate at the Cotsen Institute of Archaeology, UCLA.

Jake Page is a former editor of Natural History magazine and science editor of Smithsonian magazine, as well as the author of numerous books. He lives in Colorado.

A selective list of other books by the authors:

⌒

J. M. ADOVASIO

Basketry Technology:
A Guide to Identification and Analysis

The First Americans:
In Pursuit of Archaeology's Greatest Mysteries
with Jake Page

OLGA SOFFER

Perceived Landscapes and Built Environments:
The Cultural Geography of Late Paleolithic Eurasia
with S. Vasil'ev and J. Kozlowski

Beyond Art with M. Conkey, D. Stratmann,
and N. Jablonski

The Upper Paleolithic of the Central Russian Plain

JAKE PAGE

In the Hands of the Great Spirit:
The 20,000-Year History of the American Indian

Hopi
with Susanne Page

J. M. ADOVASIO,

OLGA SOFFER & JAKE PAGE

Walnut Creek, California

THE INVISIBLE SEX

UNCOVERING
THE TRUE ROLES
OF WOMEN
IN PREHISTORY

LEFT COAST PRESS, INC.
1630 North Main Street #400
Walnut Creek, CA 94596
http://www.LCoastPress.com

Originally published in the United State in hardcover by Smithsonian
Books/ HarperCollins in 2007 under ISBN 978-0-06-117091-1

ISBN13: 978-1-59874-390-6 paperback
ISBN10: 1-59874-390-2 paperback

Library of Congress Cataloguing-in-Publication Data:
Adovasio, J. M. The invisible sex: uncovering the true roles of women in
prehistory/ J. M. Adovasio, Olga Soffer & Jake Page.p. cm.
ISBN 978-1-59874-390-6
ISBN10: 1-59874-390-21.Women, Prehistoric. 2. Sex role—history.
3. Sexual division of labor—History. 4. Feminist archaeology.
I Soffer, Olga. II. Page, Jake. III. Title.
GN799.W66A36.2007305.4209--dc
222006050582

Printed in the United States of America
Designed by Janet M. Evans
The paper used in this publication meets
the minimum requirements of American
National Standard for Information Sciences
—Permanence of Paper for Printed Library
Materials,
ANSI/NISO Z39.48–1992.

09 10 11 12 135 4 3 2 1

IN MEMORIAM:

Marianna Davydovna Gvozdover

June 2, 1917–December 28, 2004

. . . an outstanding Russian scholar, stimulating colleague, consummate charmer, and good friend, whose impact on Paleolithic archaeology was muted because of both her gender and her ethnicity—a modern-day example of "invisible sex" at work in academia.

CONTENTS

AUTHORS' PREFACE

This book is the product of three authors, and that may well remind readers of the old caveat about too many chefs in one kitchen, which implies a culinary catastrophe. But numerous chefs are common in the arena of scientific discourse. Some scientific papers include the names of practically everyone who had anything to do with the experiment or investigation being described— probably even the guy who delivers the pizza on late nights in the lab. In theory, everyone except maybe the pizza guy signs off on the wording of the final article, signaling an overall agreement with its contents. But this book is not a piece of scientific discourse like that.

We might never have known one another, much less worked together, except for a series of contingencies and serendipitous

events. This is fitting, since the story we will tell here is also one of contingencies, of what might be called accidents. For example, the occasional mutation occurs in some ape's genes, a mutation that does nothing to harm the creature and perhaps does something helpful. A slightly different ape emerges. Over a few million years, and a lot of mutational games of chance (most of which ended in TILT), here we are: humans.

In a similarly random manner did the three of us come together to produce this book.

Adovasio, whom we will refer to as Jim, was thrust by an extremely forceful archaeological professor into the extremely unsexy field of perishable artifacts—basketry, cordage, weaving, and so forth. These all fall into the category of perishable artifacts because they don't usually preserve well, and hence there aren't very many to be studied. Before long he was the leading scholar on all such artifacts in North America and had handled, inspected, and thought about almost 90 percent of every such artifact known on the continent. This put him, as a regular duty of his profession, in mind of prehistoric women, since by analogy to living populations it was women who usually made such stuff. Also, by an accident (if you believe in such things), he became terribly controversial when, in the 1970s in the Meadowcroft Rockshelter in western Pennsylvania, he and his students came across evidence that people had trod North America some 5,000 or 6,000 years earlier than the evidence until then showed. This kicked up a terrible fuss, of course, which is just now dying down some 30 years later, with most American archaeologists admitting that people *were* here much earlier. But to substantiate his claim, Jim and his team invented some of the most rigorous field

and laboratory procedures ever seen in the field of archaeology, including something called forensic microsedimentology, and it was this technical excellence that recommended him, it seems, to be invited to a historic pair of meetings of Soviet and American archaeologists in the early days of glasnost. One of the prime movers in these two meetings was Soffer, whom we will refer to as Olga.

Jim knew from the age of three or four that he wanted to be an archaeologist, but Olga had a stint in the fashion business first. Of Russian extraction and a native speaker of that language, she devoted most of her attention, starting in 1977, to the Paleolithic era in Soviet-dominated eastern Europe and central Europe. She also served as a scientific advisor to Jean Auel for two of her novels of the Pleistocene, *Mammoth Hunters* and *Plains of Passage*.

Since Marx had said nothing about the Paleolithic, the Soviet archaeologists could (and did) become friendly with Olga, and they all wanted to bridge the chasm that existed between Soviet and American colleagues. When Mikhail Gorbachev came to power in the Soviet Union, this aim could become a reality. Olga and George Frison, onetime head of the Society for American Archaeology, organized the first Soviet–American Archaeological Symposium in the summer of 1989 when nine North American archaeologists traveled to the Soviet Union. Jim and Olga met for the first time in the departure lounge at JFK airport in New York. Jim spoke Ukrainian, learned from his mother, and when they arrived in the Soviet Union, he helped Olga with translating and with herding archaeologists around the country to visit various seminal sites. More than that, however, Jim had

for 30 years been telling everyone in his field how important a diagnostic tool was to be found in all those perishable artifacts he had come to know so well. Nobody seemed to give a damn—except that Olga did. Right off, perhaps in part because she was as attuned to fashion as she was to ancient ceramics, she also took up the cause.

A second symposium took place in Denver in 1991, in part financed by Jean Auel, who had become a kind of archaeology angel. Later that year, Olga and some colleagues were planning the excavation of a site in the Ukraine and asked the Ukrainian-speaking and technically proficient Jim if he would like to come along. He did. Later, in 1995, at a meeting about the Ukrainian site in Olga's home in Urbana, Illinois, she showed Jim some slides of enigmatic impressions she had taken while working on another project in Moravia in the Czech Republic. There she had been looking at a huge collection of fired clay from some 26,000 years ago—at the time thought to be the oldest pottery known anywhere—and had photographed some that had what looked like parallel lines on them.

She projected the slides on the refrigerator door. Jim announced that the lines were the impressions of textiles, making them by far the earliest such artifacts. Olga and another colleague wondered whether he was not mistaking the texture of the refrigerator door as textiles, and Jim gave them a look that nearly turned them into pillars of stone. So the Paleolithic Era (a.k.a. the Stone Age) got its first textiles, which play an important part in Chapter Eight of this book.

Meanwhile, not long after this historic meeting in the kitchen, Jake Page, a onetime science editor at *Natural History* and

Smithsonian magazines and then a freelancer, had been given an assignment by *Smithsonian* to write an article about what was new in the archaeological pursuit of what was called Early Man in the New World. This necessitated a trip to Jim's haunts at Meadowcroft, which led not to an article on the subject (*Smithsonian* decided not to publish the article because they heard that the editor of *National Geographic* had one in the can) and then to a collaborative book called *The First Americans.*

So, when the idea arose for a book on the female side of human evolution and prehistory, it made sense to take advantage of all these earlier contingencies, all this serendipity. Or, as we have joked on at least one occasion, perhaps given so many coincidences, a cabal of Paleolithic Venuses got sick and tired of being thought of as either madonnas or whores, and imperceptibly pushed us to . . . well, none of us really believes in that kind of thing.

THE INVISIBLE SEX

INTRODUCTION

A famous archaeologist once said that science is not truth; it is, instead, a method for diminishing ignorance. It is simply in the nature of scientific inquiry, not to mention other methods, that the frontier between understanding and ignorance is in constant motion. And science is a human enterprise practiced by people whose feet can easily be clay—and usually are. Scientists live in their particular era and usually share unconsciously in the many common underlying and often unspoken beliefs or biases of their time. When you realize that until recently the field called archaeology (along with geology, paleontology, and all the other specialties involved in our story) has been practiced almost exclusively by men, it will be no surprise that the story they have told

has been largely free of females, of women. This book is an attempt to rectify that.

Many people consider such a female-less picture as merely another example of the cosmic putdown of the female in the long-running, overweening, and basically felonious patriarchy that has ruled the world since the agricultural revolution. This view (to which we return later on) is an extreme position, and not a very likely one, either. It is also a bit Eurocentric. Yet, there is a less extreme version that has to do with the invention of the deep past. Humans, of course, create the past. For every creature from a virus to a wolf to a chimpanzee, there is no past that extends backward before one's own life. And for thousands of years after humans invented writing (about 5,000 years ago) and could describe events that we would define as history, there was no *pre*-history as such. There was mythology, of course—events that occurred at some unspecified time earlier: myth time, it is called: dream time. Later in this book we will look back at the transition from a mythological past to the origins and progress of archaeology and the other ways of scientifically uncovering (and then creating) the past.

It is, as we said, our intent to rectify the situation in which females and women have been excluded from this creation. We will first examine some of the common narratives about prehistory and point out their flaws, looking briefly as well into the development of the very idea of prehistory and how it came about. We will go on from there to produce a new version of the story of human evolution—one that is neither HERstory nor HISstory (a word game that is more politics than science or linguistic sense). If anything, the goal here is to OURstory—a past

populated by a full range of actors who lived and loved, hunted, gathered, learned to speak, cooked, sewed, built, thrilled children with fabulous stories about mythical beings, played, laughed, got sick, got wounded, mourned the dead, invented religion. They were a diverse lot: young, old, female, male, brave, cowardly, dreamers, and doers.

In the retelling of this long story, we explain much of what has emerged in the past few decades about the roles of females, of women. Thanks to the work of numerous scholars in several fields, it has come to light that female humans have been the chief engine in the unprecedentedly high level of human sociability, were the inventors of the most useful of tools (called the String Revolution), have shared equally in the provision of food for human societies, almost certainly drove the human invention of language, and were the ones who created agriculture.

From the work of many types of scholars, the long-invisible sex of human evolution and the gender roles of *Homo sapiens* are beginning to emerge. The full story will never be known, and the story as we have it today cannot be told in the manner of a complete motion picture. Instead, it is more like a slide show, with gaps to be filled in by future archaeologists, paleontologists, geneticists, linguists, and others.

PART 1

THE BEGINNINGS

THE STORIES WE HAVE BEEN TOLD

In which the authors present tales of male derring-do and explicate their failures in accounts of the deep past, along with a bit of the history of science and the reasons why women have not been found in those old tales.

Since the beginning of archaeology, stories like the following three have been told, illustrated, and taken as the true way in which our ancestors lived and worshipped and fed themselves. They are in much the same vein as most museum dioramas of ancient times and are matched by most magazine and book illustrations as well. Warning: these tales can be dangerous to your understanding of the human past.

THE PLACE: A hill overlooking the Vezere Valley in southwestern France, not far from a cave called the Grotte de Rouffignac.

THE TIME: 14,000 years ago.

A group of men makes its way single file along a steep and narrow path that winds up a limestone hill. It is dusk, and the day has been stormy and dark. Impatient gray clouds have commanded

the sky, and from time to time they have sent spring rains down, turning the path to mud and making footing difficult. The weather is yet to feel the true onset of spring—that day when the sun begins to warm the earth and the winds turn kind.

The men climb silently in the gathering dusk. Some of them are slender, in their teens. Others are filled out, in their prime, having lived thirty or even a few more years. Among them are three boys, alert and excited but subdued with apprehension. They shiver, though not from the remnant cold of winter. They know they face an ordeal, but they have not found out its dimensions yet, which makes it all the scarier. Tonight they will become men. Later they will learn the arts of hunting, of mating, of being responsible providers for their yet unborn sons and daughters.

Some of the men carry branches that will be used as torches once they have been surrounded by the oncoming dark. Others carry spears with shafts of rare hardwoods, topped with serrated bone points affixed with cord or sinew. One of the men in the front of the line struggling up the path has a leather pouch slung across his shoulder. It is full of red and black powders ground from local minerals like hematite or magnetite. Another, the oldest one with white in his hair, carries a knife of flint and a flat soft stone with a depression hollowed out of it. In the depression animal fat has solidified. In it lies a fiber wick. When lit, it will be the first light into the depths of the sacred cave whose entrance they now are nearing.

Below them, the last of the day's light glints off the river, a shining serpent that lies along the length of the valley still brown with the winter's dead grasses. The three boys take their last glimpse of the valley and apprehensively follow the men into the

The Invisible SEX

dark mouth of the cave, the flint knife gleaming in their minds' eyes. The older man has led the way, his tiny flame glowing. Behind him, the man with the leather pouch walks gravely, followed by the men with torches, who alternate with those carrying spears. Huge shadows leap wildly on the rocky walls, and a low chanting like a distant wind begins to fill the cave—words the three boys can barely make out, words they have not heard before. For all they know, it is the cave itself that sings. They see the forms of animals emerging from the walls and the ceiling as the shadows dance past.

Deeper into the magic cave they go, and the ceiling begins to come closer until the men ahead stoop over, crouch, their torches' flames blackening the stones. The smoke from the torches burns the eyes of the three boys, but they say nothing. Soon the ceiling has lowered to the point where everyone must crawl, scraping their bellies along the mud and stone of the floor.

At last (it seems a very long time but it has only been a short trip), they reach a chamber where they can all stand, the men in little groups. The boys huddle in the middle. All around them are the sweeping figures of the great bison, graceful horses, the grand mammoths, all looming high above on the walls. In the flickering light of the torches and the gathering murk of smoke, they come alive. They seem to move.

Preparations begin. The oldest man selects an empty spot on the wall while the man with the leather pouch of powders— the one they now start to call the Painter—prepares his paints. The boys are taken to the unpainted wall, where the oldest man begins to sing. His flint knife is nowhere to be seen. He sings a story about hunting, about the habits and the wiles of the

animals they hunt, about great hunts where everyone rejoiced in the bounty, and about failures: times when the hunters themselves were hunted and fell prey in the great and bloody exchange that sustains the world. The old man sings of times when the animals left, disappeared, because the hunters forgot to honor their spirits and give due homage to the Owner of the Animals.

All the while the Painter works. He takes the black mineral powder into his mouth, mixes it with his saliva, and blows a spatter of black onto the wall, making a dark line. As the songs gather momentum and the hypnotic power of the chant turns the men to stomping and dancing, the boys are amazed to see a mammoth materialize on the wall before their eyes. The Singer carries on, an insistent monotonous song that properly asks the Owner of the Animals to share them. He chants the secrets and prayers for killing the huge beasts respectfully, the prayers that these boys will memorize along with so much else this night. The magical mammoth glistens on the wall, as suddenly a long shriek arises in the gloom and the best of the group's hunters leaps forward to hurl a throwing spear at the image.

Its ivory point snaps. A mark is gouged from the mammoth—a gouge that marks the beast's heart—and the spear clatters to the ground. The old man, the Singer, hands it to one of the boys and bids him throw it. The boy hesitates, looks about him at the grinning men, shrieks as best he can, and throws.

The ritual continues until dawn. Some time thereafter, the boys emerge into the light on the hill overlooking their valley. They bear the reddening welts and incisions of ritual, they bear the beginning of the hunters' wisdom, and they have become men—untested yet, but men nonetheless.

Home beckons, and from the high ground amid the aroma of dew they can see that a small herd of reindeer, seven in all, has left the cover of the trees and, in the early morning mist, is drinking from the river far below, skittish, lovely in the thin light of the morning.

WHAT'S WRONG WITH THAT PICTURE?

The Grotte de Rouffignac is one of the richest sites of prehistoric images in Europe and the world. It contains more than 250 engravings and paintings of prehistoric animals, the work of people who lived toward the end of the last Ice Age. This astonishing exhibition extends some 500 yards from the cave's entrance into the labyrinths beyond. One hundred and fifty-four mammoths are pictured, including one enormous specimen today called Grandfather. Although the cave is privately owned, the public is still welcome to visit it.

The story told here is typical of many that have arisen, at least in outline, from about a century and a half of study and guesswork about these astounding images found principally in western European caves. Most scholars and most people call these images art; we shall return to this topic later on. Many scholars say that it is when these images began to appear—about 30,000 years ago—that anatomically modern humans finally reached the height of brain power and creativity that characterizes today's human beings. This is most likely true.

In this story, there are of course no women present, no girls being initiated. For decades, artistic achievement was seen as a man's world, as was hunting: the procurement of meat. The presumption has been that the extraordinary caves like Lascaux and

this one not far from the town of Les Eyzies, which some take as the "capital" of European prehistory, were a man's world. The implication was (and still is in many such accounts and illustration) that women of the period may well have never set foot in such places and, if they did, certainly were not actively involved in their creation. There is absolutely no evidence, however, that women and girls were not participants. Indeed, there is not even any evidence that men were involved.

THE PLACE: A promontory overlooking the confluence of two small rivers that, a half day's walk toward where the sun rises, empty into a larger river known today as the Dnieper. The landscape all around is flat, hardly rising above the riverine flood plain in to-day's Ukraine. Steep-sided ravines slice through the surrounding cold dry grasslands. In the river valleys themselves, stunted trees—mostly pine and birch—grow in stands. For nine months a year this is a landscape of awesome desolation and temperatures that can drop to 40 degrees below zero, but in the three, sometimes two, months of summer it warms to the low 70s and teems with fecund life.

THE TIME: 14,000 years ago, a late summer day when the breezes of morning foretell the long season of cold to come. People must now ensure that they have the needed stores of meat and clothing to see them through the dark cold days ahead.

Some 15 families have gathered in a group at the confluence of the two rivers. They are dressed in their summer furs: tailored parkalike tops with hoods thrown back, and lightweight suede

The Invisible SEX

trousers that end as form-fitting boots. In the warmth, some of the men have bared their bodies to the waist. On the promontory above, several of the men keep a lookout lest the nearby herd of mammoths moves down river. The mammoths, a herd of some 30 adults and younger animals, graze on the lush grasses of the river's edge. They rarely move far from a river, needing mammoth amounts of water to quench their mammoth thirst and to cool down their shaggy bodies.

Below the lookouts, the camp bustles with preparatory activity. Many of the men are going over their hunting gear, making sure that their ivory throwing and thrusting spears are sharp and in order. The working edges are polished with pieces of gneiss or sandstone. One hunter, an expert stoneworker, knaps (chips) long flint blades from a specially prepared core. These he will turn into keen-edged knives for skinning and butchering the animals killed. There is an air of suppressed excitement among these hunters, men in their prime and a few younger ones whose tasks will call for less expertise than the experienced leaders of the hunt. Another group of men is readying the beaters: flat mammoth shoulder and hip blades that the younger men will strike with long thin shin bones topped with bits of soft fur. The fearsome noise, along with the flaming torches some will carry, will drive the mammoths into the range of the great hunters once the sun has reached the height of the sky.

As planned, the band of hunters rises and moves stealthily in various directions down the river toward the unsuspecting herd. Within the hour, they have all taken up their positions, surrounding the herd, each as close as he can get without being detected by the naturally near-sighted beasts. The mammoths,

having drunk their fill from the river and feeling drowsy in the midday heat, have earlier moved into the shade provided by the low trees along the river.

Torches are lit. The drumming begins. Fifteen screaming hunters leap up and race toward their prey, closing in on the herd and driving it toward the nearby ravine. The animals, terrified by the noise, the fire, and the missiles that rain down on them, charge ahead into the ravine, tumbling thunderously over one another, bellowing in pain and fear, legs broken, helpless. The men descend into the melee and, with their powerfully built thrusting spears, deliver the coup de grace to mammoth after mammoth, young and old, until within an hour all the animals are dead. Their warm carcasses lie ready for butchering.

By the end of the afternoon, choice pieces of mammoth meat have been sliced away from the bones of a few of the dead beasts, and a grand feast begins. All in the group—some 70 people in all, young and old—fill their bellies with meat roasted over sizzling fires while the hunters retell the high drama of the chase, the adrenaline-filled thrusting and leaping of the kill, the spouting of warm blood. Later that night, stomachs full and hearts content, the group will sleep. Tomorrow they will busy themselves hacking their bountiful harvest into smaller packets of meat that can be stored in pits dug for that purpose, stores that will see them through yet another windswept, freezing winter. The larger bones of the mammoths will be used to rebuild their bone houses; others will feed the fires that warm them in the cold. Little will go to waste. The prayers made so earnestly to the Owner of the Animals have been answered, and the people will survive another year in this place.

WHAT'S WRONG WITH THAT STORY?

The village built of mammoth bone houses on the promontory above the two small rivers—the Ros and the Rossava—was discovered by archaeologists in 1966 and called Mezhirich. The site is still under study, but the remains of some 150 mammoths were found in the vicinity. Adult mammoths weighed in at about three tons, of which more than a ton was pure animal protein. The first archaeologists at this site assumed that the Paleolithic people of Mezhirich, with their specialized mammoth-hunting culture, lived in this same place for as much as an entire generation, so plentiful were herds of mammoths and other large prey animals in the neighborhood of the rivers. In other river valleys in this large region, they assumed, either the hunters were not as adept or the herds were less plentiful, and those Ice Age groups needed to move more often, leaving behind less impressive ruins for the archaeologists to discover.

Today one can see dioramas of such hunting villages with mammoth bone houses in many museums, including the American Museum of Natural History in New York, Chicago's Field Museum, the Hot Springs Museum in South Dakota, and Le Thot in the Dordogne region of France. The first such house excavated has been reconstructed in the Museum of Paleontology in Kiev, Ukraine.

In hunting "scenes" such as the story above, and the dioramas, there is little sense that women are present except as passive consumers. That they might have assisted in the butchering, if not the hunting itself, was not considered until recently. But more to the point, we will see later in the course of this book that such hunts, in which huge numbers of these enormous beasts are slaughtered,

probably never happened. Such hunts appear now to be myth-making on the part of the paleoanthropological community.

THE PLACE: A narrow rocky canyon in the foothills east of the Grand Tetons in present-day Wyoming.

THE TIME: 11,000 years ago.

Seven men stride into the mouth of a canyon and descend into the shade. It is midsummer, hot, and the men wear only skins around their loins. They carry long thrusting spears tipped with finely chipped points of chert, some longer than a man's hand. The hunters are an advance party, headed north, exploring new country. Where they have come from, farther to the south, the game has grown sparse. No longer do the great elephantine mammoths still roam in large herds, and, with the rapid drying of the world in the south, the vast herds of giant bison have all moved north. It has been some time now since these men have enjoyed a successful hunt, and the women and children they left on a promontory a few miles back have been complaining for days.

The canyon narrows as it deepens, and an even narrower side canyon opens to the north, a slight trickle of water reflecting the sun. The men slow down, chatter quietly among themselves, and then turn up the side canyon. They have seen the droppings of mountain sheep and horses alongside the water. Some 15 minutes later, they reach a place where the canyon turns west toward the high mountains. Cautious now, having seen the whitening bones of a few bison and sheep, they follow the canyon west and are brought up short by the sight of a huge bear lying in the shade

The Invisible SEX

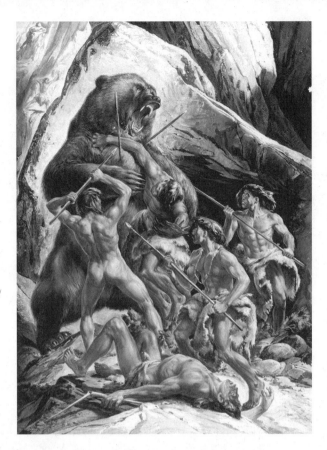

Figure 1-1.
Prehistoric hunters in America battling a giant bear.

ANDRE DURENCEAU/
National Geographic
Image Collection,
Image ID 613071

below the canyon wall, gnawing on the carcass of what appears to be a freshly killed bighorn ram.

In a brief whispered conference, the men decide to scare the bear away from its prey. They approach silently, bare feet on rock, ducking behind boulders, moving forward. Now, within some 30 yards of the bear and his distinctive pungent musky smell, they leap out as one, screaming, rushing at the creature. Enraged, the bear rears up and roars. His huge head with its wide mouth rises some 14 feet; he towers over the attacking band of hunters. A huge paw at the end of a long and slender arm slashes the lead hunter across the chest, sending him hurtling backward

onto the rocks. The other arm reaches for another attacker, who jams his spear at the bear's stomach, and the other hunters leap and duck, feinting, thrusting, screaming.

WHAT'S WRONG WITH THAT STORY?

This advance party is known today as Clovis Man, from the exquisitely made spear points that were first discovered near the town of Clovis, New Mexico, in the 1930s. Clovis Man arrived in North America, it seemed, 11,500 years ago, and his points and other weapons and tools have since been found sporadically throughout the lower 48 states. Until recently it was almost universally believed that Clovis Man was the first entrant into the New World, the greatest and fastest-moving hunter to appear anywhere on earth. Within less than a millennium, proliferating Clovis hunters had managed to reach the southernmost tip of South America and along the way had sent some 30-odd genera (not species but genera) of large mammals to oblivion.

The absolute epitome of this Clovis myth—for that is what it has turned out to be—is embodied in this story and in the accompanying illustration. So ferocious was Clovis Man that without much thought to their safety, a handful of them would supposedly have attacked an animal we call the great short-faced bear, known to science as *Arctodus simus*. On all fours, this bear stood as high as the shoulder of a moose, and its long limbs probably gave it the capability of short bursts of horselike speed. It was almost surely the continent's ultimate carnivore, standing at the very pinnacle of the food chain and capable of bringing down any prey except perhaps an adult mammoth. That any group of humans armed with only spears would ever attack such a creature

The Invisible SEX

is of course ludicrous. They would instead have exercised all their wiles to stay out of the way of such a profoundly dangerous killer. Yet, the very reverse image leaped into the imaginations of people who had convinced themselves that these supposed first Americans were preternaturally gifted hunters, capable of feats now known only from the special-effects departments of Hollywood.

∽

How does such a notion come about? There is no known evidence of any kind that humans took on these huge bears, but we have modern illustrations of such activity, not for pulp magazines and penny dreadfuls but by respected scientific illustrators and published in such places as *National Geographic*. The roots of this fantasy can be traced at least as far back as the mid-19th century and a popular French sculptor, Emmanuel Fremiet, who produced a life-sized sculpture in 1850 of a gladiator fighting a bear. But after Darwin's book was published and prehistory was discovered, Fremiet's bear-fighting gladiator became a Stone Age man engaged in mortal combat with a bear, and the two were intertwined from then on.

Across the Atlantic, artist Charles Knight emerged as the premier painter of extinct animals in the first half of the 20th century. In addition to illustrating numerous books, both technical and popular, he decorated several of the major United States natural history museums with murals of prehistoric beasts from the dinosaurs to the giant Ice Age mammals. Since his time, Americans have tended to see the lost worlds of the planet largely through his eyes, and most popular illustrators of prehistory have followed his lead. By the turn of the 20th century, illustrators

including Knight were augmenting the bear-versus-man theme until it became a largely unquestioned assumption in many minds that Clovis hunters, in amazingly romantic and dramatic encounters, took on even the great short-faced bear. It goes without saying that women played no role in any of these depictions except perhaps to stand off in the distance looking desperately alarmed or, in a few instances, fleeing. King Kong and a screaming Fay Wray were not far behind.

How is it possible that the largely female-less world characterized by our three stories could have arisen? It is a world of male hunters and huge game animals, a world where women, children, and old people are barely present. By inference, women bore children, tended them, and gathered a few edible roots and tubers—the extent of their contribution to the battle for survival.

It is as if, 20,000 years from now, archaeologists were to discover the first few sites dating back to the 21st century, and all of them it turns out, are locker rooms in the remains of those arenas where the National Football League held its contests. The archaeologists would find what were clearly helmets and the padding of gladiators of some sort, as well as a few decayed bits of cloth, some of which appeared to be designed to shield the reproductive organs, and others, bearing numbers, that may have represented the order in which the gladiators were to fight or perhaps to be sacrificed. Of course, it would be an all-male affair, as has been our general take on life in the Ice Age, or what is more properly thought of as the Pleistocene. Where did this testosterone-drenched, macho, men-only world come from?

Until recently in Christian countries, including most of Europe, the Bible described and circumscribed all of history. It

began with the Word and proceeded through a long series of begats to the present, the beginning of things being pegged to the year 4004 before the birth of Christ. God had created the earth and everything upon it, living and inert, pretty much all at once, and all living creatures—the many species of animals and plants— were immutable. To think that something like a whole species could have gone extinct was taken as a heretical insult to God's planning and execution of his plans.

To be sure, there was a certain amount of murk in the earliest of times, since much of the then-current world had been rearranged from an earlier, pre-Flood world (the Flood being the one which Noah and his ark survived, but later becoming several floods). By as late as the middle of the 19th century, a few geologists still attributed such phenomena as huge round boulders sitting totally out of place high up in the Alps to the propellant power of that great watery catastrophe, rather than to the advance and retreat of glaciers. The major features of the planet, to the extent they were studied and understood, were conceived to be the result of (sudden) catastrophes, for the most part great floods. But by this time, the notion of so young an age for the world as specified by parsing the Bible was beginning to come apart at the seams.

An English geologist named James Hutton suggested toward the end of the 18th century that processes like erosion, which were visibly taking place in his time, had always been the prime forces shaping the earth. This came to be called Uniformitarianism, and it was soon championed by Charles Lyell, an Englishman considered the true sire of modern geology, in his multivolume tome published between 1831 and 1833, *Principles of Geology*.

By this time, woolly mammoths had already entered the scene—dead ones, that is: fossils. As early as the 18th century, fossil mammoth bones were a hot research topic, much as genes are today. By the close of that century, the great French naturalist Georges Cuvier had positively and blasphemously identified them as the remains of extinct mammals. (Thomas Jefferson apparently did not believe in animal extinction, and he instructed Lewis and Clark to look for live mammoth specimens out west during their famous expedition from St. Louis to the Pacific. Jefferson also was a bit miffed by European assertions that the New World's fauna was poorer and smaller than that of the Old World.) Before too long, the idea that mammoths and some other beasts had become extinct became more palatable, but these extinctions had no doubt taken place well before the pre-Noah Flood, and therefore it was not possible that humans had lived alongside them.

Then, in 1837, a French customs official and amateur naturalist, Boucher de Perthes, began turning up chipped flints he found associated with extinct animals, including mammoths, from the gravel beds near Abbeville on the Somme River. Even earlier, in England, other naturalists had seen similar associations; but these were in caves, and the stratigraphy of caves was, at the time, considered impossible to sort out. De Perthes' assertions were greeted with derision until the site was visited in 1859 by a committee of distinguished English geologists who pronounced him right.

Humans had indeed coexisted with mammoths, regardless of theologians' views on the subject. Human prehistory had finally been discovered, located in the gravel beds of the Somme.

At this point, a crucial assumption was made: the geological association between the flint tools and the mammoth bones was taken as proof not only of contemporaneity but also that the mammoths had been slain by humans. Thus arose the nearly indelible picture of Early Man the Mighty Hunter from an error no first-year statistics student would be allowed to make today: correlation equals causation. One can show this fallacy by noting a correlation between more city streets being illuminated and a rise in street crime. Do street lights cause crime? Of course not. In any event, the image of the Woolly Mammoth and the Mighty Hunter has been with us ever since. As Bjorn Kurten, the great Finnish paleontologist of the Pleistocene, wrote, the mammoth became "the embodiment of the ice age. Long may it live in our imagination, a black, top-heavy shape looming up in the swirling snow, great tusks gleaming: to our forefathers, perhaps, a demigod." More recently, French historian of science Claudine Cohen iterated the thought in her superb book *The Fate of the Mammoth*. The mammoth, she wrote, "is the totem animal of vertebrate paleontology, but it plays the same role in human prehistory."

Hunters with the skill to bring down such enormous beasts (standing some 14 feet at the shoulder) would surely have been talented enough to produce so much protein for their families that women and children would have played only a minor role in human evolution and the development of human culture. This was the prevailing view until quite recently, and it is no mere correlation that archaeology, for its first hundred or so years as a professional field, was essentially the exclusive province of males, just as so many other fields of endeavor were.

As a matter of fact, signs that women played anything but

a minor role in prehistory were hard to find in a field where the record consists of what often amount to mysterious, dead, silent scraps of any kind of evidence. Most of the artifacts that have come to us from the last Ice Age were made of stone and bone, materials that can exist in the ground for a long time. It has been assumed that stone and bone chopping tools, especially projectile points, were made and used for the most part by men. Beyond that, the remains of materials used—for the most part, it is assumed—by women, such as willow for making baskets and cordage for making bags and other useful items, are plant remains and therefore preservationally fragile. Things made of plants do not last very long in the ground except in the most extraordinary circumstances, such as in extremely dry caves or submerged in anaerobic bogs. They belong to a class of objects called perishables, which also includes leather, fur, and other organic materials.

So mostly male archaeologists found almost entirely stone tools and weapons and assumed that it was a man's world back in the Pleistocene and earlier. Women were largely ignored. Not until recently were some archaeologists even trained to look for much else besides stone and bone tools, so they tended to miss (or dismiss) whatever evidence of the woman's role had survived. The bias was, in a sense, self-fulfilling, but it was more an unconscious bias than a deliberate and nasty plot against women. That scientists, like all other human beings, are products of their times can hardly come as a surprise to people living in the 21st century. Today, most scientists (male and female) are aware of the existence within themselves of such unexamined assumptions, and they try to take them into account—at least when they "do" science. New archaeological techniques and technologies have also

The Invisible SEX

recently emerged that make perishable artifacts and other items more accessible to scrutiny. What is far more decisive, however, is that women have recently joined the archaeological (and paleontological) workforce in far greater numbers than ever before.

In 1994, the chief organization representing archaeologists in the United States, the Society for American Archaeology, made a census of the field. At the undergraduate level, 51 percent of the students majoring in archaeology were women. At the graduate level, women also formed a slight majority. In some universities, such as the University of Arizona and Arizona State University, women accounted for some 70 percent of recent PhDs in the subject. Set against these figures, however, as women enter the archaeological workforce, there is a precipitous fall-off. Sixty-four percent of archaeology professors are male—the same percentage as in the overall archaeological workforce. This is not a "pipeline" problem that will even itself out over time. Part of the problem is the matter of combining family and career that is often faced by professional women. It is also that women in archaeology are more likely to obtain positions in less prestigious sectors of the archaeology profession—museum work, government work, or private archaeological work (once called salvage archaeology, but now called CRM—Cultural Resource Management). The aristocracy of archaeologists usually consists of those who run or have run large multidisciplinary excavations, complex operations entailing large numbers of different kinds of specialists and costing a great deal of money. Most such big shots are men, by far. A classic example of all of this is that since its founding, the Society for American Archaeology has been presided over by 61 individuals, of whom only five have been women.

Modern feminism—the movement that exploded on the scene in the 1960s and 1970s—was late reaching prehistoric (as opposed to classical) archaeology. It arrived only in 1984 with the publication of a widely read article in an academic volume on methods and theory. Entitled "Archaeology and the Study of Gender," the article's authors, Meg Conkey of the University of California at Berkeley and Janet Spector of the University of Minnesota, brought attention to the invisibility of women in our reconstructions of the past—of all those women who were neither queens nor goddesses. Since then, the attention of large numbers of prehistoric archaeologists has been refocused onto issues of gender.

Gender, in this usage, is a cultural value that humans have imposed on top of biological differences. Each category presumably came to embody certain duties and responsibilities; each had proper ways of acting, feeling, and being. In the deep past, there is no sure way to get a glimpse of gender. We can see, and infer, males and females as biological entities, but the roles they played are largely invisible until the world of the Upper Paleolithic, which begins about 45,000 years ago.

2

ORIGINS

A visit back to dear old Charles Darwin, a care-
ful look at the first female hominid with a name,
and where she may have led us all, however
inadvertently.

For perfectly good reasons, most people cannot conceive the im-
mense amount of time involved in the grand narrative of evolu-
tion. It is hard enough to imagine the passage of a thousand years,
but it is nearly impossible to grasp the 7 million or so years that
have passed since one species of apelike creature gave rise to the
lineages both of chimpanzees and gorillas and of us. And then,
after all that time and effort, we are told that there is barely a
dime's worth of difference genetically between us and chimpan-
zees. Estimates vary from 2 percent to 1.5 percent difference. It
all seems confusing. And the more one looks into it, the more
confusing it can be.

It has recently been suggested that chimpanzees (whose
scientific name is fairly insulting: *Pan troglodytes,* which means the
Greek demigod who gave us "panic" and a degraded cave dweller)
should be reassigned and take up a position in *Homo,* the group
that includes us and also once included Neanderthals and even

earlier versions, such as *Homo habilis,* who lived until about 2 million years ago. One might be forgiven for thinking that this taxonomic rebellion by the ape-lovers suggests the dumbing down of the human race. But it raises yet again the question of what is it exactly that makes us human. And as opposed to what, exactly?

Taxonomy, by the way, is the science of breaking down the world of living things into categories of various levels of specificity. For example, to speed over the details a bit, we are vertebrates, more specifically mammals, even primates, and finally the only remaining species of *Homo,* which is to say we are humans.

A tendency exists among paleoanthropologists who discover ancient humanlike remains in places like Ethiopia to pronounce them a new species. Wouldn't you, after all? But then the revisionists come along and several of the species will become one. In the light of these shifting assessments, people make judgment calls about when we stopped being proto-humans and became what can be thought of as real humans, and that of course rests on the question of what is a human, and as opposed to what.

In the particular quest of this book we will be running through a good deal of evolutionary history. First of all, it would be good for us all to be on the same page about this matter. To begin with, evolution is not a theory, and Charles Darwin and other previous and subsequent biologists have never suggested such a thing. Evolution is a fact, visible in literally millions of phenomena. It has been observed occurring as recently as the past few decades, for example, among the Galapagos finches that so charmed and enlightened Darwin long ago, and practically daily in the developing resistance of a host of bacterial and viral disease organisms to antibiotics.

Darwin's theory has to do with the mechanism that enabled evolution to occur: natural selection. *That* is Darwin's theory. A scientific theory can be proved, and natural selection has proved to be the way that evolution works, producing new species out of old ones in the great preponderance of instances. (There is evidence that plants can hybridize to create new species, and it even happens rarely among some animals.) Squabbles arise only in the realm of how natural selection works in detail.

The idea of natural selection is really quite simple, though many people—even scientists—don't get it quite right. In any group of creatures of the same species, there will be some variety. Maybe one female butterfly has a spot on her wing that looks a little more like the eye of a snake than the spots of all the others. Since the birds that typically eat these butterflies are more scared of this particular snake-eyed butterfly, she has a better chance of surviving predation and laying eggs for the next generation. So, over time, nature selects her lineage of ever increasingly snake-eyed butterflies. Or, as with the Galapagos finches, often referred to as Darwin's finches, suppose there was one species with a little beak for crunching little soft seeds, and then a terrible drought hits the island, and over time the plants develop big tough seeds (for some reason). The finch in the group that has a thicker stronger beak is most likely to get a bit more nutrition, and given enough time and generations, thick-beaked finches will wind up replacing all—or at least almost all—the small-beaked finches in that neighborhood, becoming a new species.

The thing to understand is that natural selection works only on individuals, not on the whole group at a time. And it occurs largely as a result of contingency, such as a drought that

changes the local ecosystem, or a random shift in the expression of one species member's genes. It can just as easily cause not the evolution of a new species but the extinction of a species. In fact, the two processes often go hand in hand, one or more species replacing the progenitor species. And as with the creation of new species, extinction tends to take place incrementally, a local population of the species dying out, then another, and so forth, until across the entire range of the species it is gone. Naturally enough, scientists will find all sorts of fine-tuned arguments within this basic framework to keep their technical journals busy. For example, a British biologist, Richard Dawkins, introduced the notion of the selfish gene some decades ago. To state Dawkins's idea simply, your DNA simply packages itself in what you think of as you, in order to perpetuate itself. All you need to do is reproduce, and your DNA is happy and fulfilled. Anything else that goes on in your life is irrelevant, or at most secondary. This is kind of fun to think about: the notion that the great cathedrals, religions, works of art and music, and all of scientific inquiry are nothing more than byproducts of all these gazillions of strands of DNA fighting the good fight. On the other hand, we know now that the important work of the genes is to produce the countless proteins of which we are made, and the production of these proteins is often a matter of timing and other environmental factors. Which is to say that the end product—you—is more than just what the DNA specifies but also what the surround permitted or encouraged by such things as good nutrition, a certain amount of hygiene, and the luck of the draw. Another way of saying all this is that your genes constrain your possibilities, but what you actually become is epigenetic—above and beyond genes.

In any case, the main point is that natural selection works on the individual level. This means the whole individual, usually not just some single trait and not necessarily on the actual DNA. If that butterfly we mentioned earlier, the one with the bigger "eye" spots, also (hypothetically) evolved a left wing that was smaller than the right, it would have a hard time flying, and no matter how scary its "eyes" it would surely be selected against—which is to say, in this case, eaten. Every individual is a huge array of traits, and the entire bundle of traits is what makes its journey through the gauntlet of life.

Beyond natural selection, another force is at work in evolution: sexual selection. This force can seem to work on a single trait or a small collection of traits rather than the whole individual. The male lion's mane, the peacock's elaborate display of feathers, the great size of the male silverback gorilla—these are all traits that are writ large because over the eons females of the species have selected mates based at least in part on them. The peacock with the most rococo grandness of the tail gets the peahen, and such grandness is passed along to the pair's male progeny, while the preference for such a display passes along to the female progeny. Thus do some traits get amplified, sometimes almost to the point of the absurd. There is an obstacle to such escalation, of course, and that is natural selection. If, in an evolutionary leap to be the most preeminent of his kind, one male peacock were to wind up with a tail too huge to lug around, he would be doomed.

These examples of what might be thought of as macho males winning all are meant to be taken as explanatory, of course, and not the only sort of males that can win out in various species. Praying mantis females actually chew the head off the smaller male while

the two are mating, and for many women through time, the nurturing house-husband type has been a winner. A puny young male can be far better off by helping nurture a relative's offspring than by trying to dethrone a brawny alpha male. Woody Allen has done well in films, though he uses an entirely different approach than does Arnold Schwarzenegger. There are plenty of strategies in all of this.

What is important to keep in mind is that natural selection, working as it does on the individual level, works on males and females of any species on an individual level as well. What may make a given female more fit (that is, with a better chance of surviving to reproduce—and her offspring to reproduce, too) may not be of particular benefit to a male. And vice versa.

There are several ways of trying to look back at the grand procession of evolution that led to us humans and to inspect the role of women in the process. One is the fossil evidence. Another is evidence from today's primates in general and the great apes in particular. Another is the behaviors of hunters and gatherers who are still with us, such as the San or !Kung of the Kalahari Desert in southern Africa and others. And then there are genes and molecular biology, and hormones and such. There is some hard evidence, and there is a lot of circumstantial evidence, and there is also a great deal of speculation, some of it informed and some of it not so well informed or thought through. We will look at all these kinds of evidence to try and produce as full as possible a picture of women throughout the long reaches of prehistory. We will try to be clear about what is good evidence, what is reasonable speculation, and what are just far-out imaginings. We can start with one of the most complete and well-known fossil hominids ever—evidently a female.

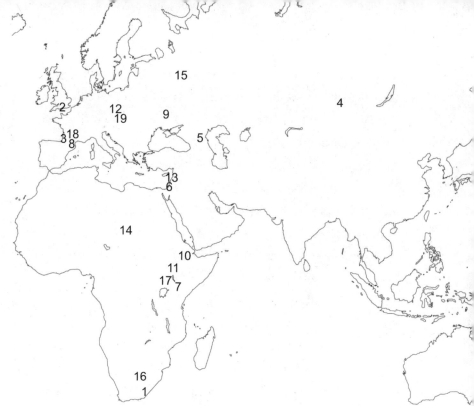

Figure 2-1.

Map of the Old World showing some of the sites discussed in this book.
1 — Blombos Cave, South Africa; 2 — Boxgrove, England; 3 — Brassempouy, France;
4 — Denisova Cave, Siberia; 5 — Dmanisi, Georgia; 6 — Kebara Cave, Israel;
7 — Laetoli, Kenya; 8 — Lespugue, France; 9 — Mezhirich, Ukraine; 10 — Middle
Awash, Ethiopia; 11 — Olduvai Gorge, Kenya; 12 — Pavlov, Czech Republic;
13 — Qafzeh, Israel; 14 — Sahel, Chad; 15 — Sungir, Russia; 16 — Taung, South Africa;
17 — Turkana, Kenya; 18 — Vizere Valley, France; 19 — Willendorf, Austria.

JEFF ILLINGWORTH/Mercyhurst Archaeological Institute

THE STORY OF LUCY AND HER KIND

Nobody today knows exactly how it happened. Maybe she just got out over her head and couldn't swim, or maybe she was exhausted. Anyway, she drowned. Lake sediments covered her remains, and over the centuries her bones turned to stone via the process of fossilization. Then some 3.3 million years later, on a

fine sunny November 30 in the year 1974, she was found. Forty percent of her skeleton, now in bits and pieces, came to light during an expedition led by a recent PhD paleoanthropologist and fossil hunter, Don Johanson of Case Western Reserve University in Cleveland. The members of the expedition were in a remote valley of the Awash River in the Afar Triangle northeast of the Ethiopian capital, Addis Ababa. She was one of the most spectacular finds in the quest to understand the evolution of hominids, and not only because her remains were so comparatively complete. (Many finds in this field consist of only a few fragments of skull, or some teeth, or a few bones like fingers or femurs. From such fragments, Sherlockian paleontologists can sometimes deduce a whole creature, even a whole new species.)

In the afternoon of the day Johanson and crew made their find, he was back in camp listening to the Beatles singing "Lucy in the Sky with Diamonds," and she became known to the world as Lucy. She was clearly an australopithecine (which insiders typically shorten to the simpler "australopith.") Australopiths were first discovered in southern Africa in the 1920s, and in the interval various types or species of australopiths had come to light. But Lucy was so different from all of them that Johanson and his colleague, Tim White, also a recently minted PhD, named her a new species: *Australopithecus afarensis*. Before too many years had passed, Lucy and her kind were deemed to be directly ancestral to every human being alive today.

The scientific name *Australopithecus* was coined in the 1920s and means "southern ape," but Lucy and the other australopiths might, some argue, have been named as early members of the genus *Homo*. In any event, the australopiths were all bipedal and

therefore are considered hominids, which is to say ancestral to us. Lucy was less than four feet tall and couldn't have weighed more than about sixty pounds. In fact, she was the size of a young-ish chimpanzee. Importantly, her feet, joints, and pelvis gave evidence that she walked upright on two feet—at the time, the earliest known human ancestor to do so. As we will see a bit later, walking erect—called bipedalism—was unquestionably the most important first step in human evolution. This would become clear only after Lucy was discovered. For Lucy's brain was (shockingly, to the field) only marginally larger than that of a chimpanzee: 420 cubic centimeters, as opposed to a chimp's 395 cubic centimeters. Up until her discovery, most scholars (except Darwin) had assumed that an enlarging brain had driven the fantastic voyage of human evolution from the beginning.

This all would have been a heavy set of messages to hang on 40 percent of a lone australopith girl, but the following summer Johanson and crew returned to the Afar Triangle and found about 200 bits and pieces of fossil bones that represented in all some 13 individuals, including four infants. Some were much larger than Lucy—up to five feet tall and a hundred pounds: still chimp-sized to be sure, and also showing what was taken to be a considerable difference in size between males and females. This is called sexual dimorphism, and it would soon enough lead to a lot of argumentation. The group were taken as members of Lucy's species, *Australopithecus afarensis,* and were soon thought of informally as the "first family," for it appeared to some but not all observers to be some sort of extended family. Indeed, some thought that the entire family had been wiped out in a flash flood, though such an event would be very hard to prove.

Three years later, Mary Leakey, the wife of the legendary Louis Leakey of National Geographic Society fame, and also the one whom most people in the field think of as the better field archaeologist of the two, made a discovery that was in some ways even more stunning than Johanson's Lucy and the first family. Her discovery took place some 3,000 miles southwest of Lucy's resting place, at Laetoli, in Tanzania. This was no cache of fossil bones. It was the footprints of two australopiths walking through some wet ash from the eruption of a volcano not far off. (Some scholars believe that it was the footprints of three upright walkers.) At some point after these prints were laid down, the volcano erupted again, sealing the prints under another layer of ash. Once they were uncovered, you could see the imprints of the actual flesh of their feet, almost as if they had passed by recently. You could see their very strides and deduce their gait. One set of prints was quite a bit larger than the other, and it appeared that the two, a male and a female, had been walking together in sync, matching their paces. From the prints, some analysts suggested that the pair were holding hands or, more likely, that the larger one, presumably male, had his arm around the shoulder of the smaller female.

Everything about the prints suggested that the couple was also *Australopithecus afarensis*. In due course, a brilliantly produced diorama in the American Museum of Natural History in New York showed the couple walking through the desolate landscape of volcanic ash, the volcano still smoking on the horizon. The australopith female's head is turned; she looks slightly alarmed, as if she had just spotted the museum visitor through the glass, and the australopith male is looking forward, resolute, his arm

The Invisible SEX

resting (possessively or affectionately or both) across her shoulders. It is somehow a poignant scene for many who see it, even endearing. One can feel the connection between the two australopiths and between them and oneself.

But not if one is a feminist scholar with a different interpretation of such matters.

Paleoanthropologist Adrienne Zihlman of the University of California at Santa Cruz was one of the most vocal to protest. The diorama struck her immediately as derivative of the expulsion from Eden (and everybody knows that *that* was all Eve's fault). The arm draped controllingly over the woman's shoulders was sexist. Not only that, but the diorama selected the two-person interpretation of the scene over the three-person version, simply to make the male-dominant point. "The concept of women in evolution," she wrote, "remains encased in the glassed-in Old Testament diorama held down by a Paleolithic glass ceiling." By the 1980s when this tempest blew up, pronounced sexual dimorphism such as that shown in the diorama was taken to be the sign of a society of animals in which males fight over control of the females, as with chimpanzees, meaning that the toughest male is profoundly dominant. Here, then, one could see the primate seeds of the patriarchy, already supposedly in place more than 3 million years ago according to the American Museum. Indeed, both the artist and the curator who combined to produce the museum's all-too-persuasive diorama were men. But there was room for skepticism of the actual science involved, as well as outrage over biased male assumptions. Zihlman forcefully questioned the large-male and small-female hypothesis that was reified in the diorama and assumed in the scientific descriptions

of Lucy and her kin. She insisted that the footprints could just as well have been those of a parent and a smaller teenage offspring. Also, perhaps all these different *afarensis* finds in fact represented more than one species, and she challenged even the designation of Lucy as female. In fact, Johanson, when questioned about this, pointed out that there was no way to sex the fossil by its pelvis or other characters revealed in the fossil remains—except by their very smallness. She was a she because she was small.

Such questioning has always been a valued, even the crucial, feature of science of any kind, and in this case it has forced the field of human paleontology to reexamine many cherished ideas, concepts, and reconstructions of the past, particularly those notions that have until recently rendered prehistoric women the invisible sex. The feminist discomfort with traditional ideas has done the great service of setting the field actively looking for women and their works and their role in the evolution of humanity. In such epochs as that of Lucy, and especially before her time, the task is almost superhumanly difficult. That a question remains to this day of what sex Lucy really was suggests the difficulty of sorting out even which fossils were female and which male. Indeed, Lucy has also been dubbed Lucifer in some quarters. Some notable gains have been made, however, thanks to the very fact that questions about sex have now, after more than a century, been asked.

THE TRAIL OF THE AUSTRALOPITHS

The first australopith to be found was an infant. Called the Taung Baby or Child, its sex was undeterminable. Its skull was found in the fall of 1924 in the Taung limestone quarry in South Africa by

Raymond Dart, a neuroanatomist by training. The skull was very much like that of an infant ape, but Dart perceived some human-like features, named it *Australopithecus africanus* anyway (southern ape of Africa), and then proceeded to annoy the world of British paleontology by writing a paper—without British help or consultation—pegging his find as ancestral to humans—that is, a hominid. The Brits rejected the hominid notion: Piltdown Man was a better candidate, they thought, and so was Peking Man, recently found in Asia, where, opinion of the day held, mankind had arisen—not in Africa; never mind that Darwin himself had said that Africa was probably the cradle of humanity.

The quarry also yielded various pieces of animal bone that appeared to have been sharpened, and Dart assumed that the australopithecines had used these to attack and kill prey. But, having been scorned by British scientists, he went back to neuro-anatomy, believing nonetheless from his researches that humans were inherently aggressive. He was backed up on this by another medical man, Robert Broom, a Scot who turned to paleontology late in life, moved to South Africa, and eventually found many other australopith fossils (including a very robust one, meaning bigger and heavier than most) which he was able to show had walked upright. By 1946, Broom's researches and the support of a British anthropologist, W. E. LeGros Clark, had persuaded the world that australopiths were indeed hominids, vindicating Dart and also his gloomy view of these ancient ancestors. It was generally agreed that *Australopithecus* was a savage hunter, armed with sharp-pointed bones and using them to kill even his own kind. After all, some skulls had holes in them: signs of murder.

Soon there arose the idea of the "killer ape." After the

huge-scale horrors of World War II, people in general had a pretty discouraging take on human nature, and scholars and writers in the field of human evolution were not immune. An American playwright, Robert Ardrey, popularized the notion of early man the killer in such popular books as *African Genesis,* while the scholarly German biologist Konrad Lorenz, in his book *On Aggression*, made the case that humans, like many other animals, were hard wired to be horrible to each other. In 1968, the opening scene of Stanley Kubrick's hugely popular science fiction film *2001: A Space Odyssey* brought the message to a far wider audience that weapons of aggression were the very hallmark of mankind. Our hominid past looked pretty grim, and of course basically without females, though a role for them in reproduction of yet more murderous males was assumed if largely unspoken.

The next phase of the quest for australopiths and their nature took place more to the north, specifically in Olduvai Gorge in Tanzania, under the direction of the aforementioned Leakeys, indefatigable hunters of human fossils. Louis Leakey himself tended to be a splitter in these affairs and usually announced a new find as surely being a new species along the trail. Many of these finds have since been lumped into the australopithecine genus. It became clear that there were many species of australopiths, some of them contemporaneous. For example, smaller gracile ones, called *Australopithecus africanus* (as were many of Dart's and Broom's finds) lived alongside a bigger, heavier version now usually called either *Australopithecus robustus* or its original name, *Paranthropus*. One feature of *A. robustus* was large teeth with a thick covering of enamel, and the dental wear confirmed that this species depended mostly on tough plant food that required a

lot of heavy grinding to be edible. Leakey thought of him as Nut-cracker Man. On the other hand, the smaller teeth of A. *africanus* suggested a more generalized eater, with perhaps some meat in her diet.

Up and down the great African Rift Valley, australopiths of various kinds were turning up from the late 1950s into the early 1970s. These finds made mincemeat out of the long-held idea that (with the exception of that much later dead-ender, Neanderthal Man) there was a single direct lineage of humankind. Instead, here were various species, experiments along the path, many of them inhabiting the world in company with one another. Today some scholars see as many as seven different species of australopiths, stretching from South Africa north into Ethiopia and Chad. These all fall into two categories, the gracile and the robust, but no one has been able to show that one category led to the next. Instead, there seem to have been various versions of each category through time. The australopiths existed from more than 3 million years ago to about a million years ago—a long and successful run indeed.

Practically all the specimens were found on what had formerly been lake shores or river shores, or even river beds—places where all sorts of other animals from hippos to tortoises had come during the day to drink, and where carnivores came with more than water on their minds, as is the case today. This apparent tendency to gather near water would lead to at least two theories about the australopiths and some pretty ferocious argumentation.

Meanwhile, in the early 1960s, the Leakeys had come upon various fragments in Olduvai Gorge that were interpreted as

Homo, the first of what could at the time be called the hominid line. This designation, too, was controversial, since this creature, which the Leakeys dubbed *Homo habilis* (handy man), had a brain estimated to be of only some 640 cubic centimeters. This was considerably larger than an australopith brain but not even half the size of a modern human one. The earlier idea that an enlarged brain led to all other human traits such as bipedalism was gone for good. *Homo habilis* was dated to a time as far back as 2 million years ago, meaning of course that it had lived alongside at least one of the australopiths Other specimens came to light over the years, and they appeared a bit different from one another, and arguments arose as to whether there were more than one species of *Homo* in this era. It is generally agreed now that there were at least two species, *habilis* and a larger and more robust *rudolfensis*. That this is the last word is highly unlikely, and not merely because other specimens will probably be found as the years go by. Revision is the name of this game.

What amounts to a nearly classic example of paleo-revision has to do precisely with the australopiths, who, as we noted earlier, were first taken to be aggressive hunters and killers—indeed, the killer ape. This was a notion that suited the times in which it held sway, notably the early years of the Cold War following on the horrors of the world wars and the Holocaust. But in the late 1960s and the 1970s, a new view emerged, along with flower children and a worldwide peace movement.

The bone-laden sites near water sources where most australopiths and *Homo habilis* specimens were found were taken to be "living floors"—in short, home bases where males, having killed their prey, hauled it back to share with their families. This

heartwarming neo-Brady Bunch view was the brainchild chiefly of Glynn Isaac, who worked closely with the Leakeys in East Africa. The food-sharing hypothesis suggested that cooperation was what led us to being human. Isaac was a bit dubious about the effectiveness of hunting by these diminutive creatures with virtually nothing by way of hunting equipment. Even so, as late as the early 1980s, Owen Lovejoy, of Kent State University published an influential article, "The Origins of Man" in *Science*, the prestigious magazine of the American Association for the Advancement of Science, arguing that the australopiths had begun to walk bipedally in order to free up the hands for killing and carrying food. He saw this as the very foundation of the nuclear family. It was a peaceful, loving life, one of caring and sharing, and it seemed to suggest a direct line through millions of years of evolution leading to the late 20th-century suburban family with Dad running off each morning to fight the good commercial fight while Mom stayed home getting the noisy but fun kids off to school and then spending a fulfilling day doing housework and errands.

Lovejoy's view of these eternal gender roles was immediately challenged by women scholars representing the second wave of feminism, but they were not widely heard by the profession. A bit later, two male archaeologists objected and were heard: one a South African, Charles K. Brain; the other an American, Lewis Binford. Neither cared much about prehistoric gender roles. They were more expert about ecology and the processes by which the patterns of fossil animal remains occur, specifically the patterns of bones left behind in predators' dens and kill sites, than about feminism. These patterns were exactly what

were found on Leakey's and Lovejoy's "home bases," but with one difference. Most of the bones were the result of lions or other big predators killing their prey and feeding on it, followed by hyenas and other scavengers. At the so-called home bases, one found assortments of what appeared to be stone tools, as well marks that might have been the result of cutting or bashing. But these marks almost always occurred at the midpoint along a bone, evidently the work of australopiths arriving after the hyenas and getting the last morsels of marrow from the bones the hyenas couldn't break with their jaws. In other words, these protohumans were not brutal hunters and killers. They were not Ozzie and Harriet–style nuclear families engaged in hauling food home and sharing it. They were opportunistic scavengers.

This extreme view would come in for yet further challenge. Computer studies suggested that some of the bone patterns could in fact have resulted from hunting by hominids, while some were indeed a matter of scavenging. In what proportion, however, seems beyond discovery. Another bit of revisionism occurred fairly recently when scholars took note of the fact that the australopiths and even *Homo habilis* had some peculiarly apelike features with regard to arms, legs, and feet. The arms were longer and the legs shorter proportionately than in humans, and there was a pronounced curvature to the toes. This suggested that Lucy and her later cousins still repaired to the trees in such times as danger or nighttime but walked around upright on the ground during the day, presumably in a quest for food of a type somewhat different than that consumed by the remaining apes in the forest. Lucy, then, and the others were basically bipedal apes. Maybe even *Homo habilis* needs to be excluded from the genus

Homo. There is a suggestion that the australopith toes were sufficiently intermediate between ape and human (no opposable big toe, for example) to prevent the infants from being able to cling to their mothers' fur, having only two grasping hands, and that instead they had to be carried.

Other lines of inquiry, other insights, and additional facts about these early hominids who came and went for some 3.5 million years or more will arise in a subsequent chapters. Meanwhile, our overview of human origins will pick up where *Homo habilis* and *Homo rudolfensis* gave way to other major players.

STRIDING OUT OF AFRICA

Sometime before 1.7 million years ago, during an extremely long period of drought when much of Africa was semi-arid, there arose a figure especially well suited to such an environment. The drought-tolerant grasses common to the African savannahs today had, at this ancient period, replaced the grasses adapted to cool shaded areas. It was a time of diminishing areas of forests, increases in open land, longer heat spells, unpredictable rains, and an overall aridity. The newcomer is called *Homo ergaster* by some scholars who see this creature not only as the first unarguable member of the genus *Homo* but also as a separate species. (*Ergaster,* by the way, is derived from the Greek, meaning "workman," which if pursued in English would give this species the redundant monicker of Workman Man.) Other scholars see him simply as the African member of the species *Homo erectus,* to whom we shall return in due course. Indeed, it is assumed by some of the supporters of *H. ergaster* as a separate species that this arid-land inhabitant was the progenitor of all later species of *Homo,* including us.

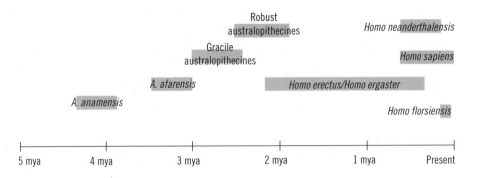

Figure 2-2.
A highly simplified timeline of hominid evolution.
JEFF ILLINGWORTH/Mercyhurst Archaeological Institute

Homo ergaster may have come about relatively quickly. There is little by way of fossil evidence showing any steps by which *H. ergaster* might have descended from *H. habilis,* but such a course is generally assumed. While diminutive *H. habilis* still retained some apelike features, such as disproportionately long arms compared with the legs, *H. ergaster* had arms and legs of distinctively human proportions, and a few stood six feet in height, though most were shorter. From the neck down, these hominids were essentially modern. Another reason some scholars believe that *H. ergaster* may have come into being rather quickly is that at this period there also appears to have been a sudden increase in the sophistication (if that is the word) of stone tools, notably such carefully crafted items as hand axes. At the same time, there was a reduction in the size of the teeth that lie behind the canines, suggesting that *H. ergaster* individuals were using tools of some sort to process and soften the food they ate, calling for less nutcracker-like molars.

From the few skull and other fragments that have been found and a nearly complete skeleton of a youth known as Turkana Boy,

The Invisible SEX

it is clear that *H. ergaster*'s nose projected outward from the face (as ours do). This has the effect of moisturizing dry air and is an adaptation to aridity. Yet another new anatomical feature in human evolution was to be found in *H. ergaster*'s greatly diminished sexual dimorphism which is to say that male and female *ergasters* were closer to being the same size. (Actually, it is not a certainty that the australopiths and the more primitive members of *Homo did* display sexual dimorphism.)

Homo ergaster's diminished sexual dimorphism suggests to some scholars that these hominids were a hunting and gathering (or mostly scavenging and gathering) people who lived as adults in what were probably at least temporary monogamous pairs, cooperating in the quest for food resources for each other and their children. To quote one of the leading paleoanthropologists, Richard Klein of Stanford University, the evolution of *H. ergaster* into a successful forager of the savannahs "has sometimes been attributed to the males' enhanced ability to hunt, but it may actually have depended more on an [sic] females' enhanced ability to locate, excavate, and process tubers." On the other hand, many tubers are poisonous if not cooked, and there is only the slimmest evidence that fire was used in the *ergaster* era. One can speculate (and only speculate, since no physical existence exists) that *ergaster* females probably used some sort of wooden digging sticks and similarly handy items as tools, as chimpanzees are known to do.

While all this sounds surprisingly modern for a creature that walked the earth between 1.7 to 2 million and some 600,000 years ago, *H. ergaster* would probably appear a bit alarming to people today, for the *ergaster* skull had pronounced ridges over the eyes and a forehead that sloped backward at a far greater angle

than ours. It contained a brain greater than its predecessors—850 to 900 cubic centimeters as opposed to the 600-odd of *Homo habilis*—but much smaller than the 1,300 cubic centimeters that is the average size of our brains today. Brain size, of course, is not the whole story; how the brain is organized is the most important feature.

Whatever *H. ergaster's* brain organization was, it was likely sophisticated enough to bring about a new array of tools that fall into the category called Achuelian and that persisted in use largely unchanged beyond some 400,000 years ago when the skulls and brains of the genus *Homo* began another spurt of growth. Some believe that *H. ergaster* was the first hominid to make tools to a particular *pattern*. Hand axes, for example, were teardrop-shaped implements, some say, carefully crafted to be relatively symmetrical. To make such tools suggests a more complex mind that can hold within it a template to be matched by the hands. Other scholars believe that hand axes, with their symmetrical shape, were simply the accidental byproducts of the removal of flakes of stone, not an end in themselves. To further complicate the matter, other scholars assert their belief that the Oldowan tools of *Homo habilis* (mostly stone flakes) were sufficiently similar to suggest that they were made with some kind of pattern in mind, however dim. This would then make the Acheulian tools an evolutionary improvement rather than a sudden leap of newly implanted genius.

Also, dating approximately 1.5 million years ago, in *H. ergaster's* time, some burned cobbles and bones turned up in a South African site. There is no way to tell whether the fires that produced these objects were natural or artificial. If they were man-

made, these sites represent the first known use of deliberately set fire. That it probably was not the first such use is suggested by the fact that it is almost another million years before the regular use of hearths appears in the archaeological record, and one would simply imagine that so useful a tool would have spread like—er, um—wildfire.

As noted briefly before, there are those who think of *H. ergaster* as a single species and the progenitor of others of the genus who followed. But others see it as nothing more than a slightly different African version of *Homo erectus,* a hominid who was first found in Java in the 1890s by a Dutch physician, Eugene Dubois, and was called Java Man and *Pithecanthropus.* Other Asian finds included *Sinanthropus,* or Peking Man, and this suggested to late 19th– and early 20th– century anthropologists like Teilhard de Chardin that humanity arose in Asia, not in Africa, as Darwin had postulated. Current wisdom suggests the opposite. The Asian specimens are all now taken to be forms of *Homo erectus.* The most widely accepted scenario holds that it was *H. ergaster* who wandered out of Africa into what we now call the Middle East, reaching Asia perhaps a million years ago. Over time these wanderers evolved into *Homo erectus,* who ranged throughout much of southern Asia for almost a million years, while *H. ergaster* later gave rise to other primitive human beings, including the Neanderthals and what are now called anatomically modern humans: *Homo sapiens.* But, as usual, other finds have tended to throw a monkey wrench of variety into this smooth and linear tale, which is often called Out of Africa I.

It seems that there was more than one form of *Homo erectus* (or *Homo ergaster*) marching around the landscape at about the

time we see the first of *H. ergaster* some 1.9 million years ago. A question had arisen: why did it take so long for this strapping and at least somewhat brainier member of the genus *Homo* to move out of Africa? The fossil record showed another gap. Perhaps, it was thought, the great diaspora had to wait until these early members of *Homo* developed that Acheulean technology we spoke of before—handaxes and all that. The oldest signs of humanity outside of Africa were, in fact, Acheulean stone tools dated to about 1.2 to 1.4 million years ago in present-day Israel.

But recently, in a site called Dmanisi in the Republic of Georgia, a treasure trove of hominid bones, stone tools, and animal remains turned up, dated to about 1.75 million years ago. Three skulls found there in 1999 and in subsequent years had brain capacities of 770, 650, and, most surprising, a mere 600 cubic centimeters. This put all of them well below the capacity found in *Homo ergaster* and *erectus*. The stone tools were not Acheulean in nature but were similar to the adventitious Oldowan tools associated with *Homo habilis*. And it is clear from a few associated fossil bones like clavicles, an upper arm, foot bones, and so forth that these were small creatures—about the size of *Homo habilis*. For now (late 2006) these remains have been classified as *Homo erectus*, but others see them as intermediate species between *Homo habilis* and *erectus*. In fact, some say that *four* different species are involved at Dmanisi, and some Georgian scholars argue that at least one of them is a brand new species, *Homo georgicus*. Whatever they were taxonomically, they could have been the pioneering ancestors of proper (big) *H. erectus* or dead-end groups that, for reasons now inexplicable, left Africa, reached Georgia, and died out. It is altogether possible that many times over the millennia

The Invisible SEX

people in Africa began to expand their ranges, proceeding into what were probably Africa-like regions. Fossil giraffes and ostriches, for example, have been found in the Dmanisi site.

We will return to this period of time and these players on the evolutionary stage, but first we need to put some of the early steps of human evolution into a sharper focus, the better to perceive the role of women along the way.

THE IMPORTANCE OF BEING UPRIGHT

In which we look back from present conditions to early human evolution and find that the female pelvis may well have saved all us humans from a life of bowling alone as well as letting us become super smart.

The legendary *New Yorker* essayist E. B. White might well have been talking about human evolution when he wrote, "There's no limit to how complicated things can get on account of one thing leading to another." What happened that let us become human? Did anything absolutely *make* us become human? These questions lead to very complicated matters, many competing answers, and some few that are complementary. Practically all the answers proffered are subject to immediate revision with the emergence of new fossil and artifactual evidence, which seems to be happening with greater frequency these days, probably as the result of more paleoanthropologists and archaeologists combing the earth than ever before.

One way to look at the matter raised by such questions is to see members of the human race today as very fortunate survivors. We derived from Miocene apes, the Miocene being the period from about 23 million years ago to about 5.2 million years

ago. Along the way from there to the present, virtually every lineage of great ape and hominid offshoot vanished, died out. No one is in much doubt that the variety of hominid species, some of whom were introduced in the last chapter, was probably greater than we know from present fossil evidence. But of all the hominids that ever walked the earth, only one species remains.

Today, there are but four species of great ape: gorillas, orangutans, chimpanzees, and bonobos (the latter having previously been called pygmy chimps). Yet, from about 23 million years ago to some 17 to 16 million years ago—the early Miocene—the world was brimful of ape species. In all, there were at least 30 genera of apes (each with one or more species), and they inhabited the rain forests, temperate woodlands, and swamps of Asia, Europe, and Africa. Some were relatively small climbers and leapers; others were much larger and partly terrestrial; some ate fruits, others leaves, and still others seeds or nuts; and a few may have had a more diverse but still vegetarian diet. From all of this ape creativity, only four great ape species remain (along with the smaller gibbons and siamangs), and they are confined to parts of Africa and parts of Southeast Asia. How is that?

The real trouble for apes started some 16 million years ago when their world began to go sour on them. Global climate went through one of its occasional changes of life, with the upper and mid latitudes growing cooler and the lower latitudes becoming drier. In Africa, the very earth itself was altering. Huge crustal rifts occurred, producing the rift valleys that have been so helpful to paleoanthropologists in recent times, while the climate turned arid. As a result, what had been huge, continuous belts of African tropical rain forest—dense places with nearly continuous forest

canopy, making for a cooler, shadowy habitat of incredible diversity—began to contract. What forests remained became more open woodlands, drier and with more sunlight. Largely the same conditions occurred in Asia and elsewhere. For many tropical rain forest species, including some of the apes that had thrived in such forests, the dry hot air and the bright sunlight piercing their lives was a catastrophe.

The climate change may have been rapid (in geological terms) and can be traced in several ways, some of them quite subtle. Not so subtle is a sharp increase in ungulate species (antelopes and other grazers) at the same time many forest-dwelling species declined quite abruptly. A confirming chemical story can be read in soil samples as well as in fossil teeth. Like virtually all other plants, trees and grasses create food from sunlight via photosynthesis, and the pathway by which this works depends on the element carbon. But the photosynthesis pathway of a tree calls for a different form (or isotope) of carbon than do those of grasses or sedges. Trees use 13C, while grasses use 12C. In soil and teeth of this period, one sees a sharp and pronounced spike in 13C. Clearly, forests were thinning and giving way to hotter grasslands, while many remaining forests were probably more open, sunnier, and drier.

Many ape species could not cope and went extinct. The remaining ones all had to have adapted to these new circumstances somehow. Some developed a body shape and a mobility of their limbs that permitted them to hold their torsos upright (what scientists are given to calling orthograde posture) and to climb hand over hand. Some also developed new dental conditions, notably thicker enamel over enlarged molar surfaces along

The Invisible SEX

with reduced canines (fangs). All this facilitated the consumption of harder-to-chew food in a world where soft fruits were increasingly hard to come by. Probably most of the Miocene apes that lived in forests took to the ground occasionally in search of food, but at least one and probably several of the late Miocene apes took to moving around on the ground as matter of habit. And some of these—no one knows whether it was one species or more—began to walk, however clumsily, on two feet.

Exactly when some apes began to totter around on the ground as their main mode of locomotion is simply not known. There is a huge gap in the fossil record of apes and hominids between some 12 million years ago and about 4.5 million years ago. Still, we have some arguable evidence of when in that interval the line that led, however circuitously, to humans broke off from the line that led to today's chimpanzees. In July 2002, French and African scientists led by Michel Brunet reported they had found a fairly complete skull of a creature that was dated to a period just shy of 7 million years ago in northern Chad, which lies just south of Libya in that drought-ridden region called the Sahel. The creature lived some 2,500 miles west of the major *Australopithecus* finds in Kenya and Ethiopia, and it was dubbed *Sahelanthropus tchadensis*. Previous to this, most scholars had thought that the creation of the great African Rift Valley had separated those that would become apes (to the west) and those that would eventually lead to humanity (in the east). But *S. tchadensis* puts a major hole in that theory. It had a massive brow ridge, suggesting that the specimen was male, and something humanlike about his canines. In all modern and fossil apes, the canine teeth have sharp edges along their backs, presumably the better to fight off

predators or competitors. Humans evolved without fighting teeth. They have smaller canines that wear in a different manner against the lower teeth. In this new find from Chad, the canines have changed, Brunet says, toward the human condition, but the molars do not have the thickened enamel of hominids. Its face did not protrude as much as an ape's but was more vertical like that of a human, or at least a hominid.

So was *S. tchadensis* just another ape or something on its way to being a hominid? Did it stand at the place where the two lineages split apart? Did it stand up on two legs to cross the ground? Brunet posited that this creature represents the point from which the two lineages separated and, one would presume, was bipedal. Critics of this interpretation erupted almost immediately, some asserting that it was a quadrupedal ape with a diet of difficult-to-eat plants and that its smaller canines simply meant it was a female. Though much of the skull was present, it is missing the lower part where the backbone meets the skull (called the foramen magnum), a diagnostic feature that can indicate whether the owner stood erect, in the absence of other bony features of bipedalism like legs. Therefore, there is no certain evidence to tell us whether or not this creature was bipedal. As usual, there is plenty of room for informed analysis and interpretation, and plenty of room as well for the grinding of axes.

Walking on two feet, however (also called bipedalism), is now widely considered the first truly important step on the way to becoming human. Of all the remaining descendants of the many Miocene apes, humans are the only ones who walk habitually on two feet. Among not only the great apes but all the primate species alive, and indeed among all mammals, humans are

the only ones who habitually stride and even run bipedally. And while we do not know when this transition actually took place, we also possess no absolutely certain way of explaining why it happened at all, though explanations of its advantages are many.

Until recently, one candidate for the crucial advantage was based on the belief that those apes that did become hominids were the ones that left the trees to venture out onto the savannahs, grasslands that are interspersed here and there by stands of trees. By becoming upright they would be able to see over the tall grasses and thus be better able to avoid predators. But from reconstructing early environments by means of faunal and floral remains as well as soil chemistry, we know now that these transitional creatures lived much of the time in the forests or at least on the forest margins. They moved around on the forest floors, becoming full-time savannah dwellers only much later. Peering over tall grasses would be a definite advantage one day, but hardly the thing to impel an animal toward such a huge change in anatomy as bipedalism calls forth, particularly if it only rarely ventures out into the grass.

Another suggestion was that walking bipedally freed up the creature's hands to carry food, infants, and other things. But evolutionary steps (regardless of how fast or major they are) do not occur with some distant goal in mind. Presumably the first bipedal apes foraged around on the forest floor, on the edge of the forest, and maybe even occasionally out in the hot grassy realm of the savannah, and they probably ate what they found on the spot. At some point they would have found that their hands were free and handy for carrying things and much, much later for making tools. But evolution proceeds step by step, or at best a

few steps all at once. Walking bipedally was not "designed" to lead some bipedal species to growing an enormous and complex brain some millions of years down the pike. It took place in what was an essentially new environment (a drier world of more open forest) and conferred what was an immediate advantage—or at least not a serious disadvantage. Infants would still be able to cling to their mothers' fur when whatever species took up the bipedal life, for presumably they still had fur.

As for making stone tools, none show up in the archaeological record for several million years. The first appeared about 2.5 million years ago, long after the appearance of the australopiths. This of course does not prove in any way that these bipedal apes did not make tools of one sort or another, just probably not stone tools. It is not at all unlikely (however speculative) that they might have pulled the leaves off twigs to use to probe termite mounds and draw tasty morsels out. After all, chimps do that. But chimps did not need to become bipedal to achieve that. One even weaker suggestion was that they could use their arms for making signals like the gorilla's defiant gesture of chest-beating. But gorillas, after all, have never needed to be habitually bipedal. So some other major advantage needs to be found for this profoundly important step in evolutionary history.

Standing upright would have exposed less of the body to the direct rays of the sun at noon, and it has been argued that this came about in response to stepping out of the shadowed forests into the glare of the savannah. But, again, this simply couldn't have been the prime engine of bipedalism because it began to come about in the forests, so far as we can tell. Many of these advantages are what some biologists called exaptions, more or

less accidental and fortuitous pluses that came about as a result of some particular adaptation. Certainly one important effect of some primates taking up terrestrial living and bipedalism is that they were no longer constrained by the size of tree branches. They could, and in many instances did, get larger, which automatically brings with it an increase in brain size.

The impelling plus, however (meaning the immediate advantage of heading off into a bipedal way of life), may be connected to energetics. Numerous studies have been made of the energy expended by various forms of locomotion, including comparisons of the knuckle-walking of chimpanzees and the erect stride of humans, and the running of horses. It turns out that human walking takes far, far less energy than knuckle-walking, and the running of four-footed mammals is less energy expensive than human running. It also turns out that such comparisons shed little light on the originating advantage gained by some early Miocene ancestor that began to take up the upright life. Its feet, for example, would have necessarily have been more apelike than the feet of a modern human, meaning that the body weight would be transmitted along the outside of the foot, and the push with each step would pass along the middle of the row of toes. By contrast, a modern human's foot passes the body weight along the outside, then across the ball of the foot, with the push-off by the big toe. This is far more energy-efficient and was a long time coming, as was the solid platform of the human heel.

Even so, it is most likely that what made an early form of bipedalism advantageous has to do with energy. The reduction in Miocene forests probably reduced the density of the areas of fruit and other vegetal sources of food for some if not many of the

forest-dwelling Miocene apes. They would have had to move to a more varied diet found over larger territories. Those apes of the period that did take up the bipedal life would have saved themselves at least some energy as they traipsed around the forest floors looking for food, gaining an advantage over the knuckle-walkers or other four-footed gaits, for they would have needed less energy (therefore less food) to cover the same amount of ground. Alternatively, they would have had more energy left over after foraging to devote to other needs, such as the energy-intensive business of reproduction.

Are there any other candidates for this pioneer of bipedal foraging besides the recently discovered *S. tchadensis* with its humanlike face and cranium? At least two, suggesting that there may well have been several different populations of erect apes or hominids strolling around the late Miocene landscape between 5 million and 7 million years ago. One of these, found in Ethiopia and known as *Ardipithecus ramidus,* may have existed as far back as a little under 6 million years ago and persisted until some 4.5 million years ago. *Ardipithecus,* chimpanzee-like in many particulars, is taken to be a hominid on the basis of its fragmentary arm and foot bones, skull architecture, and dentition. It had thinly enameled teeth but sharp incisor-type canines. It had strongly muscled arms with elbows that could have locked (an aid to swinging in the trees). However, its leg bones suggest that it was bipedal, as does the more forward position on the skull's base of the foramen magnum, the place where the spine meets the head.

Another such creature is *Orrorin turgensis*, found in north-western Kenya. *Orrorin* is taken to be a hominid for reasons of

The Invisible SEX

dentition and especially because of three preserved femurs that show signs of having been articulated to a distinctly humanlike pelvis. *Orrorin* dates back from 5.7 to 6.1 million years ago. Except for these two and the Chad find, the hominid-ape fossil record is basically a blank from 12 million to about 4.5 million years ago. That is not much to go on, and it provides us with literally no direct information about the basic interest of this book: the role of women. For example, we know next to nothing about the degree of sexual dimorphism in these creatures and even less about the nature of their social life or divisions of labor based on sex.

One can speculate that the energetic savings, however small, of walking upright would have been beneficial to females especially, since childbearing is extremely energy intensive (eating for two and all that). Females also would have discovered that they could use their newly freed hands and arms to carry infants for longer distances. Even if these hominids had fur, which is entirely likely, no small baby could hold on by itself for indefinite periods. Down the evolutionary road, the switch to bipedalism, however gradual, would have especially profound effects on hominid women and therefore on the human condition.

Before we look at what may be the key piece of the anatomy in this truly revolutionary transition, it is important to point out that the reduction in the Miocene forests did not *make* some apes become bipedal; it simply provided a stage on which that could happen. Similarly, though walking upright eventually made a whole array of human traits possible—such as making tools—it did not make us human. It simply enabled our lineage to become human.

THE EVOLUTION OF A MULTITASKING PELVIS

Bringing forth children "in sorrow" is the fate to which the Biblical God doomed Eve and her female progeny, but it goes back a long way, probably as far back as Lucy's time 3 million years ago and perhaps even earlier. Rather than a punishment for transgressing a dietary command from on high, this fate is in large part a result of standing up and walking on two legs. Furthermore, this evolutionary step appears to have decreed that at some point along the way, midwifery would become the world's oldest (which is to say, first) profession. One can even, however speculatively, trace a fairly straightforward connection between bipedalism and the special sociability, or what some scientists call affiliativeness, among women, and from there dimly perceive and speculate about the evolutionary "logic" behind the origin of human speech. Before we head off into these distant and rarified realms, however, it is time to look at the nature of the human pelvis, in particular that of women.

Like most parts of the anatomy, the human pelvis has many purposes. To accomplish them, it is a bundle of compromises. It rests upon the legs, providing sockets for bulbous ends of the femurs, which is to say our hips, which facilitate our ability to walk upright. The pelvis also provides a bony basin in which our viscera sit, safe from gravity's inexorable pull (in four-legged animals, it is the abdomen that holds the viscera up). Of course, our curved backbone rests, however uneasily, upon the pelvis. In women, the pelvis also provides space—the birth canal—for babies to move from the uterus out into the world at large. One of the compromises evolution has had to achieve is between making this birth canal sufficient to accommodate the passage of

a human baby and, at the same time, permitting the mother to walk and run upright. For we humans are a supremely bigheaded species in comparison with our bodies, and also comparatively broad-shouldered.

When a human baby is born, its head has a longer way to go than that of a chimpanzee to become fully developed. In fact, a human baby's first three months after birth can be thought of as a fourth trimester. At birth, the human baby is far more immature and helpless than a chimp baby, and after birth its head has a far greater amount of growth in store. But even so, a human baby's head at birth is a lot larger in proportion to its body than a chimp baby's head is. Both the large prenatal head and the long period of helplessness after birth go a long way to explain why we are so advanced in many mental processes, but these two features also represent something of a spanner in the birthworks.

For a person to walk or run easily on two legs, the two legs have to be relatively close together, which means the pelvis and therefore the birth canal need to be relatively narrow. If a human baby's head were to grow much larger before birth, the mother's pelvis would have to be so wide that she could only waddle, something in the manner of a crocodile or a lizard. In effect, for a bipedal creature with the legs placed far apart on wide hips, each step would require her to laboriously and awkwardly heave her trunk around her planted foot and then forward. So the narrow human birth canal is a necessary compromise, and a parlous one at that.

In the great apes, the birth canal is large compared with the infant's head. As a result, birth in gorillas, for example, is simple, taking about twenty minutes and causing relatively little

strain on either party. Gorillas can get away with this because, while they are largely terrestrial, they locomote mostly on four limbs. On the other hand, the human infant's skull is almost exactly the same size as the opening of the birth canal. And unlike the case of the apes, the human birth canal has evolved into a tortuous, twisted path.

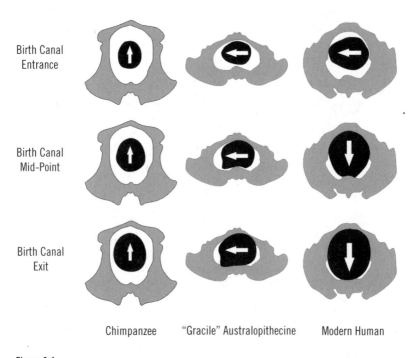

Birth Canal Entrance

Birth Canal Mid-Point

Birth Canal Exit

Chimpanzee "Gracile" Australopithecine Modern Human

Figure 3-1.
Schematic showing the orientation of a baby's head during the birthing process from an obstetrician's view. Note that in chimpanzees, the head maintains the same position throughout, while in australopithecines, the head rotates only minimally. In modern humans (and in most other members of the genus Homo), the head rotates to the point that the mother would be unable to assist the baby in the event of complications, hence some of the benefits of midwifery.
JEFF ILLINGWORTH/Mercyhurst Archaeological Institute after
Rosenberg and Trevathan 1996

The Invisible SEX

Seen from above, a baby's head is oval, and the long dimension goes from the forehead to the back of the head. The entrance to the mother's birth canal is also oval (and, as noted a very tight fit with the baby's head). The entrance is widest from side to side relative to the mother's body, so a baby starts out headfirst, facing one side or the other of the mother's body. But the next "segments" of the birth canal change orientation. The long dimension of the birth canal's oval shape shifts to become front to back, and then side to side again at the exit. The baby therefore has to twist along with the changing shape of the birth canal so that its head, and then its shoulders, are lined up with the long dimension of the canal's oval shape. This means, among other things, that the baby will typically have performed a one-eighty in the course of being born. Instead of emerging facing in the same direction as the mother's body—that is, the front—the baby typically emerges facing the mother's rear.

Women are the only primates in whom the baby emerges facing the rear. When a monkey baby or an ape baby begins to emerge, the mother, who will be squatting or on all fours in a tree or somewhere else by herself, can reach backward and guide the baby out, deal with the umbilicus and placenta, and pull the baby toward her breast. But if a human mother were to reach down when her baby's head emerges and try to gently pull it out, the pressure she would exert, no matter how gentle, would tend to pull against the natural curve of the baby's spinal cord, risking neurological damage or even death.

This tortuous trail from uterus to world is unique to humans and represents several kinds of compromises. It allows the fetus to have the maximum possible size head and still escape through

a necessarily narrow birth canal in a pelvis that lets the mother walk and run on two legs with great efficiency. On the other hand, it causes a considerable amount of pain and stress, and it also risks a good deal of mortality for both mother and child. For example, in a breech birth (which happens about 3 to 4 percent of the time) the baby's feet or knees make a poor spreader of the canal. If they get through at all, the baby's head may then get jammed long enough to cause death by asphyxiation, risking the life of the mother as well.

Even when this system works as designed, it puts a huge strain on both parties. The baby's head is necessarily squeezed as it turns and passes through the canal, the several plates of its still unformed skull being shoved away from the top of the head. One result is the well-known soft spot on top of a newborn baby's head. Another result is considerable shock to the baby as it is about to enter the world. For the mother, of course, the huge effort of contractions that can last for long periods and the actual birth are often accompanied by pain unknowable by those who haven't been through it. It is worth noting that were the human baby's head as fully formed at birth as that of a chimpanzee baby—that is, with its plates firmly joined—there would be less give in the skull, and it would rarely make it through. To reach the current arrangement can only have occurred through countless millions of individual hominid tragedies as well as successes.

Before we look at how this painful and exacting series of compromises came about, and when, an important side effect of the process on the nature of humanity and especially human females needs to be explored. Wenda R. Trevathian of the University of New Mexico's anthropology department is also a professional

midwife as well as a scholarly specialist on the human birth process. A study she co-authored with a fossil specialist, Karen Rosenberg of the University of Maryland, pointed out that the tendency for human babies to be born facing the mother's back has made human mothers the only primates—indeed, the only animals—that seek and get assistance in the birth process. It is possible, of course, for a woman to have her baby by herself, and it is even considered a cultural ideal in certain cultures such as the !Kung of the Kalahari Desert in southern Africa. Even among the !Kung, however, it is an ideal that is apparently quite rarely achieved, particularly among first-time mothers, and most ethnographic assertions about solo birthing have proved not to be the case. Certainly solo birthing is by no means the norm among peasant societies as fictionalized in such novels as *The Good Earth* by Pearl S. Buck. Assisted birth, then, is a nearly universal practice among humans, and Trevathian has written that the "advantages of even simple forms of assistance have reduced maternal and infant mortality throughout history."

Enter now what has been called (with a bit of journalistic pizzazz) the hormone of love. It is oxytocin (pronounced ock-see-TOE-sin), and it is found only in mammals. It was originally thought to be a relatively uncomplicated hormone with a few important jobs: (1) stimulating the ejection of milk from the small sacs within the mammary gland, (2) stimulating the contractions of uterine smooth muscle during labor and birth, and (3) acting within the brain to establish maternal love and behavior. Its name is from the Greek for "rapid birth." Oxytocin is in fact present in both men and women, and in both it is associated with orgasm. As with so many other hormones with which the body is flooded,

however, further research on oxytocin has shown it to have many subtle but profound influences, particularly in women. The hormone is produced in the hypothalamus, an ancient part of the brain, and in ovaries and testes.

During pregnancy and particularly just before birth, oxytocin receptors build up in the mother's brain as well as the uterus, and pulses of oxytocin not only stimulate contractions and, later, the expression of milk but also provide what Sarah Blaffer Hrdy, a leading scholar of motherhood, calls "the rush of warm sensations that suffuse a mother when she breast-feeds, the tapering off of inhibitions as two mammals sit companionably side by side, or groom each other, or when longtime mates nuzzle or rub each other." The prolonged intimacy involved in breast-feeding, an activity that brings on an oxytocin rush, is thought to have played a major role in the evolution of social relationships, which depend in part on empathy: the ability to understand and know someone else's feelings. Indeed, the more social the life of a mammal, the more oxytocin is found in its system, whereas loners produce very little.

Oxytocin has another role that has only recently come to light. It influences a woman's response to stress. For years, studies showed that the rush of adrenal hormones in conditions of sudden or prolonged stress produces the "fight or flight" response. This was of course adaptive for people or near-people living among large carnivorous animals, and it was seen to be common to both men and women.

But then one day two women scientists, Laura Cousino Klein and Shelley Taylor, both at the University of California at Los Angeles at the time, suddenly were struck by a different

The Invisible SEX

phenomenon. "There was this joke," Dr. Klein reported, "that when the women who worked in the lab were stressed, they came in, cleaned the lab, had coffee, and bonded." About 90 percent of all research on stress has been carried out on men. Some researchers have suggested that evidence concerning the fight or flight response in women was inconsistent, probably because of female cycling. Klein and Taylor realized that the inconsistency might be the result of a different response to stress altogether. A different response of women to stress, they realized, might be more than a joke. Before long they had determined that when women face a stressful situation, they are flooded by the same brain chemicals that provoke the fight or flight response but also by oxytocin, which buffers the fight or flight response and encourages them to tend children and gather with other women. The researchers found that the more women engage in this "tend and befriend" response, the more oxytocin is released into the bloodstream, leading to even greater calm. It does not work that way in men. They do produce oxytocin in times of stress but also great amounts of testosterone, which blocks ocytocin's effects. It goes without saying that all effects we have focused on in this discussion can be greater or lesser given the individual, and they also are mediated by a host of other hormones, by circumstances, and of course by decisions taking place in the human brain.

How would a tend and befriend response be what evolutionary biologists call adaptive? How would it increase the likelihood that a given woman and her offspring would survive? For a woman who is pregnant or taking care of an infant, fighting would put not only herself but her offspring in jeopardy, and flight might also compromise her ability to tend her child. Even

so, both responses would be necessary in certain circumstances. But in situations of low-level stress or prolonged stress, a different response would be more effective. Tending—quieting her offspring and caring for it—and blending into the environment could be a better strategy in many instances. And befriending—reaching out to other women—would provide safety in numbers, but it would also encourage other women to help, perhaps most importantly during that highly stressful event, childbirth. What may have started out in mammals as a chemical facilitator of vaginal contractions and/or the bond between mother and offspring may also have expanded into a system for handling stresses of various kinds, with the happy side effect of promoting midwifery: assistance during the process of giving birth through a narrow and slightly convoluted pelvis.

Incidentally, recent studies have also shown pretty conclusively that women whose labor and birthing is attended by another woman have far shorter labor, fewer caesarean sections, and even more loving, less listless interactions with their newborns. The presence of a sympathetic woman and the presence of oxytocin seem to be a reinforcing mechanism with a very ancient lineage.

When in the course of human evolution did this astonishingly complex system of anatomy and physiology come about? By the time of the australopithecines like Lucy, perhaps even earlier, the female pelvis provided a birth canal that was symmetrical, oval, and with an unchanging shape from inlet to outlet. The oval's length ran from back to front, so the fetus would enter the canal looking forward. Such a passageway would have provided little problem for the relatively small-brained (chimp-sized) and

small-skulled australopithecine fetus, except for its shoulders. Because of the shoulders, the fetus almost surely had to turn some 90 degrees—but in either direction. So it had a 50-50 chance of coming out facing the rear, which, as we saw, makes an unassisted birth far more difficult and possibly destructive. An australopithecine mother would have benefited from a midwife, but it is not likely that we will ever know whether any Lucy was helped by one.

According to Karen Rosenberg, it is likely that the earliest members of the genus *Homo,* who lived alongside australopithecines for a very long time, also had Lucy-like pelvises, which in turn restricted the possible size of the brain. But by some 300,000 years ago, the twisted pelvis was apparently present. This has been determined from at least three fossil pelvises of archaic humans: a 200,000-year-old male from Spain, a 280,000 year-old Chinese female, and a 60,000-year-old male Neanderthal from Israel. (Given a male pelvis, it is sometimes possible to "reconstruct" the female version on the basis of known differences between the sexes, and vice versa.) In these specimens, the fetus would have had to twist around, usually facing the rear at birth in a manner typical of today, and the odds are that those females who had help (whether driven early on by oxytocin or not) would have most successfully perpetuated their kind. This new birthing process, however fraught with difficulty, had the hugely important feature of permitting the hominid brain to grow increasingly large. And a large brain requires an unprecedented amount of nourishment, so it is logical that we look in the next chapter at how these ancient ancestors of ours managed that aspect of life.

4

WHO BROUGHT HOME THE BACON?

In which we find that females have a tendency, along with males, to nourish people, and we discover various strategies for doing so.

Tim White, the previously mentioned paleoanthropologist and old Africa hand who was present when Lucy came to light, visited the Dmanisi site in the Republic of Georgia in 2003 and developed a scenario to explain the remains there, offering it to the discoverers for whatever it might be worth. Even though the team had only scratched the surface of this promising and complex site, a great deal of different kinds of material had been found, and White believed that its very richness could reveal more about the actual *behavior* of hominids than could any other known sites.

Judging from the great number and diversity of carnivore species whose bones were found there, White opined that Dmanisi had been an attractive place for carnivores, a place where, having dragged carcasses or parts of carcasses to feed upon, they could take cover in bushes, trees, and holes and be free of sun, rain, or wind, as well as at least temporarily free of pesky scavengers. Whatever meat they left on the bones of their prey, and the

marrow in the bones they couldn't get to, would sooner or later be attractive to scavenging creatures. It was also a place—a lair— where carnivores themselves died of old age, wounds, or other causes.

On the other hand, invading such a place and risking waking up or disturbing a big carnivore would be extremely dangerous. "One learns in the bush to approach such situations with great care," White wrote, "even as a child." Surely, the Dmanisi hominids approached this place with both fear and caution as well as with hope for some meat. The discoverers of the site found accumulations of unmodified cobbles that had to have been brought in by hominids, since they clearly had not been washed in by flowing water (the only other way they could have arrived there). These accumulations struck some as collections of cores from which scrapers and other tools could be chipped off, but White had a different explanation.

In anticipation of the danger, he suggested, the hominids picked up stones along the way and hurled them into the thickets to test for the presence of the carnivores at the time and also to drive them away if they were present, just as native Africans (and people like Tim White) learn to do today. Over time, the cobbles accumulated in considerable numbers—far greater numbers than would have been necessary to bring as cores from which to chip off scrapers or other tools. That this ploy did not always work is probably testified to by the presence of the dead hominids. There can be no doubt that these largely unarmed early people often became prey for big carnivores, and avoiding this fate was surely one of the circumstances that exercised their brains. The incautious would have been selected against, in the cool lingo of

evolutionary biology, meaning that they would have been eaten and thus removed from the gene pool. Similar collections of un-modified cobbles have been found in several much earlier aus-tralopithecine sites in Olduvai Gorge, and this usage could well explain them. In the meantime, while there is no certain evidence of early hominids throwing things such as rocks to flush out car-nivores, it seems reasonable to imagine they could do this. After all, chimps often throw things by way of making threats.

This brings us back to the notion of these early hominids being more given to scavenging than to actual hunting (by the time of this diaspora from Africa, they were surely capable of hunting at least some small mammals, birds, and reptiles), and it raises one of the significant gender issues in the study of human evolution. Who did the hunting (or scavenging), and how im-portant—or unimportant—a part of the diet was it compared with the plant foods that were gathered—again—by whom? And what exactly did these increasingly bipedal and increasingly brainy creatures eat?

Not a great deal of direct or even indirect evidence exists to help answer these questions.

Dental measures—such as how big the molars are, or how small—along with attempts to determine the isotopic content of fossil bones have not explained much of a detailed nature. Re-constructing the habitat of the early hominids can be suggestive as well, but is one step removed. Even further removed are analy-ses of present-day apes' diets, especially those of chimpanzees, and of the diets of the few modern hunting and gathering peoples about whom such matters have been examined scientifically. But all such avenues are worth exploring.

One way to get a general notion, for starters, is to look at the nutritional requirements of one of the world's greediest organs: the human brain. Just at rest—that is, not doing a complex calculation or concentrating on a philosophical conundrum, but just idly watching the day go by—today's adult human brain (on average some 1,350 cubic centimeters in volume) requires from one fifth to one fourth of all the energy expended by that person at rest. To put it another way, the human brain consumes 16 times as much energy as muscle for each unit of weight. Anthropologist William Leonard of Northwestern University and some colleagues calculated that a typical australopithecine of about 80 pounds with 450 cubic centimeters of gray matter would need to devote 11 percent of its energy budget to its brain. *Homo erectus,* weighing in at 130 pounds with a brain size of about 900 cubic centimeters, would have to have devoted 17 percent of its energy to maintaining its brain. At the same time, chimpanzees and other primates require only some 8 percent for this purpose, while other mammals require a mere 3 to 5 percent.

No one knows for sure exactly what led the hominids to add volume to their brains over long periods of time. Australopithecine brains grew from about 380 cubic centimeters to 500 in some 2 million years, and *Homo* went from 600 in the case of *Homo habilis* to the 900 of *Homo erectus* in about a half million years. Mere increase in stature would have had something to do with it. But it can be argued without much disagreement that the increases in brain size could not have happened if hominids had not adopted a diet richer in nutrients and calories than that of the other primates. As noted earlier, taking up the habit of bipedalism allowed some late Miocene apes and their descendants

to move farther in the food quest without an exorbitant expenditure of energy, and, as the world dried out and grew somewhat cooler, one either had to take up a diet of richer foods that were few and far between or develop some great big molars and jaws to crush into edibility large quantities of such things as leaves and stalks that are far less dense in nutrients.

The very business of descending from a full-time life in the trees would also have allowed an enlargement of the body. Most branches are too small to support a large creature; gorillas, orangutans, and even chimpanzees are primarily terrestrial for that very reason. And since there is a relationship between brain size and body size, life on the ground would have allowed the brain to grow larger over the eons.

If you were to eat three and a half ounces of foliage, like a gorilla, you would obtain between 10 and 20 kilocalories of energy. If instead you ate the same amount of fruit, you would get about 75 kilocalories. But if you ate that same amount of meat, you would get a whopping 200 kilocalories. Given such differences, it is no wonder that paleoanthropologists have looked very carefully for evidence that protohumans like the australopiths ate meat, and they have found plenty of evidence, much of it compelling though circumstantial, that this was the case. Animal bones, many of them apparently defleshed with sharp Oldowan scraping tools, turn up some 2.5 million years ago in association with human remains. And, the logic goes, the larger the proportion of the overall diet that meat became, the more brains could grow; the more brains could grow, the more complex social organization became and the more effective people became at exploiting

The Invisible SEX

rich food resources, especially meat, and so on in a synergistic gyre through time, culminating in Man the Mighty Hunter.

In fact, whether it was Man the Hunter, Man the Scavenger, or, more likely, both sexes doing both, it has long been widely assumed that men did the hunting or scavenging, or certainly the bulk of it, and that it was indeed the procurement of meat—dense nutrients in manageable packets—that played the crucial nutritional role in the long march to modern humans with our big brains and our consummate cleverness. How much of this scenario is true?

We will return to brains and what little can be said of their evolution in a subsequent chapter, but first it is important to look at some other features of emerging human life that are associated with the role of meat gathering. On the basis of ethnographic studies of hunting and gathering peoples in historic times and particularly in the past century, the typical pattern of foraging has been that women gather plant foods—fruits, nuts, berries, certain roots and tubers, and other plant foods from the nearby surround—while men go forth on periodic hunts that take them farther from home base. But in many such societies, women also hunt and trap small mammals, perhaps going less far and wide than the men. In all, however, it is essentially a mobile existence, with the home base moving frequently in response to the seasonal patterns of game and plant food. Typically, if the men are successful, they return with meat, which they share with their immediate family: their children, usually their children's mother, and maybe other kin. So it has been widely assumed that a similar pattern existed, beginning perhaps with the australopithecines,

but certainly by the time *Homo ergaster* and *Homo erectus* were on the scene. An underlying assumption in all this was a distinct separation of gender roles, and in addition the prevalence of monogamy, or at least a serial monogamy, with men returning with valuable meat to share with a spouse (who is almost always on the verge of anemia from menstruation or lactation or pregnancy) and a child or two, in return for readily available sex and the assurance that the children are indeed his. Such a social arrangement would have been in place, it was assumed, once the use of stone tools came into being, since stone tools were clearly the key to hunting, which obviously was a male affair. Thus was the circle of logic closed and the gender roles assigned.

By the early 1970s, this logical representation of early *Homo* life was being severely questioned by anthropologists, many but not all of them women. For example, Sally McBrearty of the University of Connecticut and one of her graduate students, Marc Monitz, broke the male hunter scenario down into eight underlying assumptions, in a paper with an unusually provocative title, "Prostitutes or providers? Hunting, tool use, and sex roles in earliest *Homo*." The assumptions and the authors' alternative versions are as follows:

1. MEAT CONSTITUTES A SIGNIFICANT PART OF THE DIET.

But ethnographic studies of tropical foragers like the San of the Kalahari show that between 75 percent and, seasonally, 100 percent of the diet comes from plant food.

Essential nutrients missing in plants are supplied by insects, reptiles, rodents, and so forth. True, by 2 million years ago, stone tools were used to deflesh bones and to

smash bones for marrow, but there is no way to tell how important the meat and marrow gained really were.

2. MEAT IS OBTAINED BY HUNTING.

As noted earlier, there is no reason not to think that scavenging and hunting were both practiced.

3. HUNTING IS NOT ACCIDENTAL BUT A PLANNED AND COOPERATIVE JOB.

Such hunting is not a crucial and unique step on the way to becoming human. Baboons and chimpanzees engage in deliberate and cooperative hunts.

4. MALES DO THE HUNTING.

Among non-human primates, there are examples of female olive baboons providing a quarter of the kills. Among some groups of chimpanzees, females hunt with equal success as the males. It is often assumed that women with infants could not engage in the hunt, but chimp females have been seen chasing down "heavy prey" even while carrying an infant. Ethnographically, big communal hunts often include women, such as the net-hunting of the Mbuti pygmies.

5. FEMALES GET MEAT FROM MALES.

Food sharing and delayed eating are not uniquely human behaviors. Non-human primates like chimps and baboons commonly share food. Females typically share food only with their immediate families (as is also the case among human foragers), and meat is shared by males with both

females and males, as well as by females with males. Female chimps who provide males with meat reach a status from which they dominate the males. (Olga says she got this wrong: female primates share their food with their immature young. And most primatologists see the sharing of food among chimps as more of a "tolerated theft" than food sharing. The phrase, however, is a scientific oxymoron.)

6. FEMALES TRADE SEXUAL ACCESS FOR THE MEAT.

Meat sharing by male non-human primates occurs frequently between non-consorts (the equivalent of friends), but estrous females typically attract more meat than do non-estrous ones. At the same time, non-estrous females are less social and less pushy, so they tend not to be present at hunting events. Overall, among chimps and baboons, males can get sex without providing meat, and females can get meat without providing sex. By implication, the same was true of hominids.

7. STONE TOOLS ARE MADE FOR USE IN HUNTING.

In fact, it is very difficult to determine what stone tools were used for after these many millions of years, and which hominid species actually made them. Microwear is sometimes a clue, but it is less useful in Africa, where most tools were made of lava rather than fine-grained stone. Where microwear provides a clue, the tool was often used for multiple chores, such as processing meat, plants, and hides, and to make wooden tools such as digging sticks.

8. STONE TOOLS ARE MADE AND USED BY MALES ONLY.

Chimpanzees have been found to select raw materials, use them to manufacture tools, and carry them here and there for one purpose or another, such as "fishing" for termites with specially crafted twigs, or using stone or wood hammers to crack nuts on wooden anvils. Among chimpanzees, females are more likely to make tools and use them than are males. Indeed, one group of chimps, called the Tai group, and especially the females of the group, carry stone hammers as far as about 500 yards and create what can be thought of as archaeological sites.

In concluding, McBrearty and Monitz suggest that given the plastic, variable behavior of present-day non-human primates as well as ethnographic diversity and what we know from the fossil and other remains of early *Homo*, we have no need to look for a single behavioral pattern to understand the origin of our genus—and in particular, no single pattern of gender-related behavior. They do suggest the likelihood that females among the early hominids were most likely to be the tool makers—or at least the most "intense" tool makers.

In 2000, Jane Lancaster and anthropological colleagues from the University of New Mexico published their analysis of the diets of ten tribal societies of hunters and gatherers, including the !Kung of the Kalahari, the Ache of Paraguay, and the Hazda of East Africa. The study compared life histories, intelligence, and diet among chimpanzees and human foragers, both of which go after high-quality foods to the best of their abilities. The researchers found that, generally speaking, children produce

little or nothing by way of food, and women produce less than they consume throughout their reproductive life. The children and women of reproductive age are subsidized by men who can produce a surplus by hunting game, a task requiring a good deal of skill that takes a long time to learn. Meat, the anthropologists found, plays a special role because it is dense in nutrients and comes in easily divisible packages. "The original division of labor in humans," they wrote, "between male hunting and risk-taking and female gathering and care of offspring, rests on [meat's] unique characteristics."

So here are what amounts to two more or less opposite views of what might have taken place during all those eons. Both are based on examples arising from present-day people and non-human primates. Both seek a view of the deep past based on some aspects of the present. Is there a way to choose one over the other?

There are problems with both formulations. Meat was not the most nutrient-rich food available to these hominid ancestors of ours. Two pounds of cashews, for example, has as much fat and protein or raw calories as two pounds of meat, or more—and of course nuts do not put up much of a fight. And nuts—for that matter, insects, grubs, and other nearly pure protein foodstuffs—come in perfectly manageable and divisible "packets."

There is a problem of the utmost significance with the use, as well, of ethnographic analogies. No matter how superficially simple a recently living or still living group of hunters and gatherers may appear to be, they are nonetheless fully modern human beings in both the anatomical and the intellectual sense. They have the full range of intelligence capabilities and communications skills that we do. To compare the behavior of such folk with

ancient populations that have one half to two thirds the brain power is a huge stretch. It is best to remember that the early members of our genus—*habilis, ergaster, erectus*—had lifeways that were almost certainly radically different from those pursued by anatomically modern humans, and that those lifeways have been extinct for millions of years.

THE DIFFERENCE BETWEEN FEMALES AND WOMEN

Detecting women, or for that matter men, in the archaeological record is no simple task. And the more remote the time frame, the greater the difficulty. The further back in time one goes, the more the "invisibility" of women's roles and men's roles increase—if not exponentially, then at least geometrically. Generally, in recent discussions concerning the roles of human females in evolution and prehistory, it assumed that females are the invisible sex of our title to this book. But if what women did is invisible, then so is what men did. As our three stories in the first chapter suggested, the assumptions that males did this, that, and the other are simply assumptions. Most paleoanthropologists make the assumption that men, particularly, are the known representatives of hominid evolution. *Homo*, after all, means "man." Peking Man does not suggest a damsel. But beyond the traditional myopia of male researchers with their built-in gender blinders, several good reasons for this bias exist.

Actually, several layers of invisibility are at play here. In the recent past, at least, it is safe to say that all known human societies recognized the biological distinction between male and female, based on such obvious anatomical signs as exterior sex organs, secondary sexual characteristics like the distribution of

body fat, the expression and size of breasts, general body build, and the configuration and robustness of various bones. Also, behaviorally, it was clear for most that men impregnated women, that women had children, and that they nursed them.

When one moves back into the time of the early hominids, sex is not so easy to determine. Basically, only two sets of criteria exist for this task, since soft tissue is not preserved, and DNA studies, while possible in some cases, are still inadequate. In all higher primates, males and females differ in sheer size: sexual dimorphism. This is how a fossil individual can be sexed, but only if the fossil hunter is presented with enough fossil remains. With fragmentary remains (which is typically the case), especially fragmentary remains of the young, size alone is not much help.

Another means at hand is the characteristics and metric relationships of particular features of the skeletal anatomy. Typically, for example, the pelvis of a female differs in significant ways from a male's, but the situation is not black and white. A given female's pelvis may shade off into some gray zone in the direction of the male's, and vice versa. The eye orbits, as another example, of males and females typically differ, but again, not every female's eye orbits are of the classic female type; they may be more like those of a male. So it goes, down the list of anatomical differences. The paleoanthropologist tries to make sense of what are usually fragments—even small fragments of individual bones—and of relatively few examples overall. You can count the specimens identified as *Homo ergaster* on your fingers and have some fingers left over. That some remains of hominids 2 or 3 million years old are ever found at all is something of a miracle. And given the paucity of specimens, we cannot be sure of the range of

variation between or among males and females. Lucy, as noted earlier, might well have been male and could have gone into the books as Lucifer.

Gender is a wholly different matter. Gender is, as we noted earlier, a cultural phenomenon by which a society assigns a series of expectations, behavioral norms, and cultural significance to each biological sex or to different age groups. A thoroughly modern example is that when Ann Garrels of National Public Radio traveled across the border from Iraq into Jordan just before the outbreak of the Iraq war of 2003 (to which she returned), she was not asked to submit to an AIDS test because she was fifty years old, and Iraqi policy in this regard is evidently based on the assumption that women fifty or over do not have sex. It is possible that Iraqi culture equates menopause—in other words, post-reproductive age among women—with a prim and proper loss by women of the sexual urge.

To return to the deep past, if the sex of hominids is hard to determine, the social roles by which these ancient creatures played out their lives are all the more shrouded in shadows and scholarly chimera. What methodology exists by which we can fathom the gender woman (as opposed to the sex female) and, more accurately, the genders women are identified with in the deep past? The chief method is to look at contemporary tribal societies and extrapolate backwards, as in the matter of hunting and gathering. Some inferences from modern hunter and gatherer societies are probably valid, but many may not be for reasons stated above.

The archaeologist is (properly) persuaded that some behavioral roles, as in gender roles, leave some sort of "signature" in

the ground. The signatures are in the form of artifacts and eco-facts (stuff left behind as garbage, like seeds and so forth, or hearths, which do not turn up until far more recent times) or, more importantly, *patterns* of artifacts and ecofacts. The patterns and the artifacts themselves can, however tenuously, be associated with gender roles in the *recent* past or the present. For one instance, when baskets or portions of baskets come to light in dry caves or rockshelter sites where the circumstances of preservation permit their recovery, they are assumed to represent the presence of women—indeed, the food production and food collecting activities of women. Why? Because in recent times, tools and equipment made of fiber have usually been the province of women in most foraging and horticultural groups of people. But there are exceptions: some small, some large. In the society of the Hopi Indians of northern Arizona, to this day men do the weaving and knitting, tasks that are almost always the province of women elsewhere. In many societies, men make all the fiber sandals, if not other fiber accoutrements. Some items are made by men for exclusive use by women, such as manos and metates, the heavy stone implements for grinding seeds. Other objects are made by women for the exclusive use of men. No one who has survived an introductory course in anthropology should be surprised that there is a delightful variety of ways to be human.

An example of the ambiguity that confronts the archaeologist interested in the deep past can be illustrated by a pointed fragment of wood found in Clacton-on-the-Sea in England. It has been dated as being some 300,000 years old (we leap ahead here to a time closer to the final act of *Homo erectus*'s long run on the world stage). It has been interpreted by most scholars as a

deliberately fashioned spear point, but it could equally well be the fragment of a 300,000-year-old digging stick. If women are typically the ones who use digging sticks to gather roots and tubers, then this could be a gender-specific item. Of course, there is no reason to assume that any given tool was made and used for a single purpose. At times, San women use their husband's spears as digging sticks. So who knows? All we have, besides examples from modern hunters and gatherers, is an analogy from modern chimps, which also have spent an equal amount of time evolving since we—and they—branched off from someone like the *tchadensis* character.

If the wood fragment turns out finally, however, to be a spear—or a stake, or, as one wag suggested, a probe for measuring the depth of a snowfall—we are left in the dark in terms of gender. Whatever the Clacton tool was (and it probably was a spear point), who is to say that females 300,000 years ago did not make spears and use them to help feed themselves and their offspring? The persistent association of spears and other weapons (or what are assumed to be weapons) with males at all times in the past is simply another dubious assumption born of improperly applied (and in some cases inaccurate) ethnographic analogy.

The upshot of all this discussion is that until some time after a mere 100,000 years ago, gender roles of both men and women, but particularly women, are more invisible than is the biological role of the female sex. This is not necessarily going to hold true forever. More sites with hominid remains will almost surely be found. Suppose such a site were to be found with two separate areas characterized by different tools and ecofacts. This might throw a bit of light on the differing roles of females and

males, illuminating the genders—men and women. It would be, at best, a single instance of greater certainty, and that would be far more than exists today. On the other hand, while we have a few examples of societies or large parts of societies being suddenly buried and preserved (like that at Pompeii), they are vanishingly rare, and archaeologists are more than likely doomed to sort through the mess that is the normal archaeological site, replete with mixed-up uses of the same place over time (often called palimpsests), with confusing layers and interlayers brought on by events that took place later, such as invasions of rodents, and few utterly unambiguous remains or artifacts.

For now, given the limitations of current analytical and recovery techniques, coupled with the constraints of preservation over such a hugely long period, we cannot see women—or men—very clearly. The closer we come to the present, the more emerges. But for now, we are largely left to the uncertainties of looking at today's biological status of males and females and looking back into what had to be a long, arduous, tragic, and thrilling period when we made our early steps in the direction of being human. One of the most important features of modern humans like us, and one of the most telling organs in all of human evolution and destiny, is of course the brain. That is the next topic of discussion.

5

GRAY MATTER AND LANGUAGE

The authors reflect on baby talk, hobbits, instructional manuals, and intergenerational communication and the differences between male and female brains, not to mention the female invention of language.

It took some 5 million years or more (possibly 6 or 7 million) to get from a state of halting bipedalism on the part of some Miocene ape creeping around the forest floor to the present braininess of modern human beings who can live virtually anywhere on the planet and stand on the moon. Few, if any, of the steps along this unimaginably long path through time were inevitable, though they may look it in hindsight. Through this long period, the hominid brain grew in size, or volume, but not steadily—or at least from the evidence available it did not grow steadily. But many believe that if there were more evidence (that is, more skulls) and better chronological controls, brain evolution would be shown to be quite gradual. As we have seen, too, every increase in brain size did not provide a hedge against extinction. Again, in this long period, we have very little evidence about how the various hominid brains were organized. All we have are the skulls, or partial skulls, that enclosed them and some circumstantial

evidence that hominids, once armed with these brains, began to make things and leave some of them behind for archaeologists to discover. Also, we have the present-day results of all this evolution, from which we can try to work our way backward, as was done in Chapter Three in the case of the pelvis and its all-important birth canal.

We do know that Lucy and her australopith colleagues, while persistently hanging in for more than 2 million years, were nothing much more than bipedal apes with chimp-sized brains. But some time earlier than 2.5 million years ago, some creature that may not have been all that different from Lucy gave rise to a creature similar in stature—about three and a half feet tall, maybe four feet—but with a noticeably larger brain. This was *Homo habilis,* and their kind or kinds (generally presumed to be the first members of the genus *Homo*) were possessed of brains ranging from 510 to 750 cubic centimeters, the mean volume being 635. Some evidence recently came to light that this remarkable growth in brain volume might have been helped along by a chance mutation in a single gene of the creature that was becoming *Homo habilis.* Geneticists announced in the summer of 2006 that they have found a region of human DNA associated with the brain that anciently changed very quickly.

In 2003, a University of Pennsylvania surgeon and molecular geneticist, Hansell Stedman, and his colleagues were looking for genes in the newly mapped human genome that might affect muscle proteins and therefore, perhaps, shed light on the awful affliction of muscular dystrophy. Muscles are made up chiefly of proteins called myosins, and some ten genes in all apparently

produce all the various myosins in muscle. Genes are themselves made up of base pairs of amino acids, and Stedman found that one of the ten myosin-producing genes had two fewer base pairs than all the others. It turned out that this was no unusual mutation in a few individuals but common to all humans. At the same time, this same gene in some seven different non-human primates like macaques they tested had the full complement of base pairs. So what difference did it make having two fewer base pairs?

The non-human primates all have relatively large "bite" muscles connecting their jaws to their skulls, while human beings are unable to produce the kind of myosin associated with the mutated gene and therefore have smaller "bite" muscles. Smaller muscles need less bone area to attach to, and human jaws are proportionately smaller than those of the other primates. Importantly, the bite muscles in these seven non-human primates (and most others) are wrapped around the entire skull, attaching to the ridge of bone that extends across the top of the skull from front to back, called the sagittal crest. During the growth of a young primate, once these muscles are firmly attached to the sagittal crest, the bones of the skull cannot grow any further, and this puts a limit on the size to which the primates' brains can grow.

The argument, which appeared in the British journal *Nature* in 2004, was that with the reduction in bite muscles, thanks to the gene mutation, the youthful skull of emerging *Homo habilis* was able to grow for a longer period and therefore accommodate a larger brain. And, by means of fairly arcane genetic analysis, Stedman and his fellow scientists judged that the mutation in this one myosin-producing gene took place about 2.4 million years

ago, just about the time (give or take a hundred or so thousand years) that *Homo habilis* evolved from australopith ancestors. Stedman and his colleagues called this mutation the RFT mutation—"room for thought."

This discovery was taken seriously by some (though not all) scientists interested in human evolution, though they are virtually all aware that there must be plenty of other genes among the 40 million or so base pairs (of a total 3.1 billion) we do *not* share with chimpanzees that have played a crucial role in human evolution as opposed to chimp evolution or macaque evolution. The mutated muscle gene, it should be pointed out, did not make our brains grow and cause us to become real human beings. It simply seems to have permitted room for brains to grow, or so Stedman thinks. Obviously, a lot of other mutations had to have occurred as well along the way.

The evolutionary biologist (as opposed to the molecular biologist) raises some questions about all this, in particular, what immediate advantage would have been incurred by some members of an australopith group by having a smaller and therefore weaker jaw? A smaller jaw would accommodate smaller teeth (or fewer teeth), but why would smaller teeth have been a characteristic among all the other characteristics present that nature would have selected for? The best one can say is that a smaller jaw evidently would not have posed any particularly great *disadvantage,* so this change was not selected *against,* but retained. Another question that remains unanswered is this: why is it that certain anatomical features like jaws and teeth get smaller if bigger ones are not needed? Is it some sort of generational atrophy? Or does

The Invisible SEX

it have to do with how much energy a creature has to expend during childhood to grow a jaw and teeth? The less energy the jaw takes, the more is left over for growing, say, the brain. This answer seems terribly indirect, but even the most indirect process can be imagined to have taken place in the course of thousands of generations.

Perhaps the greatest difficulty is with the date the geneticists have come up with. Dating genetic events, for all the seeming precision, is the most inexact bit of the new science of molecular genetics, based on estimates of the rate at which genes mutate over long periods of time—but periods of time in which any number of things could affect the rate of change. Genes and molecules and whole organisms are a lot more malleable than the metronomic regularity of the breakdown of the carbon 14 atom, or the fixed rate at which a certain isotope of potassium turns to argon. And by such radiometric means, most people peg the earliest fossil of *Homo habilis* to 2.5 million years ago—100,000 years earlier than the jaw muscle mutation. And further, if indeed it is the earliest *Homo* and not the australopiths who were the first makers of tools (as most scholars think), then *Homo* was making tools before the mutation in jaw muscle that would have allowed a larger brain that in turn would have permitted this creature to make tools. The earliest known find of stone tools in direct association with the remains of animals was made in Kada Gona, Ethiopia, in 2000 by an Ethiopian archaeologist, Silehi Semaw, of Indiana University and his team. The site, in which flaked artifacts were unquestionably used to process animal parts, has been securely dated to 2.6 million years ago. Such are the fine

points and complexities of paleoanthropology, which is nothing if not a vibrant and disputatious old realm for the new science of molecular genetics to mess with.

In any event, it is a bit humbling to realize that our humanity might rest on many such tiny shifts in anatomy and fragile moments in time as one mutation in one of ten myelin-producing genes. But of course there has to be more to it than that. For something so relatively large and so complex as a hominid brain to come about, a great array of evolutionary processes must have been involved. One such process might have been the development of sufficient blood veins in the head to permit heat to be given off in such a manner as to keep the brain from overheating out in the sun on the savannahs. This has been dubbed the radiator theory by one researcher, Dean Falk of Florida State University. Another theory pins the enlarging of the brain, called encephalization, on the size of hominid bands: the larger the group, the more natural selection would favor a larger (and more complex) brain. One of the more compelling explanations of what might have transpired is called the expensive tissue hypothesis.

ONE WAY TO PAY FOR AN EXPENSIVE BRAIN

It takes energy to produce a body and its component parts, and the body's functions are limited by the amount of energy the fuel-burning process of the body (the metabolism) can deliver. The brain is highly expensive in terms of the energy needed for its construction and use. Mammalian brain tissue requires some nine times the metabolic rate as the body as a whole, meaning that all primates, which tend to be relatively large-brained among mammals, need more energy to operate their brains. Humans are

The Invisible SEX

the largest-brained in proportion to body size, so one would expect humans to have an especially high metabolic rate, but we don't. The ratio of our metabolic rate to our brain size is not very different from that of other mammals.

In 1995, two researchers from England, Leslie C. Aiello of London University and Peter Wheeler of Liverpool John Moores University, proposed that the hominid gastrointestinal tract, also known as the gut, was comparatively small, meaning, for one thing, that it took less energy to construct in the first place. Also, it could function properly, processing food in such a manner as to produce sufficient energy to keep the entire body (including its energy-intense brain and its shorter gut) only if there were a change in diet from low-quality foods, which placed a special burden on the gut to digest, to high-quality, easy-to-digest food. This, the researchers say, strongly implicates an increasing amount of meat in the diet (which subject we looked at in Chapter Four). Becoming human with a human brain, then, seems to have called for a large—indeed, an ever-larger—array of happy happenstances or contingencies, all probably occurring at different times but all interrelated. Even the matter of the pelvis plays, at least indirectly, into the expensive tissue hypothesis.

In looking into the question of when this all came about, Aiello and Wheeler suggested that the australopithecine pelvis was sufficiently wide (comparatively) to have housed a longer, bigger gastrointestinal tract, and probably did. But by the time *Homo ergaster* arrived on the scene, the pelvis was comparatively narrower, permitting this hominid to stride about and engage in endurance running with a largely human gait but constraining the size of the gut, as well as making childbirth more difficult for humans and

calling forth some early, sociable midwifery (as discussed in Chapter Three). The importance of the change in diet as a feature of increasing brain size is now widely accepted, but the overall hypothesis leaves room for the minor quibbles that anthropologists can feed on. Some have said that the key to the increase in human brain size without a concomitant increase in body size was more likely driven by the fact that humans (and hominids to some degree) could externalize many tasks, meaning the use of tools and other cultural equipment that replace sheer brawn. Others question which came first: encephalization, permitting better foraging for fancier grub, or fancier grub powering a bigger brain—and why would the gut atrophy in size anyway? But did a smaller gut permit a bigger brain, or the other way around? In any event, whether all these caveats and questions are ever satisfactorily answered, it is apparent that a whole lot of coevolution has gone on in the course of our evolution into humanity.

BRAIN SIZE IS HARDLY THE WHOLE STORY

Our large brain seems to have come about in fits and starts rather than in a steady progression through time. As noted before, the mean brain volume of *Homo habilis* was some 630 cubic centimeters, and it jumped to 900 in *Homo ergaster* and to 1000 in *ergaster's* immediate descendants, the wide-ranging *Homo erectus*. Later on in this book, we will meet the descendants of this latter line, anatomically modern humans (formerly known as Cro-Magnon Man and, to all extent and purposes, us) and their immediate predecessors. Apparently these immediate predecessors—as well as Neanderthals—had slightly larger brains on average than did we modern humans, and ours shrank down to the mean of about

1,300 cubic centimeters. This shrinkage suggests, of course, that actual brain volume is not the whole story, and this is confirmed by the fact that dolphins, whales, and elephants have much larger brains than ours. This is no doubt mostly a simple function of their overall body size, as was the volume of the six-footer *Homo ergaster*'s brain related directly to his (or her) size—what scientists call a case of being allometric. Not only that, but some mammals including primates have brains that are larger, relative to body size, than ours.

A remarkable discovery announced in late 2004 has thrown the matter of brain size, among other things, into confusion and a lot of paleoanthropologists into a tizzy. This was the discovery of the skull and some bones of a human female nicknamed Ebu who lived some 18,000 years ago on the Indonesian island of Flores. An adult, she stood a little over three feet tall. Bits and pieces of six others of her kind were found alongside in a cave called Liang Bua by Mike Morwood of the University of New England in Australia and a team of Australian and Indonesian scientists. Ebu and her people had brains that were almost exactly the same size as those of chimpanzees—smaller even than the brains of *Homo habilis*. But they were clearly of the genus *Homo* and had lived on Flores from as long as 95,000 years ago until a mere 13,000 years ago. Morwood's team concluded that they were the product of an early dispersal of *Homo erectus* into the region, a group of which had managed somehow, perhaps by raft, to cross the waters to the island of Flores. Once there, they were able to hunt (with fairly sophisticated stone points) and consume (with the help of fire) a range of animals from large rats and huge lizards to dwarf elephants.

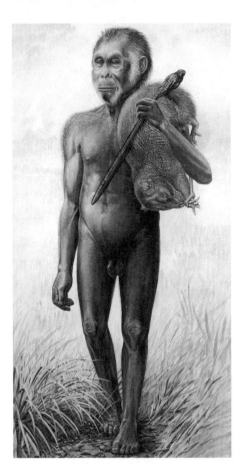

Figure 5-1.
An artist's drawing of Homo floresiensis, *the controversial "hobbit," with a large rat. The theme of man-the-hunter still holds strong, despite the fact that it was a female that was the chief find.*
PETER SCHOUTEN/Corbis

Ebu and company were named *Homo floresiensis*, a putatively brand-new human species, which the press happily dubbed hobbits. The suggestion is that Ebu's ancestors, upon arriving on the isolated island where food resources were relatively sparse, began an evolutionary process common to many animals (but obviously not all) that become isolated on islands. They began to shrink. The energetic advantages of smaller size are obvious (perhaps something worth looking into in our current century, when populations promise to be large for a long time while we run out of many useful resources). Furthermore, outside of the

pretty dimwitted giant lizards, there were no predators to fret about. In any event, as these individuals reduced in size, so did their brains, but not, apparently, their intelligence. This simply was not how brains were supposed to work. Smaller meant less intelligent. But the new find suggested that once some level of complexity has been achieved in the structure of the brain, it can be miniaturized and still exhibit a high level of intelligence.

In the years to come, if validly identified, Ebu may well become as famous as Lucy. Not surprisingly, numerous caveats have been forcefully offered, including one suggesting that Ebu may have been a "microcephalic" human—which is to say pathologically little-brained one. (To this, one archaeologist was overheard saying that some paleoanthropologists are a tad microcephalic themselves.) But even though Ebu is what might be thought of as the "type specimen" of *Homo floresiensis,* when *Time* published its story about her in the November 8, 2004, issue, the editors illustrated the piece by a male with a recently killed giant rat hung around his neck. The boys at *Time* simply didn't get it. The mighty prehistoric hunter is back again, even though he is a midget.

In the 19th century and well into the past century, however, the notion of brain size was widely considered *the* definitive key to humanness. This notion has also played into the hands of male chauvinists, be they unconsciously chauvinist or advertently. It is a fact that the human female brain tends to be smaller in volume than the male. Ergo, ancient prejudice was scientifically sound: women simply could not on average be as smart as men, thus justifying practically any sort of discrimination that sprang to mind. This was common enough even though the brain size differences tend to disappear when adjusted for body size differences.

Recently, however, it has come to light that the human female brain has the same number of neurons packed into its slightly smaller volume as the male brain does. (This may also have been the case with both male and female *H. floresiensis.*) Thus has one supposed underpinning of the idea of male superiority been swept away. Furthermore, most scientists who study the brain and track its evolution are of the opinion that how the brain is organized is far more important than size. Sure, volume is important up to a point. Also, the increases in size (from australopiths to *Homo habilis* and from *habilis* to *ergaster*) coincide in time with the appearance of the Oldowan and then Acheulian toolkits we have talked about before. This could be a matter of increased brain size but is more likely associated with some kind of new organization of some part of the brain. The part involved is almost surely within the cerebral cortex, which achieves its maximum complexity and relative size in humans.

Practically everything that can be called upon today to explain how the brain works will be considered pretty simpleminded in the future. The human brain is surely the most complex organ ever to exist on this planet. To begin with, there are some 10 billion neurons, and many of these cells, if not all, are capable of thousands of connections with other neurons. At any given moment all of these neurons are either switched on or off, so to perceive the current state of any brain is almost impossible by definition. Add to this the fact that the neurons exist within a network of other cells, called glial cells, which were previously thought to be more structural than functional, but which have now been found to play an important role in such brainy affairs

as memory. Any attempt to perceive the actual steps along the way in the 6-million-year-long evolution of the complexity of a certain unknown bipedal ape's brain into the human brain is severely limited by the obvious fact that all those brains until today's no longer exist. No one has seen or touched the brain of any hominid species but *Homo sapiens*. We do have what are called endocasts, which are casts of ancient brains made from the (often much reconstructed) skulls of fossil hominids. From these, one can see at least a shadowy impression of those areas of the brain that rest on the surface.

One such area was arguably present in australopiths, begins to show up better in *Homo habilis,* and is present in near-modern form in *Homo ergaster*. That is Broca's area, which is involved in assessing syntactical matters and providing motor control over speech. It occurs near the ear on the left side of the brain, and on the right side as well, but in greatly reduced volume. Another related area, Wernicke's area, occurs nearby but is harder to make out in endocasts. It is responsible for the comprehension of meanings in speech.

In addition to a Broca's area of some significance, *ergaster* also seems to have had the beginnings of the proper configuration of the area between the palate and the foramen magnum (where the vertebral column attaches to the skull) for making speech. It is arched slightly less than ours but more than that of *habilis.* On the other hand, *ergaster's* spinal cord had very narrow passages in the chest vertebrae for nerve cells and nerve fibers, meaning that *ergaster* probably did not have sufficient control over movements in the rib cage that are essential for speech. The

picture is thus a cloudy one, but particularly for *ergaster*, some "degree of humanlike speech may be implied," to quote Richard Klein of Stanford University.

It is not at all clear what Klein might mean by "humanlike speech." Most linguists who think about such things at all believe that speech did not come about until anatomically modern human beings arose some 150,000 to 200,000 years ago, and until recently linguists were largely uninterested, if not oblivious, to the notion of the "evolution" or development of some sort of animal vocal system into speech. Some linguists say that language evolved straight out of gestures and rudimentary sign language. Most linguists are uncomfortable with, or largely ignorant of, the vocalizations of non-human animals, and when it comes to looking for non-human antecedents of language, they get only about as far as the sign languages that have been taught to chimps and gorillas (which of course involve only capacity and not anything that has ever been seen in use in the wild) and one vocal example from the wild that we will get to later. The origins of language—or better, of speech (the vocal form of language)—is a messy, speculative subject, with very little available that can be called evidence. But of course speech, as well as its much later written versions, is at the very core of humanity, unquestionably the most distinct and unassailable difference between humans and all other animals—the most glorious and useful function of the utterly unique human brain. The most common widespread sound on the planet earth is not the roar of the surf or the rustle of the wind; it is people talking.

Where did such a supple tool come from? The image in the Sistine Chapel of God reaching out to touch Adam's finger, thus

creating living humanity in a single stroke, is probably not how speech came about, though plenty of linguists and other anthropologically minded scholars say that speech, as we know it, did not occur until *Homo erectus* had already evolved into *Homo sapiens.* Whenever it arose, however, it is axiomatic in the understanding of biological evolution that it has to have arisen from some kind of antecedents. Evolution works with (or one might say builds on) old structures. The human backbone is fundamentally more like that of a mouse than it is unlike, and so in fact are the constituents of mouse and human brain cells. Only out of a relatively conservative system do evolutionary changes and even revolutions spring.

WHO INVENTED LANGUAGE?

We have little but vague speculation about how language originated. There are in fact no truly scientific theories about it, for the very reason that any proposed theory is impossible to prove, meaning it is not a scientific theory. But ideas do exist. Some anthropologists have suggested that the ability to refer to such abstract things as events that took place in the past or objects that are not present but are to be found somewhere else—which is to say, the symbolic nature of language—arose from increasingly elaborate gestures, including such acts as throwing stones at prey (or at one another). This, the theory goes, would have permitted the human brain to make somewhat abstract associations, perhaps like the notion of something being "over there" out of sight. But how, and why, this would have eventually been translated into spoken words in some kind of grammatical order is not readily apparent.

On the other hand, there is something specific and measurable about spoken words. They are made up of sounds, and all sounds, by definition, have acoustical properties that these days are easily recorded as voice prints, called sonograms, that can be measured, displayed, and compared. On such prints, the duration is shown horizontally, and frequency is shown vertically. For a dog's vocalizations, a long, high-pitched whine appears as a narrow mark high up on the voice print, a growl in a wide line toward the bottom. Dogs whine when they are fearful or hurt or are begging or trying to appear unaggressive. They growl when they feel aggressive or when they are trying to threaten one. In the 1970s, Eugene S. Morton, a research ornithologist at the Smithsonian's National Zoological Park, produced a virtual library of voice prints of the calls of some 80 birds and mammals. He found that like a dog, they all barked. A dog's bark on a voice print shows up as a chevron, like a private's stripe. A bird's alarm call (a sound like *chirt*, though at a higher frequency than a bark) is also a chevron, as is the alarm call of monkeys. The chevron first goes up—in the manner of a beginning whine, suggesting fear—and then down, toward the growl, suggesting aggression. It means, essentially, "Hey! What the hell is that?" The calls are, in acoustic form, the same, and they bespeak the same emotion on the continuum between fear and aggression.

Unexpectedly, Morton's continuing research provided an insight into what speech may well have arisen from, in essence, the initial conditions that permitted the human invention of language as we know it. Morton found that basically all mammals' short-range vocalizations and all bird calls follow this same pattern, and this includes humans as well. We speak in a high

register to babies but in low raspy tones when we are making threats. Thus, in the vocal communication of birds and mammals, form matches function. In this case, the acoustical nature of the sound (form) is functionally the announcement of an emotional state. The match of form and function is one of the fundamentals of biology, even down to the molecular level.

Of course, human speech conveys a great deal more than just our emotional state, but information and abstract ideas as well. We are also a lot better than most mammals and birds at disguising our feelings and at lying outright, while practically all non-human vocalizations are naked, non-volitional expressions of an emotional state. Extremely few examples exist of animals disguising their feelings by uttering the "wrong" sound for the circumstances. How did our unrivaled vocal capacity come about? Voice prints shed a clue on this, but first it is time to look at the famous "words" uttered in the normal daily life of vervet monkeys in the wild.

In considering the language capacities of non-human animals, linguists typically draw attention to these medium-sized monkeys that live in fairly large troops in sub-Saharan Africa in savannah forest areas. They are preyed upon mostly by leopards, eagles, and pythons. In the 1970s, two biologists, Dorothy Cheney and Douglas Seyfarth, found that the vervets have three quite distinct alarm calls. One, a bark uttered at the sighting of a leopard, sends the troop scurrying high into the nearest tree. When an eagle soars overhead, an alarmist utters a sound like a chuckle, and the troop heads for the densest bushes nearby (an eagle can take a monkey from the ground or from the upper branches of a tree). The snake alarm is a high-pitched chittering

that causes the troop to stand up and look all around at the ground. This is as close to the specific use of sounds to convey specific factual information as anyone has ever discovered among animals in the wild, and it certainly seems as if these monkeys are using something like words.

Linguists and others argue over the nature of these calls—are they truly words or proto-words? Do they pass along exact information in the sense that we use the word, or are they emotional responses to a change in the environment—the sudden presence of an eagle overhead, for example? Is language something that, like tool-making, now has to be attributed at least minimally to non-humans? Do animals have what anthropologists call culture, meaning the passing of information of various sorts via means other than genes or mere imitation? This is not the place to enter those disputatious realms, but one of the features Morton found that does appear to distinguish the vervet alarm calls and all other non-human vocalizations acoustically from speech is the absence of consonants.

Our ears are so accustomed to hearing consonant sounds that we insert them mentally even when they are not there. The ovenbird does not, in fact, say "teacher, teacher, teacher." The graphic representations of the consonant sounds of "t" and "ch" do not exist on the sonogram of its song. Only the speech of humans among all animal vocalizations regularly combines consonant sounds with vowel sounds. What would the use of consonants do?

In the first place, they would permit the existence of one crucial characteristic of speech. It could cease being a closed system, with a limited number of possible sounds, and become an open system. With little but vowel sounds and tone of voice, only

so many sounds are possible—perhaps a hundred—and therefore only so much meaning can be conveyed by most animals. Throw in some 20 consonants, and the possibilities for distinct words are virtually infinite, a fertile field for linguistic invention rather than a genetically fixed series of calls. Not only do consonants permit one to utter distinct syllables, like "per" and "mit," but they also allow much more rapid speech. If in your speech "eee" were to mean "fetch," "ooo" meant "food," and "eeeooo" grand-mother, you would need to be very sure to stop your voice between "fetch" and "food," or you would be mistaken for mean-ing your grandmother. But consonants, Morton suggested, also would permit an entirely new strategy in vocal communication.

Animal calls, and presumably those of at least some of our ancestral hominid forms, are and were largely unvolitional, how-ever subtly graded they might have been or are as expressions of subtly different states of mind. There comes a time to bank one's feelings, or disguise them slightly, in order to accomplish other goals. Consonant sounds are neutral sounds, though they can come to take on a meaning of their own, such as the ominous "sssss" associated with a snake. But for the most part consonants do not of themselves carry emotional freight, and their early value might well have been to damp naked emotions in an in-creasingly complex and perhaps occasionally volatile world of early human society. Just when the first glimmering sounds of protospeech emerged in the course of hominid evolution remains anybody's guess. In fact, what was being "invented" throughout much of primate and hominid evolution in the last few million years—and most likely by virtually everyone—was one degree or another of society, of sociability.

As every mother (and many fathers) know, running a family successfully is a continuous series of negotiations, or transactions, all carried out among a bunch of moving targets. If A tells B to get something done, B may do it slowly or quickly or not at all. Whatever course B chooses leaves A with a different choice of follow-up action. If B, in the meantime, has a younger sibling, C, B may inflict the task on C, who may or may not do it and may complain to AA (the other parent) that B is being mean and A is not being protective enough, and so on. It is hard not to imagine such dealings taking place from time immemorial. Adding another perhaps related family to this group, or a set or two of grandparents, multiplies the number of possible relationships. In other words, social complexity tends to rise geometrically as population grows.

Alas, it is in the capacity of non-human primates, particularly chimps and some baboons, to lie and cheat that scientists have been able to perceive important features of the evolutionary expansion of intellect, the same features that apparently lie behind the development of language. To lie or deceive, one must have a sense not only of one's self and of someone else's self, but the desires or emotions of both, a sense that one is communicating, and an idea of the nature of one's communication. Among the many talents that captive chimpanzees have demonstrated, one is to recognize themselves in mirrors. Another is to withhold information from one another or even their keepers—for example, casually walking past a cache of food while others are around and getting the food only when no one is looking. In the wild, young chimps and baboons have been spotted grooming each other or having sex while deliberately hiding from the alpha male

harem master, and also withholding the usual shrieks that accompany both activities.

Such apparent deception, and also the issue of cheating in a mutually beneficial food-sharing arrangement (that is, not reciprocating), leads to what might be called arms races of the intellect, where deception and counter-deception escalate over time. Happily, other more positive activities also herald or promote primate intellect, perhaps the most important one being the drive to make up, to reconcile after a fight or altercation. Among the chimpanzees, this is usually accomplished by getting together and grooming each other after a squabble. The bonobos (formerly called pygmy chimpanzees, and a different species) are the master reconcilers, accomplishing peace by what amounts to a system of free love, typically inaugurated by the females, as often as not *before* any hostilities break out, not to mention on many other occasions and often whimsically.

Food, sex, reproduction: these are important matters on the minds of such primates, and how successful they are depends on how well they adapt to the ecosystem that confronts them— on their ability to obtain nutrition and avoid predation. But a troop of chimpanzees may spend as much as half of each day or more grooming and tending to one another. The highly socialized life is not only their means of adapting to their world, it becomes part of the greater system to which they must adapt. As Alison Jolly, a primatologist who taught at Princeton, has pointed out, "primate societies thus select for the behavioural skills of the individuals that comprise them. Individuals within them that are socially adept will be at an 'advantage' over less adept members." So we are brought to the powerful notion that the intelligence of

primates, including humans, came about increasingly through time as a means to solve the challenges of dealing with one another. Of course, in such a context, the members of society who could best communicate would not merely have an advantage over the other members of the group but have their esteem. Such skilled members would become leaders of one kind or another. Society and its pressures then can be seen as the engine driving the origins of speech.

THE FEMALE BRAIN

What made for a successful hominid female and a successful hominid male during the long, selective, and altogether unsentimental process of evolution amounted, at least in degree, to two different things. That natural selection operates differentially on females and males is not a new idea. Owen Lovejoy insisted that the gender roles had been fixed from the very beginnings whereby males went off to do the heavy lifting (hunting) in order to bring back the bacon to the passive females—a la the *Dick van Dyke Show*. And, Lovejoy insisted, it was bipedalism that kick-started—or in essence drove—the race to becoming human well before such steps as the invention of tools and the enlargement of the brain.

Lovejoy also called for a significant evolutionary lag among females. He suggested that at first, only the males among that Miocene ape band of destiny took to the ground and became bipedal. They needed to be bipedal in order to range farther afield to find the bacon needed by the females, who, while tending their offspring, evidently stuck to the trees or scrabbled around the forest floor on all fours. This evolutionary dichotomy, Lovejoy averred, had several things going for it. Lowered mobility by the

The Invisible SEX

females led to fewer accidents among their vulnerable and clumsy offspring and increased the intensity of parenting. This was all speculation, but certainly some of it was suspect on its face. For example, why this group of females would be safer from predation without males around is not clear. In any event, the notion of monogamous and passive females throughout the course of human evolution persisted, at least in some quarters, until around the turn of this century.

In 1997, by way of a corrective, Dean Falk, then at the State University of New York at Albany, traced an alternative view of the differential results of natural selection on females and males. A specialist in brain evolution, she took note of the smaller (by 10 percent on average) size of the human female brain today, as opposed to the male, but pointed out that the female brain is larger *in proportion to body size* than is the male brain and has just as many neurons. In addition, the female brain is differently "wired" than the male brain. For example, three pathways that connect the two hemispheres of the brain, especially the larger pathway called the corpus callosum, are proportionately larger in the female brain. Given the rule in biology that form and function are entwined, it makes sense that these differences (and some others) would make a difference in brain performance. Indeed, this has been shown to be the case.

Those brain functions associated with language take place mostly in the left hemisphere among men but in both hemispheres among women. Damage or age-related atrophy to the left hemisphere in men, therefore, is more likely to cause a loss of language abilities than in women. But more important, in thousands and thousands of tests, women generally demonstrate a

greater ability on tests of verbal ability, including reading comprehension, anagrams, and various measures of spoken language, and also a bias for certain emotional skills such as reading body language and perceiving the emotions of others. Men, by contrast, have a generally greater propensity for the mental manipulation of spatial relationships like mentally rotating a figure, map reading, and remembering the positions of numbers. All of this, Falk says, represents at least partially "the end product of a remarkable evolution in our species."

In other words, these differences in brain performance did not just pop into being a few thousand years ago but began anciently. This of course does not mean that all women are verbally more skilled than men. On average, the differences will be seen, and there is evidence that men's verbal skills often catch up with those of women in older age. But overall, verbally and in reading emotional states, women seem to have the edge.

When the two brains may have begun to diverge is anybody's guess, just as when protospeech might have begun remains a matter of speculation at best. As we have noted before, the entire subject is shrouded in huge thickets of controversy and mutually exclusive concepts, though many scholars seem to accept the notion that speech probably was impelled in the beginning by the need to manage social relationships. What Falk proposes is that somewhere along the way, there emerged a vocal form of communication she calls motherese.

The reasoning behind this, briefly stated, is that the chief social unit among all ground-dwelling primates as well as all the great apes (including the solitary orangutans) and humans is the mother–offspring pair. "It is primarily the *female's* reading of and

responding to social and environmental cues," says Falk, "that escort the genes of her offspring into the future." Beyond that constant unit of mother–offspring, the variety of social arrangements is dizzying. At the same time, among the apes and others, the infant will very quickly be able to hold on to the mother with both hands and feet while she moves around her habitat foraging for food for herself and the infant, or socializing with others of her kind. Among chimps, it seems, there is very little infantile vocalization unless the mother puts the offspring down for some reason, at which the offspring complains.

Among hominids and maybe even australopiths, the young could not hold on to the mother by themselves. Either the mothers had to carry them all the time, or, when the mothers were foraging in, say, a patch of berries or in a nut tree, they put their young down, they might well have developed a vocal patter to reassure the offspring that they were not abandoned. Hence, motherese (even perhaps a kind of singing) upon which platform, in due course but nobody knows when, protospeech might well have arisen, understandable by both male and female offspring but perhaps more used by the females while, as some scholarly wags like to say, the males were off somewhere hunting and inventing the Pliocene-Pleistocene version of Monday night football.

Were females, then, the main engine behind the development of the human being's most astonishing talent, language? Language is, Alison Jolly has written, "a hugely important skill claimed for the traditionally disadvantaged sex. I would like to think it true, and true because of women's role in the hugely important nexus of human social relations."

Nothing else makes as much sense.

PART 2

THE ROAD TO THOROUGHLY
MODERN MILLIE

LEAVING THE AFRICAN CRADLE

In which something like people move out of Africa.
Or maybe Asia. Or whatever archaeologists find
from week to week. We meet seven of Eve's
daughters and the authors also speak of two
kinds of evidence: genetics and archaeology.

The two most famous people of the Late Pleistocene (a period
that began some 145,000 years ago and lasted to the beginning of
the present period, the Holocene, starting 10,000 years ago) are
women. Known to millions is Ayla, the heroine of Jean Auel's
internationally best-selling novel *Clan of the Cave Bear,* along with
its sequels. Played in the movie version by Daryl Hannah, Ayla
was a Cro-Magnon, or what anthropologists now call an anatom-
ically modern human, and what many moviegoers no doubt
thought of as a real babe. Orphaned by an earthquake, Ayla was
raised by Neanderthals, was forced to hybridize, and set forth to
stride through Ice-Age Europe at the dawn of what can properly
be called modern humanity, blond hair streaming in the wind.
Tall, lithe, athletic, and headstrong, Ayla was, of course, a figment
of the imagination.

The next best known Late Pleistocene figure is the Venus
of Willendorf. She came to light in 1908, found by archaeologist

Josef Szombathy in a terraced bank of the Danube River not far from the town of Willendorf in Austria. Carved with exquisite care from non-local limestone, she is four and three-eighths inches high and was made sometime between 22,000 and 24,000 years ago. She looks nothing at all like Daryl Hannah or anyone's notion (in 1908) of Venus. Though often sculpted and pictured as nude ever since the time of the Hellenic Greeks, Venus had an aura of chasteness to her, like the Modest Venus pictured on the half-shell by Botticelli, demurely covering her breasts and pubic area with her hands. Some scholars speculate that such Venuses represent the Feminine, the Female Tamed, which is to say the unpredictable and turbulent nature of Woman brought under control and civilized by the exertions of power by men.

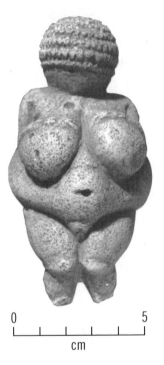

Figure 6-1.
Venus of Willendorf.
S. HOLLAND,
COURTESY O. SOFFER

The Invisible SEX

On the other hand, the Venus of Willendorf is not just nude but openly, contentedly, proudly *out there*. More than that, she is corpulent, even obese. Her tiny hands rest on the top of enormous breasts; her great belly protrudes in a roll of fat over heavy thighs. Her navel (a profound innie) stares out like a third eye above an intricately detailed vulva.

She has no face, only what appear to most observers to be braids of hair wrapped around her head. So she was not intended as a three-dimensional "portrait" of some actual woman, but an abstraction. Theories of what she represented abounded over the years. She was a goddess or at least a symbol of fertility, a figurine that could magically promote fertility. But was she pregnant, representing the wondrous mystery of reproduction and birth? No, she was just fat. Were Rubenesque women the ideal of female beauty in the Late Pleistocene? Did Late Pleistocene men—or women or both—possess some sort of ideal of female beauty? Maybe she was a portable sex object that some man made to while away the nights on hunting trips. Recalling that when first found, she was stained a bit with red ocher, some said that she represented menstruation, and obviously had been crafted by a woman, not a man. She has also been seen by many as The Overall and Universal Mother Goddess.

The Venus of Willendorf is by no means the earliest such representation of the human female form, nor was she the first to be found. A French marquis had found one (headless, armless, and also footless) in the Dordogne 45 years before the Venus of Willendorf turned up. With a bit of snobby sarcasm, he called his find the Immodest Venus. So the find at Willendorf was called a

Venus, too, and she became the very icon of prehistory, even though we may never know for certain exactly what her creator had in mind when making her. But what is really important is that the carver had something in mind. The figurine was a figment of the imagination. She represented *something*, stood for something beyond her four-and-three-eighths-inch-high being. By the time she was made, in other words, people were thinking symbolically.

Not only could a figurine stand for something and have meaning, or even many meanings all combined in one object, but such complexity of thought means that unquestionably by this time people were using words that stood for things not present in either time or space. They were representing the natural world around them and more than likely a spiritual world that lay beyond their senses—and besides creating figurines, they were probably uttering spoken words and sentences as well as producing painted images, bodily adornments, and surely rituals, songs, and dances. To the natural world and the social world had been added a complicated matrix of symbols and meanings that were passed on in story. In other words, these people interacted with their world more or less as we do. And this new array of thought and meaning was *the* common way people lived in the world. These physical representations of things are the palpable signs that the genus *Homo* had produced a species that was not just anatomically like us today but behaviorally, mentally like us. Just how long before this point in time people had become fully modern is a subject of ongoing controversy. But no people would disagree that by some 40,000 years ago, *Homo sapiens sapiens* was on the scene.

The Invisible SEX

Among other things, these people had already invented Woman and possibly Man and, probably, a few ways of being human that involved other roles.

How did this come about? Before we look in on these thoroughly modern human beings and how they managed their lives, it is time to pick up the threads of evidence left by *Homo erectus*, whom we left striding around on more or less salubrious parts of the earth about a million years ago. This will entail a brief tour of the world of the Neanderthals, those supposedly thick-headed sources of ongoing controversy about such matters as interspecies miscegenation, and the arrival on the scene—indeed, around the world—of anatomically modern humans, including the question of how in due course they replaced the comparatively dim-witted *Homo ergaster/erectus*. Two major theories exist, you will not be surprised to hear, along with various gradations in between, and both are matters surrounded with speculation, controversy, and not a little murk. Neither has much to tell us specifically and unassailably (at least so far) about females in this period of human evolution and prehistory. Yet, it is from this murk that the concept of Woman (and perhaps—but perhaps not—Man) seems to have emerged, so we will go there, review the arguments, and add some thoughts of our own.

～

Charles Darwin pegged Africa as the cradle of mankind, and practically no one disagrees. But beyond that, disagreements boil among paleoanthropologists, archaeologists, geneticists, and at least one mechanical engineer. The chief dispute is about which

African members of the genus *Homo*, following their noses but not any particular plan, drifted away from the home continent into what we today call the Middle East and went on to populate the world with anatomically modern humans. And also, of course, when this all happened.

The preeminent scenario among these scholars until about the 1980s was that thoroughly modern human beings evolved several times in several places—that they came about from regional or local populations of *Homo ergaster* in Africa and *Homo erectus* elsewhere. A multiregional human origin, it was assumed, would explain the obvious, if skin-deep, differences between Asians, Africans, Australians, and Europeans. Regional populations would have met up with somewhat different pressures and opportunities from the environment, and different mutations would have occurred, some of which would have come to the fore, leading to the regional differences in skin color, tooth shape, and the other trivial but noticeable features that energize the notion of different human races. At the same time, one had to assume that there was sufficient contact between regional populations over the fifteen hundred millennia or so to keep them all one interbreeding species. In their multiple regions, then, these geographically separate but occasionally mixed groups of *Homo erectus* gradually and at different times in different regions became more gracile—that is, slenderer and smaller—and brainier, turning into modern humans.

The alternative scenario is that at some point less than 200,000 years ago, some anatomically modern humans arose in Africa and later began to move out into Europe and Asia, in due course replacing all the other members of the genus *Homo*—

Neanderthals, *Homo erectus,* and so forth—wherever they had survived. Exactly how the replacement took place—whether by a greater ability to compete for resources like food or to produce offspring, or by some sort of violence—is not known for the good reason that little evidence of any kind exists by which to make the call.

It will be recalled that various groups of *Homo erectus*, a species of considerable anatomical diversity, had begun trekking out of Africa about 2 million years ago, fetching up in today's Georgia and, later, farther east in Asia at various times, particularly in China and Indonesia. Still later, another archaic *Homo* member left Africa and wound up in Europe some 800,000 years ago. This creature is known to some paleoanthropologists as *Homo heidelbergensis,* to others as *H. antecessor.* Eventually this one evolved into the perplexing figure known as Neanderthal, whose career there began more than 200,000 years ago. Neanderthals were among those who were out-competed, out-smarted, out-reproduced, or perhaps interbred to near invisibility by the arrival in their realms of anatomically modern Cro-Magnons. The last Neanderthals appear to have vanished from this earthly plane only some 27,000 years ago, meaning that "they" and "we" coexisted, however uneasily, for at least some 13,000 years and perhaps as long as 23,000 years or so. Just when this diaspora of modern humans overwhelmed the last *Homo erectus* folk in Asia has proved a little harder to say, since the archaeological record there shows little by way of a sudden shift of anatomy or technology. Indeed, the main problem with the "Out of Africa 2" scenario is the utter absence of an archaeological trail for this diaspora.

In any event, this projected eruption of modern humans

throughout the Old World is generally assumed to have taken place without any breeding with the locals. Species are typically defined biologically as groups separated from one another by the inability to successfully interbreed—an exclusivity that can be a matter of different anatomy or even just different behavior. The assumption made by most supporters of the "Out of Africa 2" scenario is that all the other members of *Homo* whom our direct ancestors encountered were sufficiently distant biologically to constitute different species, and, relatively soon after the arrival of *Homo sapiens,* they became extinct. This scenario gained a stunning credence when molecular geneticists announced in the 1980s that all modern humans were descended from one specific, actual African mother, a woman promptly named Eve.

THE DISCOVERY OF MITOCHONDRIAL EVE

In 1987 in the laboratory of Allan Wilson of the University of California at Berkeley, where ancient DNA and ancient people were a subject of great interest, two graduate students, Rebecca Cann and Mark Stoneking, set out to "type" the DNA of the various human strains by analyzing DNA in the placentas of 147 people from around the world: Africans, African Americans, Asians, Caucasians, Australian aborigines, and members of a native population from New Guinea. This sounds like pretty squishy work, but it was hard science—about as hard as it gets in biology.

A caste system exists in the sciences ranged along a continuum from hard to soft, with physics and astronomy the hardest, being characterized (or at least stereotyped) by stupendously expensive machinery to achieve equally stupendous precision. Physics is also the realm of the purest of scientific endeavor, since

anyone with the expertise and the money can reproduce some-one else's experiment exactly to see whether it checks out. Phys-ics can insist on perfect replicability, so hypotheses in physics and other hard sciences like chemistry can mostly be proved unargu-ably true or false—at least for the time being. At the other end of the spectrum are social sciences, those that study human behav-ior like psychology and cultural anthropology, more often than not with nothing approaching the hard edges of physics or the certitudes of chemistry.

Archaeology is more or less in the middle. It employs phys-ics (notably, the rates of decay of different elements into others for dating purposes), as well as geology and various branches of paleobiology and scientific reasoning in the analysis of a site and the artifacts and ecofacts found therein, not to mention fossil remains when present. But archaeologists also engage in a lot of educated guesswork—for example, what did those hominids really use hand axes for? The science of determining what a site and its artifacts mean tends toward the soft end of the contin-uum and may be considered, in some sense, as an art. Archaeol-ogy also is a historical science, and history just doesn't repeat itself, so it is not always possible to think of ways to make it ex-perimental in any controlled, laboratory sense of the word.

Many archaeologists and other social scientists can find the highly technical, high-precision pronouncements of molecu-lar biologists a bit intimidating. And the findings of Cann and Stoneking, along with subsequent genetic studies, threw a major monkey wrench into the multiregional origin theory. They ex-tracted mitochondrial DNA (in shorthand, mtDNA) from human placentas for analysis. Mitochondria are tiny organelles

that float around within the body cells, which also of course contain DNA within the cell nucleus that is the joint contribution of the mother and the father. But mtDNA (a much smaller affair than the prodigiously complex nuclear DNA) is passed from generation to generation *only by mothers*. The key here is the notion that it is never mixed up with any male contribution and serves only to set up and organize the mitochondria themselves, which act as power converters to energize the body cells. It is therefore more stable than nuclear DNA, changing over time *only* through random mutations.

Though it is random, the rate of mutation could be calculated over long periods of time by comparing how close the mtDNA from two species are—say, chimps and humans—given the amount of time since their descent from a single ancestor. In this case, it was believed to be about 5 million years, and the number of differences in the two suggested that mtDNA experiences one mutation per 10,000 years *on average*.

Working back from their various samples of human mtDNA taken from those 147 human placentas, Cann and Stoneking announced that some 200,000 years had passed during which enough random mutations had occurred to have produced all those slightly different people from all around the world. In other words, there lived some 200,000 years ago the largely modern, common maternal ancestor of everybody alive today. At the same time, Cann and her colleagues found two strains of mtDNA deriving from Eve—one was found exclusively in Africans, and the other in all the other populations, including some Africans. Thus, Eve was almost certainly an African.

Many paleoanthropologists were swayed by this landmark

study, and many others already were proponents of "Out of Africa 2," which soon replaced the multiregional thesis among most scholars. This preference has continued even though the math behind some of the Cann-Stoneking study was shown to be incorrect, and that it seemed that there could in fact be multiple roots for the mtDNA of human populations today. Another quibble that surfaced concerned the time involved in mtDNA mutation rates. It averaged out to 10,000 years per mutation, but that did not by any means make it an accurate "molecular clock" in all circumstances, especially for shorter periods of time such as a mere 200,000 years or less. But molecular genetics could not by any means be dismissed out of hand, and numerous labs continued to refine the techniques and publish their findings. Another problem with the whole "Out of Africa 2" thesis, as noted before, is that nothing in the archaeological record so far shows anything like it taking place. The absence of evidence on and in the ground, as far as archaeologists are concerned, amounts to putting a wooden stake through the heart of a vampire.

One of the more flamboyant molecular biologists plying the field of ancient genetics is Bryan Sykes of Oxford, whose lab managed to extract DNA from the Ice Man found in the Alps in 1991, determined who the Polynesians were, and was able to postulate that among the female descendants of Eve were seven "daughters" to one of whom anyone of European extraction can trace direct ancestry. To each of these daughters, Sykes gave a name based on the letter of the alphabet assigned to the genetic "cluster" or "clan" she founded. Thus we have Tara, Helena, Katrine, Xenia, Jasmine, Velda, and Ursula. Sykes offered to receive mtDNA samples from anyone interested (a swab from inside

one's cheek is sufficient as a sample) and for a modest fee explain which daughter the applicant was directly descended from. Ursula, the earliest of these women, lived 45,000 years ago, and all of them were thoroughly modern Millies, so we will have to leap ahead in time to meet the seven. Sykes provided biographies of the seven—stories that he based on both conventional archaeological thought and fictional imagination. Of course, other daughters of Eve existed as well—Sykes found twenty-six in all—who have given rise to everyone now alive on the earth's continents. And of course they weren't Eve's daughters, Eve having lived some 150,000 years before any of them. They were, in theory, real people—actual human beings who lived and died—but they were discovered by looking backward from living people today. Everyone Sykes could find who represented Europeans had mtDNA that fit into one of seven distinct clusters, and the seven daughters are the women who are as far back in time as we can go through an *unbroken* matrilineal lineage (except of course to Eve herself). In other words, from Ursula to today, each generation produced a daughter or two. Any woman along the way who produced only sons would disappear from the mtDNA record. Here are Sykes's seven scenarios:

Ursula: As noted, Ursula lived some 45,000 years ago at a time when the earth, particularly Europe, was cold, with glaciers gathering in the far north. Greece, where Ursula was born into a band of 25 people, was a land of grassy plains with scattered forests lying up against mountain slopes. The band lived in a shallow cave in the cliffs below what is now called Mount Parnassus and, it being spring, were in the process of moving upward into the

mountains from their winter camps below. In the mountains they could ambush bison as they made their way up through narrow gorges and passes to the summer grazing areas. In the high ground, the people had to compete for caves with cave bears, just as on the plains in winter they had to compete with hyenas for the remains of dead bison, which were too dangerous to hunt in the open.

Ursula's people rarely encountered bands of stocky, heavily muscled creatures—other humans we today call Neanderthals. They tended to keep away from Ursula's people, who were slimmer, taller, and with smaller noses—all signs of people who had come from warmer climes. Over the generations, Ursula's people had migrated from Turkey.

Ursula's mother collected frogs, birds' eggs, tubers, and roots while her man scavenged the hyena kills or occasionally hunted down a deer. Life was hard, and many, especially the young and the old, died of starvation in winter and accidents of one sort or another, as well as disease. When Ursula's 29-year-old mother died, the girl was fully grown, her dark good looks attracting a great deal of attention from the young men in the band. She eventually chose one, giving birth to her first daughter at age 15. Four years later she had another, and Ursula lived long enough to see her first granddaughter, dying at the ripe old age of 37.

Ursula's people were the first modern humans to colonize Europe, and today 11 percent of all Europeans trace their ancestry to her, concentrated mostly in Scandinavia and England.

Xenia: 20,000 years after Ursula lived, it was much colder, and what of Europe lay south of the advancing glaciers was windswept tundra. Xenia was born in a round hut made of mammoth

bones and tusks covered with bison skins. With spear points finer than anything Ursula's band could make, and with spear throwers that increased the range and power of the spear, the men in Xenia's band hunted bison and other animals from the great herds that migrated north and south with the seasons.

In the long winters, Xenia's people burned bones for heat in their bone huts. When Xenia was old enough she would occasionally join her father on the hunt, and help him skin and butcher the kill. In time, Xenia got pregnant and in due course gave birth to twins. Typically the littler of the twins would be immediately destroyed, since no mother could carry and feed two infants and at the same time gather food for herself. But in this case, Xenia's parents knew that a woman from a nearby band had lost a baby, so they wrapped up the smaller one and presented her to the bereaved mother who raised her.

Some of Xenia's descendants went east as far as Siberia, and 1 percent of the Indians of the Americas are her descendants. In Europe, 6 percent of the population arose from her line, mainly in eastern Europe but also some in France and Britain.

Helena: By 20,000 years ago, when Helena was born, the glaciers had reached as far south as Berlin, and permafrost and tundra reached almost to the Mediterranean. Living in a band on the shore, Helena grew up helping her mother find mushrooms and oysters while her father hunted small deer and other mammals. In late summer, they would join other bands, meeting in the valley of the Dordogne. These meetings were grand social occasions as well as great hunts of the migrating reindeer. From the reindeer antlers Helena's father fashioned spear points and, for

her mother, needles. Like the other women, Helena's mother tailored the clothes that kept the persistent cold at bay. Indeed, Helena's mother's prowess with the needle gave her family high status in the band.

Helena grew up and had three daughters, living much the way her mother had, making clothes and gathering foodstuffs from the surround. The men spent a great deal of time either hunting or putting on dramatic ceremonies in caves where they had painted the figures of their prey. Helena, like the other women, often watched the great reindeer kills, her only participation in this kind of activity.

Helena's descendants now account for 47 percent of all people of European stock. Just why her line has been so successful, nobody knows.

Velda: 17,000 years ago, the ice and cold had moved so far south that people had been pushed into Ukraine, France, Italy, and the Iberian peninsula. Velda was born in northern Spain in a permanent camp between the coast and the forests. Those who found themselves in such a salubrious place did not leave it for fear that it would be quickly usurped by others. The world was getting crowded.

Like other women, Velda gathered food while her man hunted. These were dangerous times, for it was not unusual for a leopard to prey on a small child, and this was less likely when the men were home from the hunt. The women banded together into a mutual protection society at such times. Velda had three daughters at a time when women controlled the mysteries of childbirth—men were not invited—but the men controlled the rituals involved in the hunt. This included making the dramatic

paintings of wild beasts deep in the caves nearby. Velda's grandfather had been a noted cave artist and also owned the needed magic for the hunting rituals. Velda, who at five feet four inches was taller than most women, was herself a talented artist, carving beautiful ornaments and dreaming of being a cave artist too.

Velda lost her husband to a hyena attack but never remarried. Instead, in gratitude for the help she received from other members of her band, she gave them ornaments and other carvings. Before she died at age 38, she finally was given the opportunity to help decorate a cave.

Her descendants constitute 5 percent of living Europeans and are found mostly in western Europe and as far north as Norway.

Tara: A contemporary of Velda's at the height of the last Ice Age 17,000 years ago, Tara nonetheless lived in a world of relative warmth compared with Velda in Spain and Helena before her, both of whom had enjoyed the abundance and clockwork regularity of the tundra's migrating herds. Though warmer, however, Tara's world was less prosperous, for her country was heavily wooded, the scene of deer and wild boar and other creatures that are not so easily hunted. Subsistence imposed a greater strain, and artistic efforts were thus comparatively stifled. Bands like Tara's were more self contained.

Tara was raised by an aunt, her mother having been killed when she was a child, and her father hunted what he could—wild piglets, martens, small deer—while the women foraged.

Tara's father had made her mother a flute out of the hollow bone of a swan's wing, and Tara played a joyous tune whenever her father returned with some meat.

In autumn, the band headed downstream to the coast, and there one day when Tara was out collecting seashells, from which she often made necklaces, she came across the carcass of a beached dolphin. She ran home to summon her people, but when they arrived on the beach, other people stood over the carcass. For a time it appeared that there would be a dangerous dispute, but finally when the two groups were close enough to each other, they saw that they were related and went on to share this booty of the sea.

On another occasion Tara and her father found a partly rotted log on shore. One side, in fact was rotted; the other was covered with barnacles. They began idly scraping away the rotted side and soon found that the hollowed-out log would float. First they saw it as something of a toy, and threw rocks into it in a newly invented game. But soon they realized that they could sit in it and paddle around. Having thus invented the canoe, Tara and her father, and later her children, took up life along the shoreline, hunting mussels and other shellfish and even seals from their fleet of canoes.

Eventually, of course, Tara died, and her family, which now consisted of three granddaughters as well, buried her in the sand dunes, having reddened her face with ochre and placed a dozen necklaces of seashells around her neck.

Today, more than 9 percent of native Europeans represent the clan of Tara. They live along the western edge of the Mediterranean, the western edge of Europe and elsewhere, especially in western Britain and in Ireland.

Katrine: Born 15,000 years ago in the thick forests that lay up against the Italian Alps, Katrine was headstrong and a bit of a

problem child, though beautiful as could be. Promiscuous, she was knocked up fairly early by a boy, who then proceeded to fall over a cliff and die, leaving Katrine with the unpleasant future of raising a child largely by herself. When the little girl was born, Katrine not only did not bond with it but hated it, feeding it only with ill spirit and yearning for the years to pass until it was weaned. Meanwhile, she played around with several other young men and, when the daughter was indeed fully weaned, found herself pregnant again. This time, for reasons that no one including her understood, she found the baby—another daughter—a joy.

Even so, she never revealed the identity of the father and thus placed on her father and brother the burden of helping her obtain enough food for her part of the family. She wished she could accompany them into the field on their hunts, but that was, of course, out of the question. On one occasion while the men were away, she sensed but did not see a gray presence beyond the fire in the darkness. Over the succeeding nights it resolved itself into a wolf, but a wolf that was content merely to peer at the group huddled around the fire. When the men returned from the hunt with two chamois they had killed, the wolf showed up as usual, and Katrine's father threw it a piece of meat. Within weeks the wolf was eating from their hands. Then it disappeared.

Weeks later, the men were returning again from a hunt, and they were followed by the wolf, who now had two cubs trailing along behind her. Back in camp, the wolf accepted scraps thrown to her and fed them to her cubs. Thus did the process begin that, replayed again and again, led to the domestication of the dog, that indispensable companion of hunters around the world toward the end of the last Ice Age.

The Invisible SEX

Ten thousand years after Katrine lived, one of her descendants made his way up into the Alps, where he died. This was the famous Ice Man. Today, some 6 percent of the people of Europe are also her descendants, frequenting the Mediterranean but found throughout the continent.

Jasmine: 10,000 years ago, Jasmine was born into one of the first villages in all of human history on the planet. She lived in a house partly dug from the ground, with stakes supporting a thatched roof, and she was part of a population of some 300 people. By this time, the glaciers had receded approximately to their present positions, and melting ice had raised the sea level and swamped many coastlines. Jasmine's village was not far from the rising waters of the Persian Gulf, a land of grass and gentle hills.

Jasmine grew up collecting acorns and pistachio nuts but mainly looking after a plot of ground where she planted the seeds of wild grasses. While on hunting trips in search of the Persian gazelle, the men sustained themselves by eating the tough seeds of wild grasses they encountered, which they sometimes brought home with them. Jasmine's husband, who was an inept hunter, took to collecting these seeds in bags and bringing them home in abundance. This got Jasmine's little experimental plot going. Soon Jasmine and her husband learned to grind the seeds that grew in her plot, making a more palatable mash, and they began over time to choose seeds from the new plants that grew closer to the stems. These seeds, they found, were less likely to be blown off the plant by the wind, and they also were plumper. Soon, others in the village took up the practice, yet other villages had learned to keep wild goats, and within only a few generations,

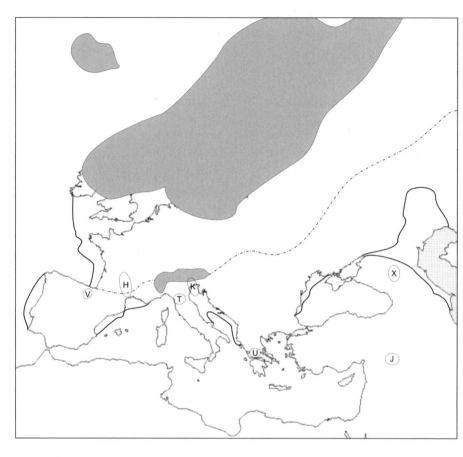

Figure 6-2.
Map of Eurasia at the last glacial maximum. Shaded areas represent areas of extensive glaciation, the dotted line represents the maximum extent of tundra/ permafrost, and the dark black line represents coastlines during that time. The circles with letters show the location of Sykes's "Seven Daughters of Eve." H=Helena, J=Jasmine, K=Katrine, T=Tara, V=Velda, U=Ursula, X=Xenia.
JEFF ILLINGWORTH/Mercyhurst Archaeological Institute

these new practices had spread far and wide, even into Europe and far to the east.

With the glaciers gone, the northern parts of the world warmed up, and some of Jasmine's people moved northward.

The Invisible SEX

With the coming of agriculture the population grew extremely rapidly, and many had to look for new territories to farm. Today, Jasmine's clan accounts for about 17 percent of Europeans, descendants who are found far and wide, especially in central Europe, the Iberian peninsula, Cornwall, Wales, and western Scotland.

～

Such are the lifeways Bryan Sykes saw for his seven daughters of Eve. The main importance of his findings in this regard was that most of today's Europeans have been in Europe for a very long time. Until he came up with the seven daughters, other scholars including geneticists had insisted that the earliest Europeans after Neanderthals—which is to say, Cro-Magnon people, anatomically modern humans—were themselves overrun and replaced by farmers who, at about Jasmine's time, burst into Europe from the Near East with their superior technology. But Jasmine's clan, though the second most successful such group of descendants of Eve in Europe, account for less than a fifth of the European population. It was the technology that spread, more than the inventors.

This discussion has, of course taken us far ahead in time, which perhaps can be excused as being a useful glimpse into where all this leads. Later we will see, among other things, whether the seven scenarios truly reflect the lives of women living between 10,000 and 45,000 years ago. In the meantime, we revert once more to questions about the out-of-Africa diaspora, how it happened, whether it did, and who exactly accomplished it.

Perhaps the most important finding that paleogeneticists have made so far came from the analysis of mtDNA extracted

from a piece of Neanderthal bone—indeed, the very first Neanderthal skull found—an event that took place in 1856 in a limestone quarry in the Neander Valley in Germany. Briefly, a comparison with human mtDNA showed almost three times the variation between the two as that found between members of *Homo sapiens sapiens*, suggesting that the ancestor whom both Neanderthals and *Homo sapiens sapiens* had in common lived from about 550,000 to about 700,000 years ago. Another conclusion from this analysis was that *Homo sapiens sapiens* received no genetic contribution from Neanderthals. In other words, they were and remained two separate species, unable to interbreed. The Neanderthals, therefore, had been replaced by modern humans, and the same thing had to have happened throughout the rest of the world. Thus was "Out of Africa 2" (or what some called the Eve theory) solidly enshrined as the theory of choice. But DNA analyses of the earliest known human skeletons found in North America suggest that they were in no way related to the current population of American Indians, and the same situation pertains to Australia. This is, in a sense, unlikely. Archaeologists tend to be unconvinced about the relative contributions of any ancient groups to populations living today when the genetic analyses are based on what literally amounts to a handful of samples.

OTHER PATHS ON THE WAY TO MODERN HUMANS

Those who are suspicious of the Eve theory (that modern humans arose in Africa sometime after 200,000 years ago and replaced all the other human groups around the world) look chiefly to the fossil record and also to the artifactual record. The Eve theory suggests that there would have to have been a considerable ana-

tomical difference once thoroughly modern humans marched into Peking and somehow by Thursday or Friday got rid of all the *Homo erectus* types who had been hanging around there for nearly 2 million years. There should be, in other words, a very noticeable discontinuity in the anatomy of the *Homo* fossils before and after the replacement. Not only that, but you might expect to see some evidence of a different if not superior technology.

The chief protagonists of this multiregional theory are Alan Thorne of the Australian National University and Milford H. Wolpoff of the University of Michigan at Ann Arbor. They represent what is a distinctly minority view of all this, but the issues they raise are not to be ignored. They point out, for instance, the anomaly of Chinese teeth, in particular the maxillary incisors, otherwise known as the canines. Among most but not all Chinese people they are "shoveled," meaning that their internal edges curl inward. This is true of the version of *Homo erectus* in those parts as well as of the modern Chinese (and, to complicate matters, some Mediterranean populations). That whatever brought about this unique tooth shape should have done the same thing to a new, invading, and non-interbreeding population is hard to understand.

Looking at other Asian anatomical characteristics, particularly those of the skull, Thorne and Wolpoff conclude that "there is a smooth transformation of the ancient populations into the living people of east Asia" and, they add, the Americas. They see a similar continuity between the invading Cro-Magnon people of Europe and the Neanderthals. For example, they point out that genetically the earlier Neanderthals were more distant from the later-arriving anatomically modern humans than were the later

Neanderthals. This is, of course, the opposite direction matters should go if the two populations were separate. They would become increasingly distinct, not less distinct.

While the matter is contentious, as are so many topics in this field, it is not a question of total and irreconcilable polarization in which geneticists and their anthropological adherents simply won't speak to the multiregionalists (and their genetical adherents). Efforts to reconcile these different views apparently occur from time to time and, as often is the case in science, it may all come out in the wash. It is safe to assume that the ultimate picture will be far more complex than anything that has been presented so far—a long and convoluted series of happenstances, chance meetings, genetic drift, and unpredictable contingencies. Even more certainly, the migration was not a one-time excursion but the result of numerous forays out of Africa and into various other parts of the world, many of which probably failed. These excursions almost surely created the occasional genetic "bottle-neck" in which one person became the founder of local and maybe even regional populations—at least for a time. It is even theoretically possible that inbreeding between archaic folk and modern humans could have produced viable hybrids that took on the characteristics of the moderns and left no genetic traces of the archaic. As has been pointed out, modern humans will copu-late with virtually anything, even barrel cacti, so one can assume that nothing with two legs would have been out of bounds. And this could have happened repeatedly over time in what is called a diffusion wave, involving small random movements. In such cases, would it have been modern males or females who did the inbreeding?

All these possibilities would make for a far more complicated population *history* than might appear in the genetic record. More artifacts, more human remains, more refinements of genetic analysis will all contribute to a finer-grained picture some time in the future. In the meantime, we have at least met seven more versions of individual women of prehistory to add to Ayla and the Venus of Willendorf, and, perhaps more important, we have reached the point where one must ask, what exactly is meant by an anatomically modern human?

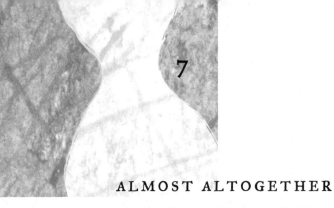

ALMOST ALTOGETHER
TRULY MODERN HUMANS

In which people around the world begin to look a lot like us, and then even begin to act like us. Two of the authors have a disagreement and remain implacable.

More than likely it will come as little or no surprise that scholars have yet to agree on exactly what distinguishes thoroughly modern human beings—people like you—from our predecessors and when the transformation took place. To begin with, the entire matter is somewhat confused by the existence of what are called anatomically modern humans who appeared in Africa about 100,000 years ago or more and who are, in fact, a bit different anatomically from what are truly, thoroughly modern human beings. Anatomical modernity arrived in fits and starts. Also, these early (or what could be called archaic) modern humans were apparently a lot different behaviorally. Many people today of refined tastes might not find these archaic modern humans desirable dinner guests (though some might), whereas the person who carved the Venus of Willendorf would —with a little work, to be sure, as with Eliza Doolittle—fit in fairly well. Another confusing point is that anatomically modern humans

became behaviorally modern humans at different times in different parts of the globe. Or at least that is what the archaeological evidence seems to say, and we are moving now into the period when a great deal more evidence has been found in the ground, and therefore archaeology has a great deal more to say.

In 1969, archaeologists came across the partial remains of one female and some fifteen males in the Qafzeh Cave in Qafzeh Mountain in Israel. They turned out to be the earliest anatomically modern humans known to have ventured forth from Africa into the Levant. People of similar anatomy have been found in numerous sites in Africa, dating as far back as 160,000 years ago and located from South Africa to Ethiopia. The oldest there are represented by the skulls of two adults and a child, found in 1997 in an arid valley near the village of Herto northeast of Addis Ababa in Ethiopia. The skulls showed signs of having been deliberately removed from their bodies in some kind of mortuary practice. The skulls showed some modern characteristics and some that fell beyond the modern range. The scientists named the remains *Homo sapiens idaltu*, the subspecies name meaning "elder" in the local language. Not for another 70,000 years would these mostly modern humans venture forth from Africa.

The Qafzeh people have been tentatively dated to about 92,000 to 96,000 years ago. Discovered by Bernard Vandermeersch of the University of Bordeaux in France, they have been collectively one of the centerpieces in the sometimes quite nasty debates about the nature, timing, and prehistory of *Homo sapiens*. They have been called anatomically modern, near modern, and proto–Cro-Magnon. From partial skeletons, it was determined that their legs were almost as robust and muscular as the legs of

Neanderthals. From cranial and postcranial fragments, it has been determined that their brains were about 1500 cubic centimeters in volume, the same size as Neanderthal brains for the most part—and *larger* than the 1300-cubic-centimeter average brain of *Homo sapiens sapiens*. Also, they had larger teeth than you or I—teeth in fact that differed little from those of Neanderthals, who, judging from signs of wear, habitually used their teeth for heavy tasks such as clamping onto a piece of leather or wood. Not only did the Qafzeh people share some anatomical features with Neanderthals, but they used the same stone technology as Neanderthals at that time—what is called the Mousterian or Middle Paleolithic technology.

But there may have been a difference in how the Qafzeh people and Neanderthals used these similar tools. One scholar of such affairs made a great deal of the hands of the Qafzeh folk, suggested that the muscles as revealed by the bones seemed to have a grip adapted to using tools consisting of stone flakes or hammers that had been attached to hafts (presumably wooden hafts) with mastic, or gum. Such tools require a different grip than that which facilitates the use of mere rocks as hammers, a grip that characterizes Neanderthals. On the other hand, wooden spears have turned up at Shoeningen in Germany dating as far back as 400,000 years ago. These were clearly designed as front-weighted javelins based on some kind of knowledge of the dynamics of throwing, and also presumably calling for some kind of precision grip on the part of Neanderthals. Indeed, to suppose that the Qafzeh people and their Neanderthal neighbors had significant differences in their hands does not sit well with other scholars, some of whom call the notion nonsense.

The Qafzeh Cave dwellers differed from Neanderthals in important respects, however. Aside from their heavily boned and muscled legs, they were otherwise smaller, slenderer—or more gracile, as the anthropologists say—than any Neanderthals. The Qafzeh people had such modern characters as a steep forehead and a high, short braincase that overlapped the face. The backs of their skulls were well rounded, not the bulb shape of Neanderthals', and they had a protruding chin. By contrast, the typical Neanderthal face was long, narrow, protruding outward, chinless, and with a large nose, this latter feature presumed to be an adaptation to the cold, as were the Neanderthals' heavy, thick body and limbs and relative shortness.

In 2003, Erella Hovers and her associates from the Hebrew University of Jerusalem found 71 pieces of ochre alongside the human bones buried in Qafzeh Cave some 90,000 to 100,000 years ago. Ochre is a form of iron oxide that can be used as a pigment, especially once it is heated. There were signs that this ochre, brought to the cave from elsewhere, had been heated and applied to several of the stone tools present. It is arguable (and, of course, much argued) that the bodies were adorned with ochre when buried, and this in turn suggests that the inhabitants had made the mental leap of associating the red-colored pigment with death. But ochre has other more utilitarian uses, such as hafting points onto handles and processing hides, so it takes more than stains of ocher on a body to settle the matter.

Another clue about the identity of these people is that their remains were associated with the remains of African animals, suggesting that theirs was a foray out of Africa when that continent's game was expanding into the Levant during a salubrious

climatic interval. But these near moderns were later replaced in this region by Neanderthals, no doubt moving south and west out of Europe, and they evidently hunted Near Eastern prey animals. The Africans either had failed to survive or had packed up when the weather changed and went home.

The Qafzeh Cave dwellers were not, of course, the only near moderns who have turned up. Many more have been found in Europe and elsewhere as well, and whether some or all of them, or none of them, were directly ancestral to the Cro-Magnon people who showed up in Europe about 40,000 years ago remains a question of juicy debate and argumentation. When truly modern people showed up in eastern Asia is a question that remains even more moot, thanks largely to a relative paucity of studied archaeological sites there. Europe and the steppes of Russia have an abundance of sites, and these regions have become the center of inquiries into the matter of modern humanity—so much so, in fact, that many scholars have sought in recent years to counterbalance what seems like a Eurocentric emphasis. In fact, Russian archaeologists have recently turned up evidence in the Altai mountain regions of Siberia as well as Central Asia of the early arrival of modern technologies as well—some time before 38,000 years ago.

In any event, even when Cro-Magnons showed up in the record—gracile and small-toothed as they were, and with fine chins—they still weren't completely and totally modern anatomically because their teeth, in particular the molars, had not shrunk down to the size of most people's teeth today. This reduction in tooth size is generally attributed to the diet—more meat and less tough vegetable matter, and also regular cooking of foodstuffs to

soften them up. Just why such features as teeth get smaller over the generations when big teeth are no longer necessary remains a bit mysterious. It probably has to do with the advantages gained by not using up energy during development to a greater size than needed. This calls for some pretty fine-tuned energy accounting on the part of natural selection, but it has plenty of time, after all.

Cooking is of course a behavioral matter, and it leaves a record in the ground. The regular use of hearths shows up around 400,000 years ago in several parts of the inhabited world and so is not considered a prerequisite for modern humanity. Archaeologists have compiled a long list of qualities and talents (regularly added to and subtracted from) that defines utterly modern humans from the rest of the creation past and present. They are based on what is detectable in the archaeological record, and they are supposed to have flowered (in Europe at least) between 50,000 and 40,000 years ago. This was when people emerged from the Middle Paleolithic into the Late Paleolithic. The Cro-Magnons are widely considered mentally to be just like you, capable of inventing the laser, for example, except that they had no history of invention that matches ours. But they were extremely inventive, and it is these inventions—these signs of new or at least fully elaborated behaviors—that leave signs in the ground or on the walls of caves, from which archaeologists deduce that the makers were, in fact, now after 7 million years, truly human. We will mention several of these attributes, some in passing and some in more detail. They derive from Richard Klein's much consulted volume *The Human Career*.

Stone tools are among the foremost markers of what we call technical progress, especially since they are so resistant to the

ravages of time. Beginning with the Late Stone Age (as the Late Paleolithic is for obscure reasons called in Africa)—indeed, defining it—there is a substantial growth in the diversity of stone tool types and their diversity. Technologies, of course, do not come about idly or of their own accord. Something that was going on in the world called for more specialized tools, and once a tool had been devised for a specific task, it was made repeatedly to the same specifications. At this time, other materials were found for tools—bone, ivory, and shell among others—and were turned into points, awls, needles, and so forth. Another technological feature was the transport of desirable raw materials, especially stone, over huge distances.

With the Late Paleolithic, we begin to see what Klein calls the earliest appearance of incontrovertible art. By this he means the great cave paintings, along with carved objects, and tools that have been decorated with abstract designs, animal figures, and so forth, and beads and other personal adornments. There is a question about whether this should be called art, since, in our Western use of the word, art is typically produced for aesthetic purposes only, whereas hunters and gatherers and many tribal peoples today usually produce what we call, a bit snottily, primitive art as an inseparable part of their everyday utilitarian and religious life.

At this time, archaeologists find "secure evidence" for ceremony and ritual, not only in "art," or what we will refer to henceforth as imagery, but also in relatively elaborate graves. For example, Neanderthals evidently buried their dead, at least some times. In the 1970s, a Neanderthal burial was found in Shanidar in Iraq that appeared to have been accompanied by flowers, suggesting some form of sympathetic send-off, even an emergent religious sense.

Figure 7-1.
*Archaeologist Iain Davidson viewing art at
the Upper Paleolithic site of Chauvet, France.*
J. CLOTTES, COURTESY O. SOFFER

It was later determined that the flowers (represented by pollen in the grave) were in all probability just pollen that had blown into the open grave from elsewhere. But still, the dead Neanderthals were buried. Or were they? Several scholars in the 1990s claimed that all "burials" found from Middle Paleolithic (Mousterian) times were better attributed to natural causes, such as windblown deposits. The argument was joined, of course, some saying that there were definite burials before the beginning of the Late Paleolithic, even if they did not show any sign of what we would call sympathy, regret, hope for an afterlife, or any other sentiment. The recently mentioned inclusion of ochre in a grave in Qafzeh Cave dated to about 100,000 years ago may or may not suggest something beyond the mere abandoning of the dead

body. There the mortuary matter rests, one school of thought claiming a gradual growth of humanlike sentiment in the few burials that have been found, and others saying there was an abrupt point that nearly human folk leaped across as they became fully human and buried their dead with recognizable care, represented by increasingly elaborate grave goods like headdresses, jewelry, weapons, tools, animal bones, and, yes, flowers.

Other attributes in Klein's list include evidence that humans could live in the coldest parts of Eurasia, northeastern Europe and northern Asia, as shown by increasing population densities and by evidence for fishing and other advances in the acquisition of food. We will return to some of these attributes in a later chapter, but for now we will look at yet another attribute on Klein's list in some detail: the oldest evidence for "spatial organization of camp floors, including elaborate hearths and the oldest indisputable structural 'ruins.'"

What might be considered the first uncontroversial and incontrovertible instances of architecture do not occur until the Late Paleolithic, the work of modern human beings. Where these Late Paleolithic folk could not find handy caves and overhangs, they constructed actual dwellings—various kinds of structures made of poles, hides, and other materials. In eastern Europe some 20,000 years ago, people were using mammoth bones for the foundations and perhaps to anchor wooden posts. Such dwellings were permanent or at least seasonally permanent dwellings, and it is almost indisputable that such people had, along with their structures, a sense of place, a sense of home. The ordering of space in these dwellings, according to Jan Kolen of the University of Leiden in the Netherlands, suggests the existence of

social categories and a separation of duties. It may also indicate that the beginnings of a mythical geography were present, the investing of a familiar home landscape with a kind of sacredness that is common to most non-Western societies even today.

In earlier times, and among Neanderthals, what might be called camp sites were more in the nature of nests, whether in caves or on open ground. These were "fluid" sites, used opportunistically and soon abandoned as the inhabitants followed game around in territories that were probably limited. Essentially, such places were cleared from the inside out, whereas the dwellings of the Late Paleolithic were built from the outside in, according to a plan. But in these camps, rocks would be cleared and thrown into the periphery, sometimes fooling archaeologists into thinking they were deliberately erected walls. One well-analyzed example is a camp in Kebara Cave in Israel. The inhabitants established round or oval hearths in the central area, using grass or wood for fuel. The fires were used for parching wild legumes the people gathered from nearby Mount Carmel and other vegetable matter and for the roasting of meat. Once the hearths had been used for food preparation, the ashes were spread over a larger area, perhaps to create warm surfaces for sleeping. Butchering and flint knapping and tool making were also done in the central area, but the detritus was thrown out to the edges. The varied and evidently sequential uses of the site may also reflect an awareness of the roles women and men may have played in society, and even an incipient ordering of space to accommodate those roles.

Putting together lists of behavioral traits, while important, does not get one to the essence of the very contentious issue of

the origin, age, and spread of modern human behavior. One reason is that most of the items on such lists arise from Europe and nearby western Asia, and this strikes many as being inappropriately Eurocentric. Europe has been pored over more completely by archaeologists than has the much larger continent of Africa or most of Asia, so Europe has provided more data from the Paleolithic. Also, Europe in the Paleolithic was a different place in climate and topography than was Africa. We know from ethnographic reports (not to mention common sense) that the more difficult or complex or changeable the environment, the more complex and perhaps sophisticated a toolkit is needed. Arctic-dwelling people like the Inuit (once called Eskimos) use a far more sophisticated array of tools than, for example, people living in the Amazon rain forest (though such people are possessed of highly sophisticated "perishable" tools). But, in general, people do not go around inventing complicated tools that are expensive in either materials or time if there is no need for them. Tools arise out of felt needs, and people living in the tropics of Stone Age Africa had no need for the likes of tailored clothes designed to keep the cold at bay.

Yet other geographic considerations are sometimes overlooked. One such is that among the best tools that Paleolithic people in Europe started making about 50,000 years ago were those made from antler, which is denser and longer lasting than tools made from soft wood. However, no animals in Africa had antlers (seasonal growths like those of elk or deer), so this sophisticated material simply wasn't available.

Perhaps the greatest problem with a list of traits as revealed in the archaeological record is that the record is by no means

complete, and it is being added to regularly. Those archaeologists who believe that the earliest date for any object involved in this story has been found, and that that date will remain the earliest forever, have taken up a peculiar type of religion and have abandoned science and, in fact, reality. For example, one tip-off that people were beginning to perceive themselves as members of a society with an identity that needed to be in some sense proclaimed is the existence of beads, a personal adornment bearing the suggestion that the owner has achieved some form of symbolic thinking. The same goes, as we noted earlier, for decorating the dead with ochre, though this is a lot more difficult to prove.

There is a broad agreement, as Christopher Henshilwood of the University of Bergen, Norway, and Curtis Marean of Arizona State University have written, that "social intelligence and symbolically organized behavior are modern human behaviors." Indeed, one can argue, and many have, that they are the key traits, the brand-new thing that occurred (in Europe) at least about 40,000 years ago that signaled that anatomically modern humans were now also behaviorally human. It is a help that beads made of ostrich shells in Africa and shells in the Near East and Europe have been found in graves and elsewhere around this time. The only trouble with this wonderfully neat arrangement is that a set of what are arguably beads made of ostrich shells have recently been found that are something like 75,000 years old. If they are in fact beads—and it is difficult to imagine what else they could be—then someone back there may have created them to assert some kind of status or rank.

In 2004, the same Christopher Henshilwood announced that he and his team had found beads in Blombos Cave on the

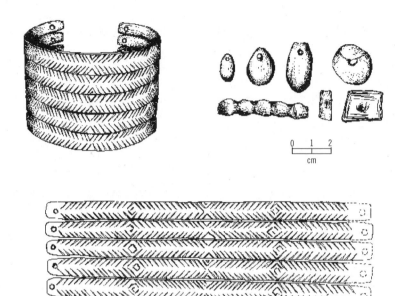

Figure 7-2.
*Bracelets and beads made of ivory from the
Upper Paleolithic site of Mezin, Ukraine.*
COURTESY O. SOFFER

shore of the Indian Ocean some 200 miles east of Cape Town,
South Africa. The beads were made from the pea-sized shells of
a river-dwelling snail-like mollusk too small to have been part of
anyone's dinner leftovers, and with no known predator out of the
rivers in which they dwelled. The nearest river in those days was
12 miles away, so we can conclude that they had been deliberately
brought to Blombos Cave for some human purpose. The beads
showed the wear one would expect on a typical string of shell beads,
and signs of ochre as well. Though 30,000 years older than any
other set of beads found so far, they suggest that at least one group
of nearly modern people were thinking some kind of thoughts
about their personal or social identity, and were changing the

The Invisible SEX

way they looked for one reason or another. Archaeologists are almost by nature suspicious of such claims as these 75,000-year-old beads, but then a more recent find has been made in Africa of what appear to be beads dated to 100,000 years ago.

Even in the face of these finds and others that show potential signs of symbolic thought well before it exploded in the Late Paleolithic, it is possible to say the scholarly version of "so what?" Just because one person or group made a set of beads 75,000 years ago doesn't prove much. It doesn't show that people in general were making beads back then in order to communicate some sense of identity or status. Sure, people had the *capacity* to make beads, and to scratch little geometrical figures on pieces of ochre and a few other little "artistic" efforts. The important thing is regular or systematic performance: did most people do it? Was it *common* behavior? Was it the way the human species of the time confronted the world? One woman making herself a set of beads (which, one needs to remember, entailed also the making of some kind of string on which to place them) is nothing at all like the tremendous flowering of imagery, complex tools, rudimentary architecture, and other skills and achievements that are found in Europe beginning around 38,000 years ago and really hitting stride about 35,000 years ago. On the other hand, we don't know how widespread bead making might have been in these more ancient times. Being biological items, they don't preserve all that well.

Many archaeologists studying this period still focus on the grand inventory of objects now in museum and university collections, and on new material coming out of the ground, in order to answer the question, what happened during this immensely important transition? The problem with such kitchen lists based on

Figure 7-3.
Reconstruction of a mammoth bone dwelling at the
Upper Paleolithic site of Mezhirich, Ukraine.
PHOTO COURTESY OF O. SOFFER

artifactual evidence that suggests particular behaviors is that the behaviors are not universal—they are local or regional and not at all synchronous. For example, some people in Europe created the amazing cave paintings in places like Chauvet some 30,000 years ago, and soon thereafter equally modern humans moved into North America, where imagery on such a scale never occurred. (But how important is scale? South Americans were producing rock art—or call it rock imagery—10,500 years ago.) In any event, the Europeans of the Late Pleistocene certainly perceived the paintings and also the expansions of range as somehow the means of improving their chances for success in the natural world or the social world, or both. But what (if anything) was universally applicable? Some archaeologists are stepping beyond the normal

The Invisible SEX

path of the archaeologist to ask not what happened but *why* the changes occurred. In this regard, it is helpful to look at the Neanderthals as well as the anatomically and behaviorally modern humans and see how the two human species (or as some others would have it, subspecies) confronted the worlds they found themselves in.

Neanderthals who lived in the more northern latitudes of Eurasia were robust people—thick of chest and limb, a bit squat, having the same general adaptations to the cold that are found in the physiques of the Inuits and other Arctic dwellers. Even so, it is possible that the Neanderthal physique was more robust not because of cold so much as the need for a more strenuous life-style, one that simply required more exertion. The Neanderthals who lived in more southern latitudes were less robust but nowhere near as gracile as the early modern humans with whom they shared the landscape for 10,000 years or so. Neanderthal remains tell a story of a highly stressful life: they tended to die well before the age of 45, usually with bones that had been repeatedly broken and badly stressed. The young ones suffered from various disorders, and child mortality was on the order of 43 percent. By contrast, among early modern humans, child mortality was significantly lower: 30 percent or less.

Recent studies of bone chemistry have shown that Neanderthal diets were more thoroughly given over to meat; these people were hyper-carnivorous compared with the early modern humans, or so a very limited number of samples suggests. Thus, Neanderthals (like the other carnivores) needed to exploit large territories, which meant roaming over great distances. This would have been particularly hard on the females, especially

pregnant and lactating ones, as well as the young. The alternative was to stay in those few places where there was a great deal of diversity of prey species and other resources and where the day-ranges of females were less. Such places were found where rivers, plains, hills, and mountains came together, and that, too, is where most Neanderthal groups evidently lived. As the glaciers continued to grow and move south, reaching their maximum about 20,000 years ago (7,000 years after the last Neanderthals died out), such salubrious places were increasingly hard to find. It is quite reasonable to think that the Neanderthals died out in a series of local extinctions, brought about not by violence or pressure of some other sort from the Cro-Magnon types but instead by the isolation of small groups into what are called refugia, making a living in a world that was changing fast. It is a truism of conservation biology that small isolated groups of mammals typically wind up inbreeding to the point at which their reproductive systems collapse, and this is the typical final cause of most extinctions of mammal species. Neanderthals were capable of changing their strategies in the face of different situations, of course, while most other animals are not, but as they became isolated into refugia, their options would have been increasingly restricted. Whether or not this explains their ultimate demise, the last of them were gone by 27,000 years ago.

Meanwhile, over the millennia, females among the early modern humans became gracile earlier than their male counterparts did, while female Neanderthals had remained equally as robust as the males. This along with other clues has led some to think that Neanderthals probably followed the same pattern of foraging as most primates—that is, the females were responsible

for feeding themselves and their young offspring. All female primates provision their young, while very few non-human male primates do. Chimpanzee males do bring home the bacon from time to time, but it is usually shared with females with whom they wish to copulate, not their own offspring.

By contrast, life for the early modern human females was becoming less stressful. They could get along with less muscle and smaller teeth. Whatever was going on, the modern females' lifeways no longer required the same amounts of physical exertion as did those of Neanderthal females. It goes without saying that this would have benefited not only the females but their offspring and therefore their reproductive partners. At some point along the way, as the Middle Paleolithic lifeways of both Neanderthals and early anatomically modern humans gave way to the Late (or Upper) Paleolithic, early modern humans began pursuing a different strategy in the world they shared with the Neanderthals.

TRULY MODERN HUMANS—
AN ABRUPT METAMORPHOSIS OR A GRADUAL EVOLUTION?

Among the two senior authors of this volume there exists a difference of opinion here, chiefly in emphasis. It will not be papered over with courteous qualifications and forelock tugging, but simply explained forthrightly. Both views have merit. Both are based on careful and attentive observation of the evolutionary scene; both are views that other respected workers in this field support. After many long discussions, neither view has prevailed between the two. In fact, to the junior author, the disagreement seems to be more a matter of emphasis, but such nuances

are often the arena where the most virulent scholarly disagreements take place.

Olga sees the fundamentally and fully human array of talents and accomplishment as coming together in coherent and coordinated fruition pretty much at one time, by some 45,000 years ago or so, in Eurasia at least. At the basis of all these characteristics lie the demands and the benefits of an increasingly complex social world—which is to say "modern" culture. In the late Paleolithic, for example, there appears a proliferation of sophisticated and diverse tool manufacture—what one male scholar has called "the Upper Paleolithic arms race." One suggestion is that it reflected a desire to be a better hunter and thereby provide better for one's family. A more cynical version is that it might reflect a desire to *look like* a better hunter. On the other hand, most of the Upper Paleolithic tools were just that—tools, not weapons.

Aside from conferring status, however, the new technologies would have assisted people as they inhabited different regions than before (especially colder ones, where resources are seasonally limited in either kind or number) to carry food longer distances and to use both local and exotic resources. Probably more important than any new tools or technologies, however, was the routine and reliable sharing that was practiced as children, males, females, and old people all became what were perceived as permanent and interdependent members of families existing not only in space but in the past and probably the future. The decrease of overall stress and the gracilization of females that took place while males continued to be relatively robust suggest that it was at this time that males began to take on some of the burden of

feeding the young. The division of labor would have arisen at this time along with regular—even organized—sharing of food.

Thus the interdependent family would have come about, and from there such families would have become linked with others like them through intermarriage and the unique human affair of extended family kinship. People would become known, for example, as uncles and aunts and cousins—people upon whom one could depend. Others would become known as grandmothers and grandfathers, for lifespans grew with the diminution of stress and the replacement of dangerous, purely physical tangles with nature (lightning, large animals) with emerging cultural means for dealing with its difficult aspects. These elders, having lived beyond their reproductive age, would have been able and presumably willing to help raise children, relieving the females of yet more stress, and also they would have served as repositories of history and experience. All this presupposes that people would have assigned specific roles—gender roles among them. Women would exist now as a mental construct, bound up in a system of different distribution of rights, duties, rules, and statuses, founded on the notion of shared resources and different talents. How men were perceived at this time—that is, whether there was such a mental grouping—is not clear from the archaeological record. Sarah M. Nelson of the University of Denver wonders if they were perceived as "not-women" or just as expendable.

The odds are that once gender roles were established (and they might have differed from place to place), some females may have been more comfortable and talented in male roles (like hunting) while some men took up female roles or functions (such as weaving). This is common in virtually all known human societies

today. Not only that, but the idea that females in the course of human evolution never caught animals and never made stone tools is nothing more than an unproveable assertion.

All of this would be underlain by what Olga refers to as inter-subjectivity. People in these groups would perceive themselves as permanently part of and dependent upon the others in their group, and less so, perhaps, on groups lying beyond. The basic and universal primate duo of mother and offspring would now have expanded to include people of different ages and sexes into an interdependent unit. Further connections by marriage and sibling connections would at some point expand into larger groups such as clans, based on descent from ancestors. Virtually everyone would benefit from such arrangements, especially children, who were then as now, of course, the future. Indeed, a certain kind of immortality would have been created: the immortality of one's lineage.

All of this was evidently brand new, according to Olga, and it created—and was created by—the new human habit of thinking in symbols, of perceiving connections and assigning meanings to phenomena where such connections and meanings had never existed before. This could have begun to emerge, however dimly, in the latter millennia of the Middle Paleolithic, but it burst into flower only after the Upper Paleolithic in Eurasia (at least) got under way some 45,000 years ago, leading to what some think of as the Creative Revolution. None of this, of course, would have taken place in the absence of human language. And while hominids probably did and humans regularly do use gesture and body language, the most important *physical* attribute of language, until the invention of writing, was speech: talking. The

most important *mental* attribute of speech is that it makes possible the transmission of information and ideas symbolically.

Olga is not especially comfortable with discussions about language, when it arose, and how one is supposed to find evidence of it in the deep past. Language does not fossilize and is implicit, but not directly visible, in physical things like stone tools or an anatomically modern skull. One can only look for hints of its existence, proxies for it, in the archaeological record, especially its undeniable symbolic essence. Thus, she looks for archaeological remains that have a clear and unambiguous symbolic component. Imagery, musical instruments, necklaces, pendants, burials where the deceased is laid out in clearly meaningful ways such as with grave goods—all this kind of evidence is abundant and all over the place from about 40,000 years ago. Nobody disagrees that all our ancestors on all continents possessed modern language by some 35,000 years ago at the very latest. The rarity of such items in the record before 40,000 years ago suggests to her that the capacity for symboling and thus language may have existed for a long time but was not habitually exercised.

What suddenly brought all this out at what amounts to one time is not so easily explained. Richard Klein has postulated that sometime around the transition from the Middle to the Late Paleolithic, some genetic mutation in the brain of some anatomically modern human, presumably in Africa, set off the explosion. (How it spread around the world at that time is not explained.) One scholar has suggested that this structural change in the brain entailed "wiring" that finally connected all the talents that had come about but that had remained isolated in various parts of the brain until this change. Olga suggests that it is in the growing

demands of social complexity that one finds the ultimate cause of whatever mental changes brought us to the current state of modern humanity in which we presently dwell.

In the Late Paleolithic about 30,000 years ago, about the same time as the Creative Revolution in Europe, there was a sudden four-fold increase in the number of adults old enough to be grandparents. There had been a minor trend in that direction for millions of years, but this was an unprecedented leap. The slow increase in longevity over the past millions of years had been called the Grandmother Hypothesis, suggesting that with at least some females surviving past childbearing age, early *Homo* gained several advantages, one being the archival function of the elder, the other being the baby-sitting function, plus the added social challenge and opportunity of having more than two generations present in one group. But all that was gradual. Now Rachel Caspari of the University of Michigan and Sang-Hee Lee of the University of California at Riverside have identified this sudden leap in the number of people surviving to an older age by studying the rates of molar wear among humans and hominids from the australopithecines to behaviorally modern humans. The sudden increase in the number of surviving elders as a proportion of the whole population "contributed importantly," the anthropologists said, "to population expansions and cultural innovations that are associated with modernity." To put it another way, the dramatic demographic change at this time may have constituted an early version of the recent information revolution, with older people's long memories serving as living repositories of useful information. The creative revolution of this period might well have been kick-started by this sudden demographic change, which might,

by a series of feedback loops, have further created the kind of world that enhanced the possibility of people living to older ages. In any event, it appears certain that the now significant roles that grandmothers and grandfathers played in this new world led to a population explosion, which, in a mere 15,000 years, saw people living in virtually every habitable place on the planet.

Neither Olga nor Jim has any quarrel with these demographic findings nor with the fact that a great deal of activity was suddenly under way. The question remains: did whatever lay behind the spurt in elderlies and the creative revolution come about pretty much all at once? In Olga's view, once you can symbol, it all falls into place, as in "once you're pregnant, you are wholly, not fractionally pregnant." Or did all these attributes begin much earlier, build slowly, and suddenly burst into flower (like the slow trend toward more elderlies) until suddenly there were four times as many as earlier?

Jim suggests that the origins of language, for example, had to be far older than anything Olga will commit to. He is not at all comfortable with the notion that the hominid brain experienced sudden growth spurts—between, say, *Homo habilis* and *Homo ergaster*. He suggests that the spurts seen in the fossil record are the result of the luck of the draw in what was preserved and what has been found. If we had skulls from various periods in between the two known fossil types, the growth of the brain would be seen as far more incremental and gradual. Similarly with language, which he thinks had to have antecedents, just like all other talents and other features that rest on some kind of biological capacity.

Language involves both thinking and communication. It can be thought of as an all-encompassing system for conceiving

ideas about both the emotional and the physical realms of human experience, modeling those realms and passing thoughts about them back and forth. It therefore has both internal aspects and external aspects. Part of the system consists of gestures and posturing, and laughing out loud and saying "ugh!" when in the presence of something disgusting. (The main part of the system, as noted earlier, is speech with written languages starting about 5,000 years ago.)

Speech consists of several attributes. One is *productivity*, which means that for every message we can send, we can add another whose meaning is neither predicted by nor predicated on the previous message. Thus, we can leap from the discussion of the beauty of a flower seen last spring to a comment on the horsepower of an engine or the sins of a neighbor. As we noted before, the number of separate vocalizations a non-human animal can make are severely limited (a gibbon has nine basic vocalizations), and while they can be combined in different ways, they severely limit a non-human animal's productivity. Similarly, gesture is severely limited in the number of meanings that can be conveyed—at least before the invention of words that in turn permit the elaborate sign language of the deaf.

Displacement is another attribute of human speech. It means that neither the receiver nor the sender of a given message needs to have any direct contact with the matter being discussed. They can talk about a potato, for example, without having one in front of either one of them. *Arbitrariness* means that there is absolutely no direct or physical relationship between the symbol we use (in this case, the word "potato") and the actual edible root in question. This is different from onomatopoeia, wherein the sound

"vroom, vroom" mimics closely the acoustical signature of a guy revving a motorcycle. You could just as easily say "bligdump" for potato so long as everyone you are talking to knows that a bligdump is actually an edible root of a certain type.

Duality of patterning, the other important feature of speech, refers to the fact that the same basic meaningless sounds, such as "toe," "tay," and "po" can be combined to form a word that has meaning. The sounds are what linguists call phonemes. The words they are made into are called morphemes. Speech, made from these features, is symbolic, and symbolic speech is one of the critical attributes—if not *the* critical attribute—of human uniqueness. One unique aspect of language is the ability to generate novel utterances—utterances that have no formal or physical similarity to all of the utterances ever produced in any language. It is totally open-ended. Anything the human mind can conjure, the human mind can make words for.

Whenever language got started, it surely lacked some or many of its current physical and probably mental attributes. It could have begun without syntax, or time sense (tense), or pronouns, and perhaps the inability to produce certain sounds that we can produce today. But at some point it became one of the most crucial attributes of humanity. Our uniqueness is certainly not found in tool use (chimpanzees and nuthatches are among the animals that use tools) or in hunting or warfare or politics.

But, in Jim's view, once language occurred even in a rudimentary form, language-based social systems would begin to come about—the kind of social systems that Olga discusses. Language enhances cooperation. Language allows us to elaborate leadership capacities (and status). Language allows us to self-identify

ourselves and name others. Language allows for tactical and strategic planning, for an effective division of labor, for an enhancement of group identity, and ultimately for the development of imagery and multilevel symbolism.

In Jim's view, anatomical evidence (such as the elaboration of Broca's and Werneke's areas of the human brain along with its asymmetries) and the archaeological evidence for the development of the capacity for symbolic thought (such as burial ornaments, cave imagery, complexity of tool kits, and so forth) could not have come into being all at once, but at different times and over long periods. And so, therefore, did language.

While both Jim and Olga disagree about the timing and nature of the appearance of symboling, they agree that the onset of gendering does occur relatively late. While we cannot see the beginnings of language in time, we can see the beginnings of gendering, and we will take a look at one time and place where we know it had recently appeared. All of this theoretical and interpretive discussion is something the reader can either take sides about or not. It does suggest the phenomenal complexity involved in identifying the core of modern humanness and also the phenomenal complexity of the quest to pin it down. It is time to see how all these paths to being human played out in Eurasia and elsewhere. We will begin along a river valley in what is today's Czech Republic some 26,000 years ago—an antidote, perhaps, to the stories of Chapter One. We have, as they say, come a long way, baby.

THE FASHIONING OF WOMEN

In which we visit a pleasant encampment full of Brooks Brothers–style weaving and other womanly creations, the first fireworks, mammoth nonhunts, and people who could be your neighbors.

THE PLACE: A camp on the gentle, grassy slope of a hill in today's Pavlov Hills, from which three limestone outcrops rise above the broad south Moravian plain in the eastern region of today's Czech Republic. The view to the north, south, and east stretches for miles over grassland and forest: a broad valley that served people and wildlife as a highway from the flatlands of the mighty Danube into northern Europe. The Pavlov Hills lie along the right bank of a river that flows into the Morava River, a major tributary to the Danube. To the north, a month's march away, lies the great wall of glacial ice. Equally far to the southwest, ice blankets the great mountains known today as the Alps. The village is not far above a swampy area fed by the river that courses through the plains, its moisture supporting a variety of deciduous trees— alder, ash, birch, groves of willows, the occasional oak, and beyond, in drier soils, the conifers, pines, spruce, and others. Off in the distance, a few clusters of reindeer and small herds of horses head

south. Beyond, a group of female mammoths and their young plod northward.

THE TIME: 26,000 years ago. The summer has ended, and the nightly temperatures in these early autumn weeks reach near freezing. It will get colder as the winter comes on, but for now the days are relatively warm once the sun rises above the hills.

THE VILLAGE: This is where several groups of people have come to-gether to spend the long fall, winter, and early spring, just as they and their ancestors have done since longer than anyone can re-member or compute. The camp is about 200 yards upslope from the river at a place where natural mineral licks attract nutrient-starved animals in the spring months, especially mammoth fe-males and their young. There the weaker ones die, leaving their bones for the people to use. Over the eons, people have made use of their bones and tusks as raw materials to build dwellings and make tools and other objects. Now they have erected five tentlike structures over depressions in the ground they have cleaned out, throwing away last year's broken flint and bone and broken tools and other household trash. Walls and roofs of skins sewed to-gether are held up by wooden poles, their edges held down against the force of the cold winds with rocks. In the largest of these structures, sitting in the middle of the camp, five hearths have been delineated with circles of rocks. The others contain single hearths. Upslope from the camp about 80 yards sits another structure, with limestone slabs holding down walls of hide on three sides. Inside this structure are layers of ashes and ceramic fragments.

On this particular morning, just as the eastern sky is beginning to lighten, a woman emerges from one of the tents and nods to the sleepy youth who is tending the fire in the middle of the camp that burns through the night as a warning to predators. She walks slowly and painfully up the slope to this small structure. Taking sticks of wood from a pile she ordered her young grandchildren to make yesterday, she builds a fire. The flames lick hungrily at the pine sticks, reaching into the cold air. Not pausing to warm herself, she piles more sticks, larger ones, on the flames, and then retreats down the slope to her dwelling. Moments later, she reemerges, carrying a tightly woven basket filled with water and a cloth carrying bag filled with dusty brown soil. By now the fire has rendered the fuel into glowing hot coals. She nods approvingly, then sits down beside the kiln with a grunt about her complaining knee joints. Making clay by mixing the fine dusty soil with water, she fashions a tiny bear's head and body. She sets that aside, fashions legs, and presses them into the body. She intones some words and throws the bear into the fire. In minutes, the bear explodes with a sharp *Crack!* and a cascade of sparks and pieces of the bear rattle off the walls of the kiln. Thus does the old woman's day begin, rendering their world as safe as she can for the rest of the people.

By now people are stepping outside their dwellings into the cold, scratching, yawning, looking up at the sky for signs of the weather for this day. Young children begin darting here and there, yelping and shouting, parents hissing at them to be quiet. Two women, each suckling a new baby, stand together talking. Some of the group's men stand in a circle, chewing on narrow strips of rabbit jerky, glancing out to the horse herds moving

across the plains far away, making plans. From up the hillside at the kiln, the sharp pops of the old woman's fireworks are reassuring sounds. As the sun rises over the hills, casting long shadows that reach down the slope, activity in the camp begins to pick up. Innumerable chores need doing. Several men are soon engaged in replacing the tiny old blades affixed to the ivory foreshafts of their wooden spears with newly knapped flint blades, renewing the lethally sharp array. These weapons are for hunting horses and the small red deer out on the plains, a task that could take several men an entire day and night and still result in failure.

Another man grinds a piece of gray slate into a pendant to replace the one that shattered the day before when he fell onto some rocks while running. An older man, his hands now gnarled and crooked, slowly opens up a long hunting net, unrolling it on the ground. He then inspects it from one end 40 feet to the other end, seeing that the knots are still all secure. Satisfied, he rolls it back up and places it on the ground near a lone tree that stands a few feet from the dwelling where he, with his family, sleeps.

Inside, his daughter boils a mush of various wild seeds in a tightly plaited basket with hardened clay inside. The thickening gruel bubbles, some of it slopping over the edge of the basket and falling into the hearth. The young woman has been feeding this to her four-year old daughter for a week now, weaning her from the breast. Earlier, she and three other mothers sent their daughters off to collect the nettles that grow in the disturbed soil around the camp and are now ready to be processed. The girls and their mothers will set about soaking the nettles to remove the outer cover and free up the finer fibers inside. The fibers will then be twisted into string of various plies.

The Invisible SEX

The Old Woman, the oldest person in camp, though she is still vigorous, will supervise the making of the string and will take the finest as warps and wefts for her own work on her loom. Last year, she taught the young girls five of the eight ways of twining, some for making baskets and floor mats, some for making the wall hangings that helped keep out the icy winds of winter, and yet others for the fine mysteries of creating loom-woven fabric to sew together into form-fitting warm-weather clothes. The Old Woman, who is a bit scary for the girls because she is so powerful, has chosen one of the girls as a special student: she will learn to sew the seams of ceremonial shirts. She will show another girl the arts of the loom, and one day perhaps this girl will become the Old Woman, the weaver who makes the finest fabric for clothing for whoever in her lifetime emerges as the leader.

As the day goes on, several of the men set out for the plains below, bristling with flint knives and spears of wood tipped with ivory and stone blades, sweating in the midday sun, their hide shirts hanging from their belts. They will be on the march most of the day, camping near a place on the river favored by horses and some of the local deer. Other men stay in camp, a few telling exaggerated tales of hunting to the boys, a few others digging up the loose dusty soil and carrying it up the hill in bags made of fiber to the old woman at the kiln. In the shade of one of the free-standing trees, three young women gossip and laugh as they grind the small tough seeds of certain prairie grasses. It is a good day for a feast to celebrate the coming together here of these related families for the season.

By late afternoon, each family's net has been unrolled and carefully inspected, and tied together to form two long nets, each

some 80 feet across. Now the children, some of the women and men, and a few elders set out with the nets. The children carry sticks, which they brandish bravely as they run along behind the adults. Several of the adults carry clubs fashioned from fallen branches. Led by the oldest in the party, they pause after a half hour's walk on the slopes that are covered by underbrush. Carefully the oldsters unfurl the nets, unwinding them from the carrying poles, which are then used to anchor the nets to the ground. Several of the younger women, the men, and all the children silently circle around upslope until they reach nearly to the top of the hill. There they form into a wide arc and on a signal begin the charge down the hill, shrieking wildly, whacking trees as they go by, setting up a terrifying din. Rabbits, foxes, and other small mammals emerge from the underbrush and dart back and forth, trending downhill to escape the mayhem coming their way. Within minutes several dozen of these creatures have leaped into the nets to be quickly dispatched by people swinging their clubs. As the sun drops down to the western horizon, the people head back with more meat and fur than they will be able to use for days.

The camp bustles with activity as preparations for the feast get under way—skinning the animals, starting the hearth fires and the outdoor fire that will burn all night, and performing innumerable other chores. Meanwhile, the old woman who was first to greet the day has returned to the kiln up the slope with one of her youthful apprentices. She has kneaded into existence a few dozen small clay pellets, several animal figurines, and, most elaborate, a figurine of a woman with broad hips and buttocks and pendulous breasts, faceless, footless, with lines etched into her back that suggest ample flesh, which bespeaks a prosperous

woman. Carefully, she places all these objects into her basket except for the figurine, which she hands to the older of her two apprentices. The girl grins widely at the honor and holds the figurine carefully in her hand, and they set out for the camp below. As the feasting proceeds into the night, a few couples slip off into the dark, heading for courting camps a short walk away in a copse of trees. Others dance and chant, while the old woman throws an occasional pellet or animal figure into the fire as she sings a special song to herself in a high keening voice and the clay figurines explode. Toward the end of the festivities, she instructs the sleepy apprentice to throw the figurine of the woman into the flames. Most of the people in camp stop to watch as the girl flips the figurine into the fire, and they wait silently for a minute or so until a loud crack signifies the end of the ritual, of the feast, of the day.

With that, the people settle down for the night, eyelids drooping, stomachs full, ceremonies properly done to celebrate the successful hunt—a good day indeed.

WHAT'S RIGHT ABOUT THAT PICTURE

How much of this scenario is guesswork and how much is certain? What is the evidence that lies behind this view of a day spent at a site that would come to be known as Dolni Vestonice I? This site has been excavated and examined by numerous archaeologists over the last three quarters of a century and, over this time, has yielded up several startling discoveries. Among the first such was the figurine of the woman that we saw tossed into the central fire of the camp at the end of the feast. She was subsequently discovered on July 13, 1925, during the Moravian Museum's excavation under the leadership of Karel Absolon. The workers found

her in two unequal pieces less than a foot apart. The Vestonice Venus, as she came to be known, became famous as the earliest ceramic object ever found. A picture soon emerged—indeed, an actual illustration by Zdenek Burian—showing an elderly man with disheveled white hair, wearing a sleeveless shirt of some animal skin, with a necklace of teeth and other no doubt meaningful objects around his neck, carefully sculpting the figurine with a stick of animal bone. It is more likely that the figurine was carved by a woman, probably the "priestess" who used it.

At the time of its discovery, one member of the crew noted what appeared to be a fragmentary fingerprint left on the Venus's spine before firing. Recently this fingerprint was analyzed microscopically to determine such features as the breadth of ridges, which correlate with the age of the originator of the print. It turns out that the person who held this figurine was between 7 and 15 years old, and almost surely was not the maker of the figurine, since it is unlikely that a beginner or a child could have made it.

On the other hand, it was possible to call into question the actual ceramic skill of this "first" ceramicist. The site of the kiln upslope was first looked into by archaeologists in the 1950s. It yielded fragments of a total of 707 animal figurines and 14 human figurines, all fired clay. In addition there were some 2,000 small pellets. This suggests two possibilities. One, the ceramicist(s) were extremely incompetent. Two, they knew just what they were doing and had no interest in creating objects that would remain intact but instead were making objects that would, by design, harden in the flames and explode. This can be achieved by, among other things, adjusting the wetness of the clay. The building of three walls of the kiln suggests that they knew full well that the

figurines would explode, adding to the suggestion that a deliber-ate effort was going on—not only the first ceramic objects ever known, but also perhaps the first example of a kind of fireworks. Our description of this as embodying some sort of ritual is some-thing of an imaginative leap, but it seems unlikely that such onerous activity would be done out of sheer frivolity at a time when survival was a full-time job.

THE CRUCIAL ROLE OF THE FIBER ARTS

More important probably than the presumably ritual use of ce-ramics in Dolni Vestonice is the discovery that by 26,000 years ago, these Upper Paleolithic people of Eurasia were well along in what has been called the String Revolution, a technological breakthrough (better thought of as the Fiber Revolution) that had profound effects on human destiny—probably more pro-found effects than any advance in the technique of making spear points, knives, scrapers and other tools out of stone. The term String Revolution was evidently the original idea of Elizabeth Wayland Barber of Occidental College in California. She wrote a lovely book, *Women's Work*, suggesting what a remarkable inven-tion string was, whenever it first was used. String's invention, she wrote, "opened the door to an enormous array of new ways to labor and improve the odds of survival ..." Comparing it to the steam engine, she mentioned the need of string for weaving and said that on a far more basic level, "string can be used simply to tie things up—to catch, to hold, to carry. From these notions come snares and fishlines, tethers and leashes, carrying nets, han-dles, and packages, not to mention a way of binding objects to-gether to form more complex tools." Indeed, she thought, so

powerful was string "in taming the world and to human will and ingenuity" that it may well have made it possible for humans to populate virtually every niche they could reach. So the fiber artifacts found in those old Moravian sites were far more important than their humble appearance would have suggested.

Three certainties exist about fiber artifacts. Compared with things made out of stone, bone, antler, shell, and even (in some cases) wood, fiber items are highly perishable. Because of this, there simply aren't as many fiber artifacts remaining in the ground as other kinds. And there are even fewer fiber artifacts in the archaeological record than have persisted in the ground because practically all archaeologists have not been trained to see them in the ground, much less recover them (often an extremely delicate and technical task). There remain only a handful of archaeology departments here and abroad where such training is available, particularly at the graduate level. The other certain thing about fiber artifacts is that, in dry caves and other places where they do not deteriorate and disappear, they have been found to outnumber stone artifacts by a factor of 20 to 1. In several other situations (places covered with water where aerobic bacteria cannot get to the artifacts, and in permafrost), fiber and wood artifacts have been found to account for 95 percent of all artifacts recovered. That amounts to a tremendous amount of information that archaeologists have missed in most parts of the world, including Late Pleistocene Eurasia.

A third certainty about fiber artifacts such as baskets is that, unlike stone or bone artifacts or even pottery, the method by which the artifact was made is apparent in the artifact itself. Modern stone-knappers who like to replicate old spear points,

for example, can do so with considerable skill, and of course they know the steps they took to get to the finished product. But the earlier steps made are not necessarily present in the point. By contrast, a practiced eye can perceive which of a finite number of logical steps the basket maker took. Indeed, no weaver of baskets and fabrics and other items makes such things exactly as anyone else does, so one can actually glimpse a bit of the living individual craftswoman. At the same time, most basket makers of prehistory operated within an identifiable cultural framework, just as one sees tribal distinctions in the baskets, say, of Apache women as distinct from Paiute women. And within such a tribal tradition, one can also see what appears to be one generation, or even one basket maker, who taught those who came along afterward.

If one takes modern ethnographic studies of hunter-gatherer societies as not wholly unrepresentative of Late Paleolithic societies, the work of most human beings—especially women—has been overlooked. One result, which we noted in Chapter One, was that this left room for the picture to emerge of Upper Paleolithic society and economics dominated by the mighty hunters setting out to slaughter mammoths and other large animals—though mammoths especially caught the imagination of those reconstructing these ancient lifeways. There was some evidence for this, but only a smidgin. Most notably, in a few places archaeologists found stone points among huge mammoth bone assemblages in Eurasia (and also North America, where we will go in a later chapter). It appeared to many that astonishingly efficient and daring hunters were taking on entire herds and killing them for food.

But there was a problem here of specialization. Paleontologists, whose interest lay in the realm of prehistoric zoology rather than in the affairs of humans and hominids, found numerous similar assemblages of mammoth bones in Eurasia (and smaller assemblages in Siberia and North America) that had no stone points. And even in those assemblages where stone points and other tools were found, butchering marks were few and far between. In other words, over thousands of years and in various places (such as mineral licks, as at Dolni Vestonice, where the remains of a hundred or so mammoths were found), proboscidians died and created boneyards from which the people made what use they could.

Ethnographic studies of modern people have turned up practically no instances of deliberate elephant hunting before the advent of the ivory trade in modern times. There is no evidence of Upper Paleolithic assemblages of enough hunters (maybe 40 or so) to take down a mammoth, much less the number needed to wipe out a herd. It is dangerous enough, in fact, to go after any animal the size of a horse or a bison if one is armed with a spear. Only the foolhardiest would attempt to kill an animal that stands 14 feet high and has a notoriously bad temper when annoyed. A statement that has been assigned to multiple originators suggests that it is more likely that every so often a Paleolithic hunter brought down an already wounded mammoth (or one slowed down a bit in the mud of a swamp) and then talked about it for the rest of his life. The picture of Man the Mighty Hunter is now fading out of the annals of prehistory. By far, most of the animal remains found strewn about places like Dolni Vestonice consists of the bones of small mammals like hares and foxes.

The finds of perishable artifacts in Dolni Vestonice I and several other sites in Moravia have done much to blow the old picture of Upper Paleolithic life out of the water, and with it the dominant figure of the mighty male hunter, and replaced it with a picture something like the one with which this chapter began. The first of these finds was made in 1993, consisting of mysterious impressions in strange clay fragments in Dolni Vestonice I, which turned out to be the imprints of basketry and textiles made from wild plants. These were the earliest forms of the fiber arts known—indeed, some 10,000 years earlier than anything found before. Just what the fragments themselves were is not clear. They might have been pieces of flooring on which items of weaving or basketry had been impressed, and turned into hard evidence when the place burned down. In any event, they and subsequent finds in these sites showed that people here were already weaving and making basketry with at least eight different styles of twining, some of which remain common today. Some of the fabrics were as fine as a Brooks Brothers shirt. People had to have been weaving textiles on looms and making free-standing basketry for a very long time to have developed such ability and diversity and sophistication of technique.

Just exactly what those people were making from all this weaving, basketry, and cordage is impossible to say with certainty, but given the excellence of technique there is reason to think that they were making baskets of various kinds and possibly mats for sleeping and wall hangings, and clothing of various kinds such as shawls, skirts, sashes, and shirts. They used whipping stitches like those used today to sew two pieces of fabric together and that no doubt served the same end 26,000 years ago.

Figure 8-1.
Fragment of netting at Zaraisk showing (clock-wise from top-left) positive impression of the cast, microphotograph of the netting structure, and schematic of the structure.
O. SOFFER, J.M. ADOVASIO, AND STEPHANIE SNYDER

In addition to knots and other signs of weaving, numerous tools were turned up over the many times these sites were examined that can now be seen as tools for weaving and other steps in the production of such materials. One puzzling artifact made of mammoth ivory was shaped something like a boomerang but without the curve. It makes perfect sense as a weaving batten (and in fact is nearly identical to the battens still in use today among Navajo weavers). Another tool, basically a rod with a doughnut-shaped end, has been fairly commonly found throughout the world dating from later times, and has puzzled archaeologists, whose best idea for them is that they were used somehow to straighten spear and arrow shafts. But when they are thought about in the context of Moravian weaving, it seems that they would have been useful in the spinning of threads into string or yarn for weaving. Fairly large ivory needles were already known

The Invisible SEX

from such places, and the assumption was that they were used for sewing together skins and furs for clothing, but the proliferation of smaller needles found across Eurasia could not have been conveniently used for stitching such tough and unforgiving materials—except for the thinnest of leather. They are the right size, however, for stitching together pieces of woven fabric. Some of the ivory needles found are so fine that they would have permitted embroidery.

The very diversity of styles and workmanship that emerges from all these perishable artifacts and their associated tools, plus the fact that most of the stone used to make stone tools was not local, all suggests that these were people who assembled here for part of the year (perhaps a large part) and separated into smaller groups—probably near-nuclear family groups—at other times. It is reasonable to speculate that each such household might well have its (her) own favored techniques and brought them to the larger group, thus accounting for much of the remarkable diversity of products.

GROUP HUNTING

Four of the fragments examined had impressions of cordage tied into sheet bends or weaver's knots and this (along with what appear to be tools for measuring the spaces between knots) strongly suggests that they were making nets for hunting relatively small mammals, as well as string bags. Earlier workers had noticed the abundance—indeed, prevalence—of bones of such small mammals as hares and foxes in Upper Paleolithic camps in eastern and central Europe, but came up with fairly weak suggestions for the means of hunting them. Anyone who has

watched these animals race and dart when threatened will find it implausible in the extreme to imagine people chasing them down in the open and clubbing them, or even throwing little spears at them, both of which have been offered as serious explanations (of course by male archaeologists). The use of nets, on the other hand, as well as cordage snares, easily explains the peoples' success. They could, obviously, have made nets of wider mesh and thicker cordage for hunting larger animals as well, but no evidence of this has been found. At the same time, the large bone needles that were assumed to be used for sewing skins together would have also been handy tools for making the nets.

What then are the social implications of all this? First of all, we know from such modern hunter-gatherer societies as the Pygmies of the Ituri Forest in Africa's Congo region that net hunting is a communal affair involving women, children, and elderly people as well as adult males. It engages essentially everyone in the group as beaters, clubbers, or net holders and makes the acquisition of high-energy and high-protein food (meat) much less dangerous and more dependable. By adjusting the mesh, they could have caught even smaller forms of life—birds, even insects. This would ease the problems involved in feeding a relatively larger aggregation of people by providing a mass harvest in a short time—a surplus beyond their immediate need that in turn would make ceremonial feasts possible. Such behavior is noted ethnographically.

Making things out of fiber is not the sole prerogative of either sex in ethnographic accounts of small bands or larger tribal societies. More often than not, for example, men make sandals for themselves and their families, and it is also fairly clear that in

The Invisible SEX

such societies both men and women *know how* to produce sandals and other items that use basketry techniques and materials. In many cases, men probably do make things like baskets that they need for their own purposes, but throughout the tribal world today women make most basketry. But loom or frame weaving is a craft practiced almost exclusively by women in the tribal world, as is the gathering and processing of plant products for such weaving. This is the case in virtually all tribal societies where textiles and basketry are produced for domestic and communal needs, and typically it breaks down only when such perishable products enter the domain of market exchange. One rare exception to this among American Indian tribes is the Hopi of northeastern Arizona (an agricultural society) whose men do all the weaving—restricted to ceremonial wear such as sashes and kilts and costumery of brides made by their paternal uncles. Next door to the Hopi, as it were, Navajo women do all the weaving—almost entirely rugs—though the looms are often built by the husbands, and a weaver's son-in-law is expected to supply her with some of the weaving tools.

In addition, from cross-cultural studies throughout the world, the making of ceramic items, especially pottery, in many societies that we are familiar with is chiefly the province of women. There are, to be sure, innumerable variations that people have invented over time for all such matters, but even in the face of some scholarly quibbles, it is safe to assume what could be called the default position: that most if not all of the ceramics, weaving, basketry, and clothing was made by women in the years that Dolni Vestonice and the other Moravian sites were inhabited. And from that and other evidence—notably the Venus figures—

it is safe to assume that the *idea* of gender—the separate category with its associated roles and identities was now present. In other words, we see here the malleable social notion of gender, as opposed to (and in addition to) the clear biological function of sex. It is not clear from any particular archaeological evidence at these Moravian sites that the *idea* of man as opposed to male was prevalent. There is virtually no iconography that suggests otherwise, but Thurber's war of the sexes (read gender) would presumably soon begin. In any event, it is safe to say that some division of labor was in place, and with it probably a set of family relatives with whom one identified and by whom one identified oneself on a permanent intergenerational basis, a group in which every segment—children, men, women, elders—stood to gain. The population explosion that took place in this period seems to bear this out. In other words, here is one of the most vivid examples yet discovered of what we can safely call thoroughly, recognizably, behaviorally modern humans.

Does this seem to be a great deal to read into these fragments of perishable items and ceramics along with a few intact tools? In fact, it isn't, and new, closer looks at those enigmatic Venus figurines that are so fascinating a feature of this Upper Paleolithic Eurasian society tend to strengthen this hypothesis and round out our picture of life in those days.

VENUSES

Some 200 Venus figurines and figurine fragments from across Europe are the most representational three-dimensional images made in the Gravettian period some 27,000 to 22,000 years ago, which, of course, includes the Moravian sites described above.

Figure 8-2.
Front and back views of the female figurine in ivory from Kostenki I.
O. SOFFER

0 5

cm

Nothing is their equal before this period from anywhere in the world, and thousands of years go by before anything comparable appears again. As a result, they have claimed the attention of amateurs and professionals alike with almost the same continuing fascination certain scholars and most kids have for dinosaurs. As we said in Chapter Six, the Venus of Willendorf is surely the best known of all these sculptures. They remain in many ways enigmatic, mysterious, even confusing. They serve many purposes today, including as Rorschach emblems for some of today's hangups. They obviously mean "female," and they probably mean "woman," which suggests that they are not simply representations of the reproductive function of the female human, or gynecological and obstetrical "textbooks," as one scholar put it. At the

same time, there is simply no denying that the sculptors of these figurines went to a great deal of trouble to show off the sexual and secondary sexual features of the female human, even to the point of leaving the rest of the figure—face, feet, arms, and so forth—either abstract or absent altogether. (There are exceptions to this, of course, but no exception in the entire matter is more obvious than the fact that there are only one or two examples of clearly male figurines from this region and period. There are many figurines that are androgenous, without visible sex.)

What escaped many observers, both male and female, for many years was that some of these figurines were partly clad. The Venus of Willendorf's head, for example, though faceless, did have hair, it seemed, braided and wrapped around her head. Others had little bits of decorations—body bands, bracelets, minor bits and pieces of material of some sort. But never mind—they were largely naked and had to represent fertility, menstruation, the godhead (as goddess), or (giggle) paleoporn.

Then in 1998, coming off their discovery of the many fiber artifacts from Moravian sites, which many of their colleagues considered an important rearrangement of the picture of Upper Paleolithic society in Europe, Adovasio and Soffer turned their attention to these figures. To begin with, a close inspection of the braids of the Venus of Willendorf showed that her "hair" was, on the contrary, a woven hat, a radially hand-woven item of apparel that was probably begun from a knotted center in the manner of certain coiled baskets made today by Hopi, Apache, and other American Indian tribes in which a flexible element is wrapped with stem stitches as the spiral grows. Seven circuits encircle the head, with two extra half-circuits over the nape of the neck.

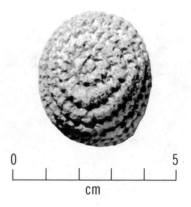

Figure 8-3.
Close-up of the coiling start of the basket hat depicted on the head of the Venus of Willendorf
S. HOLLAND, COURTESY OF O. SOFFER

Indeed, so precise is the carving of all this stitchery that it is not unreasonable to think that, among the functions involved in this Upper Paleolithic masterpiece, it served as a blueprint or instruction manual showing weavers how to make such hats. Indeed, anyone who has done any sculpting in stone or wood can tell you that the fashioning of the body, while extremely closely realized, would have been easy compared with the astounding control and staying power needed to render the stitching (even a few splices) of this hat so true and precise. The carver had to have spent more time on just the hat than on the rest of the entire figurine.

Of all the scholars who have examined these figurines over the decades (and there must be hundreds), only one other, Elizabeth Barber, ever took notice of the fiber accoutrements some of them wore. One British scholar who studied the Venuses in his youth never noticed any clothing because, he recalled, he "never got past the breasts."

Several other such figurines from central and eastern Europe wear similarly detailed radial or spiral woven hats as well as some begun by interlacing grids. Western European figurines tend to be more schematic, such as the Venus of Brassempouy,

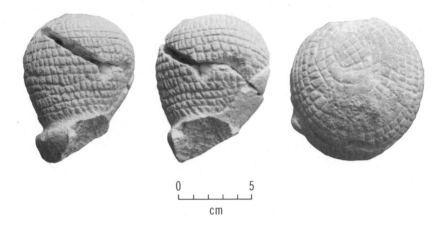

0 5

cm

Figure 8-4.
*Left, right, and top views of the plaited start of the basket hat
depicted on the marl head of the female figurine from Kostenki I.*
S. HOLLAND, COURTESY O. SOFFER

whose hair may be covered, in a more abstract rendering, by some
sort of hairnet or snood. One thing that seems fairly common to
all the partly clad figurines is that when they wear hats or caps,
the facial details are absent. This suggests a social importance to
the headgear, rather than an individual statement of personal
identity. In other words, these various forms of headgear may
speak to a particular status or rank enjoyed by at least some women.

Other forms of clothing or cloth decorations found on Ve-
nuses of this Gravettian period include straps wrapped around
the figure, often above the breasts, and sometimes held there
with over-the-shoulder straps. Yet others wear belts, often low
on their hips, sometimes connected to skirts of string. The Venus
of Lespugue, for example—she of the truly overwhelming hips—
wears a back skirt carved with a remarkable attention to detail. It
consists of eleven cords attached to a base cord that serves as a

 The Invisible SEX

belt. The cords are secured to the belt by looping both ends of a single-ply string over the belt and twisting the ends together with a final Z twist. On several of the cords, the carver made 30 and 40 separate incisions to show the individual twists, and she took great care to depict the progressive changes in angle of twist. At the bottom of the skirt, the angle of twist is much looser, clearly suggesting that the cords were unraveling or fraying at the hem.

What is to be made of all this? An important thing to note is that, except for one sexually ambiguous fragment that has a belt, such apparel appears only on figurines that are female. Clearly, as well, the garments so carefully portrayed are not the normal daily wear of women in these times, since they lived in climates where such clothing would be utterly insufficient against the cold—except of course for the woven hats. In the few known burials of the time, people were interred fully clothed. The body bands, belts, string skirts, and so forth could have been for ritual purposes, or they could have been signs of status, perhaps worn over one's daily clothing—or not, in the case of ceremonial use. Indeed, they might have been imagined, as with the halos depicted on icons of saints. What they do suggest is that such apparel was a woman thing, not worn by males, and that it served to immortalize at some great effort the fact that such apparel set women (or at least certain women) apart in a social category of their own. Much of the woven material from this period that was found imprinted on ceramic fragments is as finely done as anything done later in the Bronze and Iron Ages, and equal to much of the thin cotton and linen garments worn today. Given the amount of effort involved in weaving such cloth and also in carving a replica of it in stone, one can reasonably conclude that the

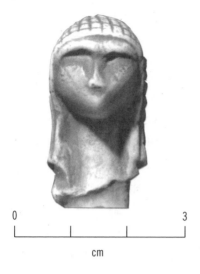

Figure 8-5.
*The Venus of Brassempoy,
carved from ivory.*
S. HOLLAND, COURTESY
O. SOFFER

0 3

cm

pieces of apparel found on so many of the Gravettian Venuses were symbols of achievement, or prestige. And it is also fair to say that, for those who were weavers or ceramicists, the workaday world was more complex, the daily round of chores, tasks, and roles more intense. Who were they?

The precision with which the carvers of the Venuses represented woven items leads almost inevitably to the conclusion that they were created by the weavers themselves, or at least under the sharp-eyed tutelage of the weavers. That it was almost surely women who did most of this fine weaving and basketry is one matter to which the ethnographic record appears to be a reliable guide.

The Invisible SEX

PART 3

PEOPLING THE WORLD

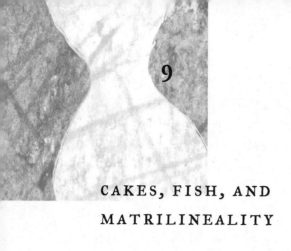

9

CAKES, FISH, AND
MATRILINEALITY

**The bread frontier and other adventures into the
Australian Outback, including the importance of
fishhooks and tides and boats and even glaciers.**

When it came to peopling the habitable parts of the world with
modern human beings, women didn't just tag along, lugging a
few necessities and herding the children, while the men strode
forth on the great adventure. Well before women in places like
Moravia were weaving fine clothes, some women who had al-
ready reached the shores of southern Asia may have been part of
the construction crews for seagoing boats that would carry them
across 50 miles of ocean to a land they could not have known
existed, at least early in the migrations. This was, of course, Aus-
tralia, the smallest, driest, and flattest of all the continents.

Before the invention of radiocarbon dating, shortly after
World War II, most scholars of Australian prehistory assumed
that the Aboriginal population could not have arrived on this
sea-girt continent until some 5,000 to 6,000 years ago. Who
they were (or had been) was a bafflement. As early as Captain
James Cook's first voyage, Cook distinguished the Aboriginal

people he found on Australia from Africans, but they also bore little relation to South Asian peoples. This matter is yet to be totally resolved: did they come from the Asian mainland or from the islands between the two continents? How they arrived was also a puzzle. One scholar suggested that a handful of people might have floated across 50 miles of strait on a log or some brush—the Australian version of Adam and Eve. (The Aborigines, when first come upon by Europeans, had nothing like seagoing boats.)

But radiocarbon dating soon changed all that, and before long sites dating back as far as 38,000 years ago were not all that uncommon, particularly in the south. Improvements in the accuracy and depth of time in radiocarbon dating have arisen over the years, as well as other techniques of which one, thermoluminescence, permits one to date burnt objects as far back as a million years. But with all the improvements, and all the precision technology involved, there is plenty of room for quibbling, with much of the debate in Australia, as elsewhere, centered on "questionable" sampling and other archaeological problems (as opposed to technological ones).

In the 1980s a flamboyant archaeologist, Rhys Jones, brought a refinement of thermoluminescence to bear on a rock shelter called Malakunanja in Arnhem Land in northern Australia. Beneath sheer walls covered with faded paintings were about five yards of sand and thousands of artifacts in every layer down to about two and half yards. The layer below the lowest stone tools was dated to a staggering 60,000 years—20,000 years older than any site dated with radiocarbon. Later, in the 1990s,

Malakunanja was reexamined, and the date came back as being between 50,000 and 60,000 years. Various other techniques have been brought to bear on the matter, and some have confirmed. Recently, however, further analysis has set the date at no earlier than 50,000 years ago, more probably 45,000 years. So, for now at least, we are back to a date of some 40,000 or 45,000 years ago for the earliest people on the Australian continent.

Earlier, in the 1960s and 1970s, archaeologists had come across numerous human skeletons in the sands of a series of Pleistocene lake beds called Lake Mungo, not far from the Darling River in New South Wales. Today these ancient lakes are dry land, but you can still see crescent-shaped sandy ridges called lunettes. The Late Pleistocene people lived on these lunettes, hunting and fishing, and on one of these lunettes a Melbourne geologist, Jim Bowler, came across an exposed block of calcrete that contained the remains of a cremation—a woman who came to be called Mungo Lady and is now recognized as representing the oldest cremation known. In subsequent years more human remains were found in the area, dating as far back as 43,000 years ago. All the Mungo Lake people appeared to be very lightly built people with delicate features—anatomically very modern. Meanwhile, in Kow Swamp in Victoria, other archaeologists had found the bones of about 50 or 60 individuals who were about 10,000 years old but were possessed of thick brow ridges, great big faces, and bigger teeth than are usually found in modern humans. Anatomically less modern people living *after* more modern people?

By way of solving this puzzle, one archaeologist put the skulls of recently dead Aborigines in a row, with the most gracile

extending to the most robust. He decided that the gracile ones were females and the robust ones male. At the extreme ends, the difference between male and female, or rugged and gracile, was huge. In the middle, a skull could be either. This rather ghoulish demonstration suggested that common wisdom of the day was right: all the variety of forms found among the Aborigines was the result nevertheless of a single founding population (perhaps those hapless folk on the floating log). But most scholars even then were of the opinion that various types of people had come at various times and mixed together to produce the modern Aborigines. In any event, they had to have come by some form of watercraft.

BOAT BUILDING—A FAMILY ENTERPRISE?

About 18,000 to 20,000 years ago, the colossal glaciers of the north were at their maximum extent, meaning, among other things, that an unimaginable amount of water had been taken out of the world's oceans and was frozen in them. Sea levels were therefore at their lowest for eons—indeed, in some places a hundred or more yards lower. Of this great region, geographers call the mainland portion consisting of present-day Malaysia and Indonesia—then mostly a connected landmass—by the name Sunda. At the same time, Australia, New Guinea, and a few islands were largely one piece of land called Sahul. Even at this time of the glacial maximum, there were some 50 miles of open sea between the nearest points of Sunda and Suhal. The situation was much the same 40,000 years ago, so the people who began to show up in Australia, presumably from somewhere on Sunda, had to have come from a maritime tradition.

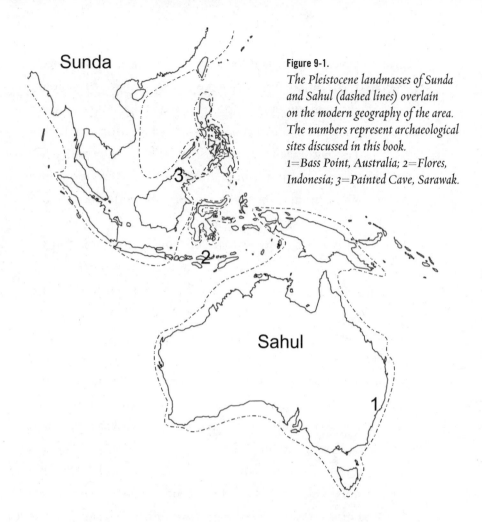

Figure 9-1.
The Pleistocene landmasses of Sunda and Sahul (dashed lines) overlain on the modern geography of the area. The numbers represent archaeological sites discussed in this book. 1=Bass Point, Australia; 2=Flores, Indonesia; 3=Painted Cave, Sarawak.

Fifty miles of open sea is far longer than one can see. Those who made the voyage were looking at nothing but a flat, landless horizon for at least 40 of the 50 miles. They needed what some call blue-water technology, which means seagoing watercraft, not some tippy little dugout hacked out of a log or a jerry-built raft.

Most of this coastal territory was covered by tropical forest and mangrove swamps, habitat that is extremely unkind to archaeologists. The dampness is inimical to the preservation of any

organic remains, and even locating sites is hard in the densely vegetated terrain. A few archaeological sites have been found there of the approximate period we are talking about, notably a 40,000-year-old skull from the Painted Cave in what is now Niah Caves National Park on Sarawak. The caves were etched out over the eons from a huge limestone reef that was thrust upward out of the ancient sea, rising high above the surrounding forest.

Exactly what people of coastal Sunda were doing in the boats they built is not at all clear. They may have been fishing, or maybe even island hopping (some islands remained in the lowered seas), looking for new places to live. It comes as a surprise to many that tropical forests are not nice not only to archaeologists but to people in general. They consist mostly of columnlike tree trunk after tree trunk whose leafy canopies are far off the ground, casting a perpetual shade in which little else has a chance to grow. Once a tree falls, a vicious competition breaks out among seedling plants to see which one gets up into the sun fastest and shades out the other contenders. Herbivores are vanishingly few, predators fewer. Small insectivorous mammals and birds are about all the readily available protein there is, outside of insects. Tree fruit is usually too high to reach and is hardly enough to support a family when some of it drops on the ground, having escaped the attentions of monkeys and birds up in the canopy. Many scholars of prehistory suspect that such places simply were not inhabited by human groups until people began growing food. Indeed, among modern hunters and gatherers in tropical forests, the Pygmies of the Ituri forest are probably the only ones who do not practice some kind of horticulture, and

they have virtually indentured themselves to the surrounding tribes in trading for cultivated foods.

Most likely the ancient people of Sunda lived along rivers and on the shores of lakes and depended heavily on water resources—fish and shellfish (both freshwater and seawater) for protein to add to what they could forage on land. And for this they built boats. Anyone who has set out to build a seaworthy boat from scratch by oneself has found that it is arduous work. Without many hands, it will take months if not years. Archaeologists are virtually unanimous that the seafarers of Sunda who eventually fetched up on the shores of Australia were behaviorally modern people. Though no one has ever recovered the remains of such craft, their boats had to have been the signature of highly coordinated social action, the kind of action possible only in socially constructed groups. In other words, men and women (as opposed to males and females) had to have been invented by this time. Going off to sea requires the cooperative action of kinfolk—of people tied to you through past debts and favors who thus feel obliged to help you build your boat. This necessary collaboration of boat building (and sailing) lets us know, without any other evidence at all, that on the shores of Sunda the concept of kinfolk had clearly been invented —brothers, sisters, parents, husbands, wives, cousins, uncles, aunts, grandparents—before the invention of boats themselves.

So these voyages, we can be sure, would not have taken place without the prior invention of women. What roles awaited these seafarers, the men and the women, when they happened onto the shores of Australia? When people fetched up in northern Australia, they found the same kind of habitat they had left

behind—tropical forest and mangrove swamps. At the time, 45,000 years ago or so, the island continent was not as dry as it is today, but it was well along in the process of drying out. The interior was beginning its transformation into desert, now called the outback, and grasslands and savannahs were beginning to replace inland forests. But along the forested shorelines, and inland on the many surviving lakes like Lake Mungo, were fish and shellfish for the taking. Early on, then, these new arrivals would have had little trouble adjusting to their new land. New species of edible plant food and new prey animals—Australia, after all, was the home of a large array of marsupials, from large kangaroos to mouse-sized creatures—needed to be studied and made use of, but in general the new environment was familiar. Only later would some of them have to become desert people.

When Europeans grew curious about the origins of the Aborigines, these first Australians were not held in high regard. Even early 20th-century anatomists looking at the few ancient skulls they had collected concluded that these early inhabitants were closer to *Homo erectus* than to modern humans. There were, clearly, Stone Age people who simply had not progressed beyond the most primitive of lifeways. As the 20th century moved along, however, ethnographers began to elucidate the complexities, subtleties, and high degree of adaptedness that existed among exotic societies globally. Even so, in the case of the Aborigines, it would be a long time before ethnographers would actually take note of what Aboriginal women were up to.

Back in 1913, the great ethnographic pioneer Bronislaw Malinowski noted that among the Aborigines, "the relation of a husband to a wife is in its economic aspect, that of master to its

slave." By the 1930s, other ethnographers were asserting that the man's role in performing the complex and nearly constant ritual life of the Aborigines was in stark contrast to the woman's simple role. Said another ethnographer as late as 1979, men controlled both women and the natural world by means of religion and ritual, thus depriving the women of political and economic autonomy all their lives.

This was all simply nonsense. Phyllis Kaberry had already in the 1930s made the first comprehensive study of Aboriginal women and had made it clear that there was nothing compulsory about all the work they did—chiefly gathering plant food and grinding much of it into flour from which grass-seed cakes could be made—except that such work was necessary for a continued existence. Women, Kaberry pointed out, were taught by women, worked in the company of other women, decided when to forage and where, and, if their men got out of line, brought them to their senses by moving out, meaning that the men would have nothing much to eat except the occasional booty from the hunt. Men, in other words, were dependent on women for food, not the other way around.

Continuing studies have refined the overall picture, with local and regional differences arising and more complex relationships being perceived. It seemed that the women's grass-seed cakes sustained the men during their rituals, but men provided nothing to the women during theirs. In essence, it began to appear that there was a kind of power balance, rather than outright dominance by one gender over the other. For example, male rituals gave the men power, but to be wholly powerful they would need to have the women go to their places to live, thus demon-

strating patrilineality. But the very grass-seed cakes that sustained the men came from flour that the women made by grinding seeds on stones that were few and too heavy for them to transport. So the stones remained the property of the female line, and the men lived in their wives' locales, thus demonstrating matrilineality, a check on male power.

To some degree, such analyses of gendered power can often be Rorschach tests of one's own perspective and training on such matters, but one thing appears to be certain about the Australian Aborigines: their land is called the flour frontier. Aboriginal groups were able to settle the interior of the continent, where the world was utterly different from what they had experienced on the coasts, thanks to a very great degree to the women and their grass-seed cakes. For, as noted, women could and did manage their own survival, whereas men managed only a part of it.

Yet other studies showed a skewed distribution of food in some Aboriginal societies. Each woman foraged for herself and her children, eating whatever she found as they moved around the landscape, and she provided for her husband and his male relatives during ritual times. By contrast, when a man succeeded in bagging some meat or fish, he was obliged to provide it to his male relatives and his children, but not his wife. Coming in last on the food chain, women rarely had enough meat to sustain them and presumably did their own hunting or fishing. In any event, there were two diets: one women's, the other men's.

Fishing is, in fact, not that easy to categorize. Going out into the water with a spear to catch a scale fish (a task reserved for Aboriginal men) is hard to distinguish from hunting. But if the same man goes out with a poisonous plant product like the

The Invisible SEX

bark of certain trees and throws it in a lagoon, knocking out all the fish so they float to the surface, it is more like gathering. But among Aborigines, men do the poisoning as well. But women were noticed to fish as well, using shell hooks and string made of plant material, and also participating in net fishing. Finally, while there is nothing to stop men from gathering shellfish, that task was normally accomplished by Aboriginal women, who, again, would with their children eat most of what they found where they found it, bringing some back for the other people to whom they were obligated.

People who gather shellfish around the world typically leave behind an artifact that can be extremely illuminating to the archaeologist: a shell midden. One such midden was discovered on Bass Point, a peninsula that juts about two miles out into the Pacific Ocean from a spot 60 miles south of Sidney. About the size of an American football field, the midden lay on a gentle slope surrounded by rocky shores. In 1969 to 1970, a young archaeologist, Sandra Bowdler, excavated a plot some of four square yards. The various layers she uncovered, coupled to ethnographic information, told an interesting tale of Aboriginal fishing economics and foraging gender.

The top 40 centimeters consisted of dense shell detritus—a midden, after all, is a household garbage dump—that Bowdler could distinguish into two levels, the Upper Midden and the Lower Midden. Beneath this was a 15-centimeter-thick layer of gray sand, and below that a 60-meter layer of white sand that rested on rock. The white sand layer contained no organic remains except some charcoal, along with a few stone points. In the gray sand, she found some stone artifacts and also some badly

deteriorated shell and bone pieces. The white sand, at the bottom, was determined to be about 17,000 years old, and where the white sand gave way to the gray sand was dated at about 3,000 years ago. It is the upper two levels where a particular story became readable.

Some 3,000 years ago, people living in this place had begun in earnest to catch fish and collect shellfish. Bone points were discovered that matched closely the kind of barbed bone points that are fixed to the prongs of the multipronged Aboriginal spear used for fishing. Indeed, the weapon resembles a harpoon, and virtually everywhere in Australia it is the exclusive tool of men.

Where the Lower Midden gave way to the Upper Midden, dated to about 600 years ago, significant change came to the people of Bass Point. In the first place, the Upper Midden had plenty of bone points for spears, but also plenty of shell hooks. A whole new means of fishing—by line—had been introduced and had become common. Throughout Australia, line fishing is still the province of women. The remains of fish continued to point to snappers as a main component; the snapper is a fish easily caught by either spearing or line fishing. But with the advent of fishhooks, rock cod, a fish best caught by line fishing, begins to appear in considerable quantity.

Differences in the proportion and species of shellfish also changed at the 600-year mark. In the Lower Midden, large shell-fish like tritons, which live at the outer edge of the tidal zone, were rife. But in the Upper Midden there was a shift to the familiar blue-black mussel shells, a creature that lives farther up on the shore, where the tide covers them only for a shorter period with each tide. The larger shellfish, of course, provide a gatherer

with more bang for the buck in terms of foraging efficiency than the much smaller mussels.

Was it just a coincidence that once line fishing was introduced, the shellfish gatherers switched to the less efficiently gathered mussels? Had they overcollected the larger shellfish?

Or could there have been some behavioral change out on Bass Point, some new tactic in what is sometimes thought of as the battle of the sexes but might better be called the battle of the genders?

Dr. Bowdler came up with an ingenious (though she admitted speculative) explanation of these few facts. In the first place, she said, before the fishhooks show up some 600 years ago, all of the fishing was done by men and their (no doubt closely held) multipronged spears, while women "doubtless spent a good deal of their time gathering shellfish; and this was probably done in a thorough and systematic fashion, with due regard to the schedules imposed by the tides." In other words, they needed to go shellfishing at low tide to get the big succulent gastropods in the deeper waters.

Then the shell fishhook comes along 600 years ago, and, unlike the spear, it was probably not sacrosanct to the men, who may have been sleeping, as they say, when this new small and seemingly insignificant technology came along, more than likely invented by women looking to get some scale fish into their diet. No one will probably ever know. The fact that much of the fish detritus in the later level is from the same species as before, like snapper but smaller, tends to confirm that line fishing was prevalent, since shell hooks would not be good for catching larger fish.

The women, still deprived of scale fish (though presum-

ably less so) to feed themselves and their children, continued to gather shellfish as well, but perhaps they had less control over when they were free to do this collecting. They were spending much of the day line fishing, and it may have been difficult to match up their hours that were free for collecting to the tides, as Bowdler writes: "time and tide wait for no (wo)man." So they abandoned the systematic and regular gathering of the big juicy gastropods except when their free hours and low tide matched, and instead went for the easily gathered, economically inefficient mussels, which they could reach at any time of day.

Is it fair to twine ethnographic reports and details with archaeological sites that are up to 3,000 years old? We have raised that question several times in discussing artifacts and behaviors that are far older than that. Generally speaking, it is dangerous to assume that behavior that was common a couple of centuries ago was the same or very similar to behavior that is older by tens of millennia. If there is, however, any place where it seems particularly legitimate, it is Australia, where modern human beings found many straightforward ways to subsist in many salubrious but more quite hostile environments, developing skills that were by no means simple but certainly sufficient and, feeling little need to improve the economic or material ways of their lives, turned their creativity to the invention of fabulously rich stories, wondrous art painted on and etched into the rock, and other ways of celebrating their existence. Such societies do not change much over time because they don't need to. Traditional societies tend to operate on the principle of doing things the way their grandparents did it; they are conservative, given to the notion that, as we say, if it ain't broke don't fix it.

One can easily imagine the Aboriginal men of Bass Point sniffing contemptuously at the shell hooks and the laboriously made strings that their women were using, making invidious comparisons of those little toys compared with their mighty, multipointed, barbed, aerodynamic spears and other large instruments. Real men did not line fish. But once the Europeans came and introduced far more effective metal fishhooks, the Aboriginal men took up line fishing with alacrity, the way a man might absolutely require a Harley after years of riding a bicycle.

10

SEAMSTRESSES OF THE FAR NORTH

In which women make complex stuff to permit people to venture north of the Polar Circle as well as into the New World.

The poet Stanley Kunitz remarks that "the iron door of the north clangs open," and life spreads southward along with a cold wind, but that is not really how it was. For most of the last million or so years of the Pleistocene, the iron door of the north remained closed, some of it buried under the unimaginable tonnage of glacial ice that arhythmically pulsed southward, retreated, and pulsed southward again, over and over. Where the ice did not cover the ground in the far north, the climate was too severe by far for any tropical or subtropical organism to approach it. As long ago as 500,000 years ago, some hominids (people or not quite people, depending on your taste in such matters, but nevertheless creatures designed by and for a subtropical lifestyle) would take advantage of any warming trend, any glacial retreat, and push northward. Why they did this no one knows. Neither, probably, did they, except to follow the familiar.

Signs of habitation by none other than *Homo erectus* have been found much farther north than one would imagine them venturing. We find their tools in one of the caves at Zhoukoudian

near Peking some 500,000 years ago, along the banks of the Lena River in Yakutia in northeast Siberia, and in Boxgrove, England. They penetrated as far as 60 degrees north not far from the zone where the world goes completely dark for part of the winter. But these ventures never led to anything like a permanent settlement. They were adventitious and opportunistic ventures into areas where, during the much warmer and wetter interstadial periods when the glaciers receded, the climate could be as mild as these areas are today, and indeed even milder. The visitors to Boxgrove a half million years ago saw hippos wallowing in the Thames.

Later, Neanderthals moved north as well, developing short stocky bodies that conserve heat, reflecting adaptations for living in cold climates. But the Neanderthals were hardly equipped for what lay beyond the iron door of the north. The body design that maximized volume and minimized the amount of body surface exposed to frostbite was not enough, even with the benefit of controlled fires and hides to snuggle in. When the oddball times of warmth gave way to another southward pulse of the great ice, the Neanderthals too fled back to more southerly regions.

It was not just the cold that drove these ancient hominids and Neanderthals out, though the northern landscapes were bone-chillingly frigid for most of the year. On the East European Plain during the last glacial maximum about 20,000 years ago, the mean January temperature was −30 to −40 degrees C, while the temperature in the brief three-month growing season of summer could rise to 18 degrees C—a tremendous fluctuation. These northern regions could not have been more different from what confronted the seafaring people of what is today Malaysia when they arrived on the shores of Australia. The original Aus-

tralian "colonists," however many times groups arrived and went back, or stayed and died out, or eventually stayed for good, found a tropical land hardly different from what they had left behind. It would have been their descendants who much later would have to have learned to cope in the desert.

In the northern reaches of eastern Europe and Russia, the combination of the cold, the aridity (most moisture being locked up in ice or permafrost), and the huge distance from the moderating influence of the Atlantic Ocean added up to an extreme seasonal variability in which food was available in "boom or bust" cycles. The growing season, while extremely short, was highly productive of the kind of vegetation that could feed huge herds of gregarious herbivores—horses, bison, reindeer, mammoths, and boars. Waterfowl teemed in lakes and rivers. The trick for humans was to harvest the incredible seasonal bounty and to store food for the long cold season, either as portable pemmican or in underground larders.

Life in such a bipolar world called for a whole bag of cultural tricks involving both new technologies and new social arrangements. To begin with, they might have been able to survive in parts of the north by just throwing a cloak over themselves, as the Yaghan and Ona peoples of Tierra del Fuego did. But a far more expeditious means for living in the far north was to have tailored clothes, and this means that a great number of things had to be invented first—sewing, for example.

Some of the oldest eyed needles we know of come from a site called Denisova Cave in the Altai Mountains of southern Siberia near the juncture of Russia, Kazakhstan, and China. Someone was sewing in that cave some 37,000 years ago, but it is not at all clear

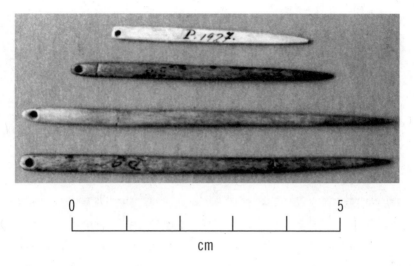

Figure 10-1.
Eyed needles manufactured from ivory from various Upper Paleolithic sites in Moravia.
O. SOFFER

who. Denisova is a small cave, unsuitable for any sort of semiper-manent dwelling (in fact, most caves aren't suitable, being dark, damp, and available as harborage for carnivores). But if caves are found to be carnivore free, they make fine places to spend a night or two on a hunting trip—Pleistocene motels. Today, no native hunter in the north sets out without a needle or two in his toolkit so he can patch up a tear in his parka: at temperatures tens of degrees below zero, when even a small rip in one's outer clothing can bring on frostbite or worse. Probably the needle at Denisova Cave was part of a hunter's traveling toolkit. He was almost surely wearing a set of clothes with feet attached to the legs. And we can also be sure that his clothes were manufactured in the first place at some home base by a woman or women in his family.

Signs of clothes can be seen in some burials, which, in this

Late Pleistocene period, became more elaborate in many cases and unquestionably deliberate. At a site called Sungir' northeast of Moscow, archaeologists came across a double grave that proved to be more than 22,000 years old. The grave had been dug into the permafrost (no simple chore) and contained the skeletons of two children placed head to head—one female, the other arguably male. Almost 5,000 beads covered the "male," in positions that suggest that they were attached to close-fitting clothing. In addition, some 250 fox teeth formed what appears to have been a belt, and the body was accompanied by ivory carvings and a highly polished human femur. The female was covered with more than 5,000 bead fragments, also presumed to have been attached to clothing, and accompanied by ivory lances, antler wands, and other objects. Archaeologists estimated that the beads had required thousands of hours to manufacture, never mind sewing them onto the clothes. In all, the Sungir' burial suggests ritual and a notion of some sort of afterlife, which both women and men were destined to enter.

Thus attired, people were reaching as far north as the Arctic by 35,000 years ago. Their artifacts have been found in a site called Mamontovaya Kuria, dating to that period, just above the Arctic Circle a thousand miles north of Moscow. Ten thousand years later, people had penetrated 500 miles above the Arctic Circle to 70 degrees north. Such extreme forays did not lead to a permanent settling of the Arctic, but they do show what the newly invented technological arrangements permitted people to attempt. These extreme northern sites were mere outliers—almost oddball efforts—as people spread both north and east in Europe and Asia.

Throughout the cold Eurasian regions, people needed not just fire and well-insulated dwellings and cold-proof clothes and structures built of bone where wood was unavailable. They needed long-term planned economies. They needed to delay consumption in the growing season and to create storage facilities to fill with meat and other foodstuffs, larders that could feed families during the long cold season when nothing grew and most creatures had migrated south. No single one of these tactics would have sufficed. They needed to implement an entire strategy.

In this same period, people lived in the vicinity of Lake Baikal in southern Siberia and left behind spectacular archaeological records, including beads, pendants, diadems, decorated plaques, and bird and female human figures. The carved human images are of women dressed in hooded parkas, none of them being visibly pregnant. Therefore, we can assume that they were not fertility figures but instead reflections of the status of some categories of women, like the Venuses found in eastern and western Europe.

By 13,000 years ago, Siberian women were making pottery along the Black Dragon River, better known as the Amur River, the eighth longest river on earth at 2,744 miles long. The river rises where Mongolia, Russia, and China meet and extends more than a thousand miles eastward along the Russian–Chinese border, then turns north to empty into the Sea of Okhotsk in the Arctic Ocean. In its course, it flows through every sort of habitat from taiga to subtropical forest, from mountain to plain. At several places along the upper and middle reaches of the river, archaeologists have come across several Late Pleistocene sites

where ceramic shards show that pottery was being made, the earliest in the Russian Far East. Not only are these among the earliest signs of pottery (which has also been found dating back to even earlier in Japan) but also they show that a highly sophisticated industry of textiles and basketry, as well as cordage construction, was practiced. Many of the shards recovered were impressed before firing with fiber matting or fabrics, which, under microscopic analysis, reveal warp and weft patterns that would be familiar to a weaver or basket maker of today.

ON TO THE NEW WORLD

During the millennia of the Late Pleistocene, behaviorally modern humans were able to spread into regions where earlier humans and hominids could not survive, particularly in the northern regions of Eurasia. Vast quantities of ocean water were tied up in the huge glaciers of Europe and in North America, with the result that much land that is now underwater was open. Such was the case where the Bering Strait now separates the Old World from the New. But at the time when people were making a living in Siberia and even above the Arctic Circle (66 degrees and 30 seconds north), the Old World extended well into the New by means of a land bridge called Beringia.

The word "bridge" in this regard is unfortunate, conjuring up the notion of a narrow isthmus of land over which mammoths and mastodons picked their perilous way, risking a tumble into the icy waters on either side. In fact, Beringia was about a thousand miles wide from north to south, a huge area of taiga and bog and permafrost just like the land to the west in Siberia and the land to the east—Alaska. During the million years plus of the

Pleistocene, as glaciers came and went, so did Beringia, providing a broad highway over which the great elephantine creatures traveled, along with bison, musk ox, and numerous other large creatures, while other animals like horses, camels, and beavers left North America and went east to Asia. Indeed, these creatures of the north almost surely went back and forth. The Bering doorway swung both ways.

By the time that some Asian people had figured out how to live in the Arctic climate, about 25,000 years ago, the glaciers were building up to another maximum, which occurred about 20,000 years ago. East of Beringia, the huge Laurentide glacier extended from eastern Alaska all the way across the continent to Greenland, and as far south as New Jersey. Along the west coast of Canada, down into present-day United States, a narrower glacier, the Cordilleran, came together over the coastal mountains. From time to time an alley would open between these two glaciers, connecting the open land of Alaska with the open land far to the south.

There is no reason to doubt that people did not go back and forth across this grand highway, some of them staying in the east. On both sides, archaeologists have found signs of small generalized hunter-gatherer groups, sparsely spread on the land, exploiting a wide variety of plant and animal resources including small mammals and birds, making their opportunistic best from the rigors of the cold. All these people used similar harvesting and processing technologies, including the making of baskets and cordage and woven and sewn clothing. On the Asian side, the groups lived along the banks of the Lena and Aldan rivers in central Yakutia (the westernmost province of Siberia) with a toolkit

(another way of saying "culture") that archaeologists call Dyuk-tai. On the Alaskan side, similar inventories have been divided into two consecutive cultures called Nenana and Denali, arguing (in some quarters) for two separate incursions of Asian people into the New World.

The Dyuktai culture appears to be somewhat older than the Alaskan ones, which have been dated to about 14,000 years ago. But a great deal of archaeological evidence now lies below the ocean along coasts that were drowned as the glaciers decayed and receded, pouring unimaginable amounts of water back into the seas. It seems unlikely that there would have been only one or two or even a handful of "incursions," given the nearly monotonous sameness of the lands stretching from eastern Siberia to western Alaska. More likely, people in small groups came and went, some staying in Alaska not far from the gigantic glacier. As the world began to warm and the oceans began to rise again, these people would have been cut off from their Asian roots. They would become the first Americans.

It might well have happened that way.

11

SETTLING DOWN IN AMERICA

In which the authors explain that the first Americans were not vicious exterminators of great beasts but just hunting and gathering folks with whom the so-called war of the sexes was typically a standoff most of the time.

Without any doubt whatsoever, the most ferocious, the most bloodthirsty, the most lethal hunters who ever followed the spoor of prey on the surface of the planet earth are known in the aggregate as Clovis Man. By the chief account of his doings, Clovis Man burst into what are now the lower 48 states of America from the alley between the Laurentide and Cordilleran ice sheets 13,500 years ago in a group numbering no more than 100. (In this scenario, proposed by geoscientist Paul Martin in the 1960s, it is not clear whether the entire group numbered 100 or whether there were 100 hunters attended by their women and children. Neither Clovis Woman nor Clovis Child comes in for much in the way of discussion.)

Arriving in the midst of some 35 genera of large animals, like mammoths, mastodons, giant bison, giant sloths, and saber-toothed tigers, that had never seen anything with two legs bearing spears and thus were as easy to knock off as the dodo, Clovis

Man proceeded to wipe out 30-odd genera not just in North America but in Central and South America, all the way down to Tierra del Fuego, which he reached a mere 700 years after arriving in Minnesota. Never had so rapid a colonization of new lands taken place, and never had so few eaten so much meat in so short a time or left so much blood soaking into the ground. Clovis Man, practically everyone agreed, was corporately the first American.

This super-macho version of the Clovis story, which arose in the 1960s and was called Pleistocene Overkill, was controversial—particularly at first among American Indians, who were presumably descended from these rabid wildlife slaughterers and were at the time trying to get billing as natural ecologists. Clovis Man had been "discovered" in the early 1930s when archaeologists found some astonishingly beautiful and elaborate spear points in a place called Blackwater Draw in the dry plains near the town of Clovis, New Mexico, then a prominent part of the dust bowl of Depression America. The discovery of these Clovis points followed an earlier discovery to the north in Folsom, New Mexico, of Folsom points, which were associated with the violent death of several giant bison. It was clear that Clovis points were older (they were found at Blackwater Draw *beneath* some Folsom points), and before long Clovis Man was established as the first one here in North America. Nothing convincing was found to question his primacy for a very long time. His points were found from the Rockies all the way east to the Atlantic coast and down into Central America, even into the southern regions of South America (or at least points that could be taken as his). Clovis Man resonated with many Americans as the Late Pleistocene version of John Wayne.

In the late 1950s and 1960s and beyond, the technique of radiocarbon dating came into widespread use and allowed archaeologists to put firm dates on Clovis Man. No one had ever found so much as a little finger of the actual Clovis Man (nor since), but his points and some other tools he used were dated back to 13,500 years ago and were replaced by the more delicate Folsom points about 700 years later. At the time, in the 1960s, Clovis Man's tenure seemed to correspond precisely with the extinction of the great mammals of the American Ice Age. Some archaeologists resisted this circumstantial evidence of nearly instantaneous slaughter, pointing instead to the terribly disrupting effect of the glaciers' retreat, pouring huge quantities of freshwater onto the continent and changing its climate in patchy, unpredictable ways. Later, it became clear that the extinction of large mammals had begun well before 13,500 years ago and had continued after 12,800 years ago. It also became clear that,

2 cm

Figure 11–1.
A typical Clovis point from North America.
JEFF ILLINGWORTH/
Mercyhurst
Archaeological Institute

with all the Clovis sites that were found over the years, very few of them showed Clovis points in direct lethal association with the remains of mammoths or mastodons—in all, about 15 sites. It also became clear that at places like Blackwater Draw, the people dined on turtles and other small animals far more often than they enjoyed mammoth steaks. Even so, the Pleistocene Overkill theory persisted in many scholarly circles, and Clovis

Man the Mighty Mammoth Hunter as the first American persisted even longer—with still vanishingly few mentions of Clovis Woman, of course. The main discussion of Clovis Woman, in fact, was to wonder whether she (while racing along in pursuit of ever-famished Clovis Man) could have produced enough offspring on the fly, as it were, to accomplish the colonization of the entire Western Hemisphere in a few hundred years. Even as late as 2000, some mathematically minded archaeologists took this approach, considering Clovis Woman as little more than a mobile reproductive device.

For example, Todd Surovell, now of the University of Wyoming, used an elaborate mathematical model that estimated the costs of raising children for highly mobile hunter-gatherers and found that if they moved their base camps frequently (but not over too great a distance), the women could produce lots of children, which would make colonization of the hemisphere in a matter of centuries possible. The only problem with all this is that it never happened anywhere else that anyone knows of. Typically, most hunter-gatherers do not happily march off into some new ecosystem with new plants to learn to eat (and one learns about poisonous plants by someone getting poisoned) and new animals to learn to hunt. Examples of people who regularly move their residential camps are, in fact, few and far between, one of them being the Ache of the Paraguayan forests, who move every week but not out of their familiar region. Clovis Man and long-suffering Clovis Woman would have had to move from boreal forest into open plains, desert, mountains, tropical rain forest, coastal highlands, pampas, and what not without much time to become culturally accustomed to any of them. Fortunately for

those of us who wish Clovis Woman a better deal, none of this was necessary. Nor did it happen.

The explosive arrival of this bloodthirsty handful of hunters, as specified by Paul Martin, fit the unspoken and unexamined idea of the time that the discovery of this continent by people was a single event, the arrival of a group in the New World, much as Columbus and a handful of sailors arrived much later. But the likelihood is that several, even many, pulses of people made their way across Beringia, following a familiar landscape and familiar plants and animals. Some might well have gone part way and turned back to Siberia. Others might have perished along the way. It is also quite possible that some people from Asia floated or paddled north from such places as Japan, following the warmer current that flows northward, and then circled eastward and to the south, bypassing the Cordilleran glacier on the coast by putting into small ice-free harbors. Or some might have made their way on foot down the west coast at a time when the glaciers in the coastal mountains had not yet coalesced into the Cordilleran ice sheet and the valleys were open. Still others might well have traveled south via the narrow alleyway between the two great ice sheets, but only when enough time had elapsed and the polar desert that opened up between the great jaws of the vise of ice had mellowed into more hospitable wetlands where abundant waterfowl and plant life could be exploited with the perishable technologies that had been on hand for millennia—nets, baskets, and other tools bearing the signature of women at work.

The timing of these arrivals is not clear now, but it has been pushed far back from the first appearance of Clovis Man. Indeed, if Clovis Man had in fact raced southward across the Isthmus of

Panama and down the western coast of South America, he would have found that people had preceded him there by at least 2,000 years. In his eastern sprint, he would have found the woods near Pittsburgh already inhabited by hunter-gatherers who had been around those parts for some 5,000 or 6,000 years. Monte Verde in Chile and the Meadowcroft Rockshelter west of Pittsburgh are the first two archaeological sites to show that people were surely here before Clovis Man. First probed in the 1970s, the two sites predictably set off a firestorm of acrimonious argumentation among American archaeologists, since many in the field had invested their lives in a rigid, dogmatic school of thought called Clovis First. But what archaeologists call Paleoindians have turned out to be a lot more *paleo* than was previously thought.

THE PALEOINDIANS OF NORTH AMERICA

Thirty-six miles inland from the Pacific Ocean, and about 45 miles from the mountains in southern Chile, a group of 20 or 30 people constructed an elaborate camp alongside a creek about 12,500 years ago. The chief structure of the camp was 20 feet long, framed with logs and planks staked to the ground, and walls of poles covered with animal hides. Using cordage of local reeds, they tied the hides to the poles and similarly divided the interior into separate living (or working) spaces, each with a clay-lined brazier.

Outside were two large hearths, one with quartz tools and the remains of estuarine tubers and fruits, the other given over to the working of hides. Nearby they built a wishbone-shaped structure of wooden uprights set in the sand, which was hardened with animal fat. Here they butchered mastodon carcasses they had found

mired in the nearby bogs and brought back to camp. Here also a person knowledgeable about medicinal plants had a dispensary, passing out doses of nine local plants and nine others that came from the ocean or the mountains. The same plants are used medicinally by the locals today.

It is clear that these people knew the area well, situating themselves in a place convenient to so many resources. They chewed seaweed, perhaps for the iodine, and ate freshwater mollusks and other aquatic plants from the creek, lots of wild potatoes, and meat from the llamas of their era as well as the occasional mastodon and various small mammals. From the beach a day's march away they brought smooth round pebbles they made into tools for chopping. Except for a few bifacially chipped projectile points and some grooved stones for their slings, their durable toolkit was simple. From bone, they crafted digging tools; from wood, digging sticks and spear shafts. With bitumen from the shore they fastened some stone tools to wooden hafts.

At some point they left this salubrious site, the waters of the creek rose and drowned the place, and it filled in with peat—a bog that was discovered more than twelve millennia later and excavated by Tom Dillehay of the University of Kentucky and a host of Chilean archaeologists and students. Much of the usually perishable material was preserved in the anaerobic bog, not to mention three footprints of someone, perhaps a teenager, who walked across some clay that subsequently hardened. The place is called Monte Verde, and the people who used this camp stayed there for a good part of the year, if not year round.

Everything about Monte Verde was unexpected. Paleoindians (like Clovis people) were highly mobile, but these were

semipermanent if not permanent residents. This was a more sedentary society than anyone could have imagined for such an early period in the New World. Paleoindians lived in small groups, maybe even in nuclear families for most of the year. But here as many as 30 people—women, men, and children—combined their skills to accomplish a large range of tasks with a large and eclectic range of materials and resources.

Even earlier was Meadowcroft Rockshelter, which was excavated by Jim and a host of multidisciplinary colleagues from the University of Pittsburgh and other universities and their students. The rockshelter is some 40 feet wide and 40 feet high, and people have been overnighting there longer than in any other place known on the North American continent. Located on a creek that feeds into the Ohio River, it has always been a good way-station, especially for people living by the river and making the trek into the wooded highlands on hunting or gathering trips. Sixteen thousand years ago, it was surrounded by a mixed forest of deciduous and evergreen trees, habitat for deer and other huntable creatures. The southern edge of the great Laurentide glacier lay some hundred miles to the north near Erie, Pennsylvania, but Meadowcroft was in an enviable place, low in elevation and facing south, so it was warmer than such proximity to the great ice would suggest.

Among the 2 million artifacts and bits and pieces of animal and plant remains retrieved from Meadowcroft were numerous small blades (the kind of thing that could severally be affixed in a linear fashion to edge a spear or dart), hearths, pieces of basket and cordage, stone "knives" and points, bone tools like awls, and implements of wood and shell. Much of this dated back as far as

16,000 years, and, knowing that such finds would be greeted with skepticism, the archaeologists took extraordinary measures during the excavation and ran a then-record number of radiocarbon assays. Clearly, the people who had stopped off at the rockshelter 16,000 years ago were highly skilled craftspeople, both male and female, and made a living from a wide variety of available resources. Indeed, the team at Meadowcroft turned up what may be the oldest perishable artifact ever found in the Western Hemisphere—what appears to be an intentionally cut strip of birchlike bark similar in shape to the strips that were later used at Meadowcroft in making plaited basketry. The strip dated as far back as 17,000 years.

It took about 30 years after the discovery of the two sites for all but the last die-hard Clovis Firsters to accede to the pre-Clovis existence of people in this hemisphere. Since then, several other pre-Clovis sites have come to light. One of these is Cactus Hill in Virginia, where small blades and other artifacts dating as far back as 15,000 to 17,000 years ago were found in a sand dune in a layer that was clearly lower than the one harboring Clovis artifacts. Another such find is the Topper site in South Carolina near the Savannah River. There, in the late 1990s, inspired by the Cactus Hill finds, not to mention Meadowcroft and Monte Verde, Albert Goodyear of the University of South Carolina returned to a Clovis site he had excavated in the 1980s, where, having found Clovis material, he had stopped digging. Now, below the Clovis level and a 40-centimeter layer of barren soil, he found artifacts similar to those at Cactus Hill. Such artifacts, like those at Meadowcroft, suggest that these early people were generalized gatherer-hunters, taking a variety of plant food and harvesting mostly small game.

Figure 11-2.
One of the plaited basketry specimens from Meadowcroft Rockshelter, Pennsylvania.
J. M. ADOVASIO/Mercyhurst Archaeological Institute

So Clovis people could not have been the first on the continent. Recent systematic attempts to locate and excavate Clovis sites led, in one instance, to eastern Texas and a large site called Gault. There, Michael Collins of the University of Texas at Austin has led an exploration of a large Clovis site located in a salubrious area in a stream valley where an abundant spring was located, as well as outcrops of chert excellent for making tools, and a variety of habitat and food resources. It was inhabited, at least on and off, for long periods, gainsaying the notion of Clovis people as always highly mobile. It suggests that the famed Clovis points were not a specialized tool for killing mammoths, since they persisted in use at Gault long after mammoths had become extinct in the area. Indeed, the complexity of this Clovis home base and its associated artifacts shows that Clovis people were—

much like their predecessors—generalized hunter-gatherers, taking advantage of a wide range of food resources, both plant and animal. They killed the occasional mammoth and giant bison in an opportunistic way, but surely they were not responsible for any mass extinctions. They could perhaps have given the coup de grace to a few species that were already at the end of their rope in the rapidly changing climate and landscape.

And when Clovis people (and others, for that matter) actually did move their residential camps, the chances are it was the women who said it was time to go. According to a suggestion by Gary Haynes of the University of Nevada at Reno, since women were the ones most intimately involved with running and feeding their households on a daily basis, they would be the first to notice that good things to eat were getting scarcer near camp, or that they had to go farther and farther for firewood. Certainly they would have had as much say in the matter as the men. It was most likely the sum total of these increasing daily inconveniences, each requiring more work by women, that set the family in motion to seek greener pastures. The ethnographic record here, too, suggests that such was the case.

The question arises, again as a result of the ethnographic record: who were women and who were not? In our society, biological sex and social (or culturally determined) gender are pretty simple. Males are men and boys, and females are women and girls. This goes for heterosexual, bisexual, and homosexual people. (There are no male lesbians, for example. There are cross-dressers and actual transsexuals, of course, but they are relatively few and far between. Even rarer are hermaphrodites. It is only among these people that real surprises about gender are likely to occur.)

GENDERINGS

In 1879, explorer John Wesley Powell of the Smithsonian Institution's Bureau of Ethnography dispatched a team to travel to the American southwest, in particular to the Zuni reservation in western New Mexico. In doing so, he unleashed one of the first ethnographic expeditions in the history of anthropology. It was led by an army man, James Stevenson, whose wife, Matilda Cox Stevenson, soon became a powerful, even overbearing collector of the daily objects of tribal life there but also of the customs and beliefs of the people, especially the women of the Zuni tribe.

Matilda was aided in learning about these customs by We'wha, who taught her the ways of Zuni women and accompanied her back to Washington, D.C. There this "Zuni princess," as she came to be called, described the female domain at Zuni to fascinated audiences. Matilda went on to publish voluminously about these matters and became the first professional woman anthropologist in the United States. What she did not know at the time was that We'wha, while perfectly comfortable in the women's world, was in fact what is called a man-woman. That is to say, *he* was biologically a man who lived as a woman, did the work of women, and was respected as a woman. This was a common role in several parts of native America. Such a person is sometimes called a *berdache* (a derogatory term from the French) but is usually referred to as a *two spirits*. The term "two spirits" highlights the fact that in small groups and societies whose survival is not by any means guaranteed, every individual is valuable; there are simply not enough people to exclude anyone for something as unimportant as sexual orientation.

Just as common in American Indian society and history were women who took on the normatively male role of hunter and/or warrior. The Chiricahua Apache Vittorio is considered by military scholars to be one of the greatest guerilla leaders in history, having led a small band of warriors as they outfought, outran, and outfoxed a considerable fraction of the United States Army for more than a year. But when it came to the serious up-close fighting, his sister Lozen was considered Vittorio's equal.

A principal insight of ethnographic studies is that gendering gives rise to an astonishing variety of roles beyond the purely biological. Another such insight is that quite commonly, as part of the social system a particular society invents for itself, gendering tends to foment complementarity and interdependence. Complementarity often means breaking down the tasks of living into those practiced by the different sexes, or ages, or both. Some societies have broken the tasks down not so much by sex as by the materials used—men and stone, women and shell, for example. We have little archaeological evidence (like the artwork from Late Paleolithic Eurasia) to help us figure out how the Paleoindians of North America negotiated their gender roles and leadership.

Most archaeologists believe that the early Americans lived in small groups based on kinship and probably operated on the basis of group decision making, or consensus. Consensus is, historically, how many American Indian tribes have functioned until recently. Also, unhelpfully in this particular quest, most American Indian groups have shown a great deal of flexibility in assigning gender roles, so how Paleoindians organized all this—in western Pennsylvania or Monte Verde or even later at Blackwater Draw—remains opaque. But the very earliest Americans had to have

been adapted to life in the cold, at least seasonally, so some of the features of present-day cold-living groups can be considered useful, however speculatively, in picturing how those original (if unwitting) colonists may have lived.

In their book *Women in Ancient America,* Karen Olsen Bruhns of San Francisco State University and Karen E. Stothert of the University of Texas at San Antonio report themselves tempted to infer a Paleoindian lifestyle from some of the traits and traditions of people called the Ingalik, Athabaskan people of Alaska. Their lives were chronicled in the early 20th century when traditional ways were still largely intact, a time before snowmobiles and television reached the Far North.

The Ingalik and the earliest Americans shared a cold climate, the need to use wild species of plants and animals for all of their food and their tools, and the manufacture of everything they used by hand from local materials. It turns out that everything they made carried with it some ideological content. In other words, various genders made various things for use by specific other genders.

The group made 280 separate items in all, ranging from simple awls to clothing and hunting equipment. Men made almost 100 things they used exclusively, while women made 14 things men used. Men made 56 things used by women and 19 things used by children. Meanwhile, women made 40 things they used and 39 things children used. One key statistic here is that while men made many things for the women to use, these items were used to make far more complex things for each subgroup. In other words, a man would fashion an awl or a needle, and a woman would use it to make things that called for a far greater

The Invisible SEX

investment of skill and time, such as a set of coldproof clothes the man wore out on the hunt.

Ingalik men did their work outdoors or in special houses that were also used for ceremonies (both men and women had separate rites as well, based respectively on ochre and shell), while women did their work inside other houses with other women. Men used only certain materials to make cordage, while women used other materials for the same purpose. Both sexes, then, controlled their own work but relied upon each other for needed equipment. This interdependence—wherein both sexes participate in the hard work of existence—tends to make the two sexes equal in terms of respect and authority, the authors suggest.

The Ingalik arrangement was one of many possible arrangements. In her groundbreaking book *What This Awl Means*, archaeologist Janet Spector concluded that among the 19th-century Hidatsa, men and women had separate spheres of information and activity. Ethnographers have found some hunting and gathering societies in which, unlike the Ingalik, the men and women make their own tools. Most such arrangements produce a world made up of both separation and complementarity.

Clearly, our rigid categories of men and women, or men versus women, and children as opposed to adult, and so forth, are cultural inventions. They are loosely inscribed on human biology and change through time. In our Western culture, it was not all that long ago that the work of children to help sustain their families came to be considered child labor and banned—in great part as a result of the need to protect children from the less attractive components of the Industrial Revolution. "Teenager" as a concept and a term is not much more than a century old. Such

categories are subject to change, given all the different kinds of forces impinging on humans and their families. Imagine what the person who carved the Venus of Willendorf would make of walled residential complexes where no children, no childbearing adults live—only old people.

As noted many times before in this book, archaeologists, especially male ones, have over the decades been greatly entranced by stone tools, and none have ever made a greater impression than the exquisite Clovis points and the Folsom points that came into use next. No stone points are more elaborately made, with tiny pieces being chipped off to form the blade, which is then treated to firm pressure from the bottom, pieces being lopped off to give the points what is called fluting, a vertical channel on both sides. This is an exclusively American pattern. The channel is not necessary either to let blood out or make it easier to withdraw the blade, like a typical hunting knife today, or to facilitate tying the blade to a shaft.

No one knows why these points were so elaborate. More than likely their manufacture was ritual, ceremonial, certainly ideological in some way that we will surely never know. At any rate, they were wondrous creations of a technical skill matched perhaps only by (unfluted) Solutrean points from some 20,000 years ago in Europe. All the other stone tools from the Clovis era receive a lot less ink: they are scrapers, choppers, knives, and simple flakes knocked off some rock. At one Paleoindian site, Indian Creek in south central Montana, people returned year after year, staying from late winter through the early spring. They hunted bison but much more frequently dined on smaller crea-

tures—prairie dogs, voles, and jackrabbits, probably hunted by net. In all, 85 percent of all the stone tools consisted of scrapers and knives, suggesting that women were at least partners in the tasks. These tools are the core of any stone toolkit, and practically anyone could make such tools, and probably everyone did make them and use them, including women and older children.

Paleoindians began to graduate into the archaeologist's next category, Archaic Indians, at different times and different places, but in general terms at the end of the Late Pleistocene and the beginning of our current period, the Holocene, some 10,000 years ago when the great glaciers had all moved well back to the north in Canada. In fact, archaeologists may have to come up with a redefinition of "Paleoindian" and "Archaic Indian," since we now know that the Clovis people and the subsequent Folsom people (the classic Paleoindians) were not highly mobile mammoth hunters and bison hunters. Instead, like their predecessors and the folks that came later, they were really generalized gatherer-hunters, who tended to live for considerable periods in camps like Gault.

In general, however, along the continuum of time, Archaic people began to settle down more. And as they became more rooted, one can assume that they tended to make more systematic efforts to bury their dead or otherwise dispose of them. Burying is not universal by any means in the archaeological or ethnographic record. People have cremated the dear departed, burned them on funeral pyres, left their bodies in funerary platforms or caves, sent them off to sea in burning ships, and so on. In fact, we have very few human remains from the Clovis era or

before and very few in the thousand or so years thereafter. The earliest known place that could be thought of as a large (that is, greater than family size) functioning cemetery in North America is, in fact, a pond in a subdivision called Windover Farms a few miles from Titusville, Florida, a coastal town about 10 miles north of Cape Canaveral. Cemeteries are eagerly sought after by archaeologists because they can contain a lot of information about who was who in ancient societies and who used which artifact.

GENDER MESSAGES FROM THE GRAVE

In 1982, a backhoe turned up some human bones in the blackened muck from a pond in Windover Farms. The county medical examiner was called in and pronounced the bones very old. The developer, following the laws, notified the anthropology department at Florida State University which sent some faculty people to the site. They decided that the bones, given their excellent state of preservation, could be only a few hundred years old. But the exceptionally careful developer (EKS Corporation) paid to have two samples sent off to be radiocarbon dated. The dates came back ranging around 7,100 to 7,300 years ago. Later dating at the site showed that some material was about 8,000 years old.

The Windover area was obviously what people of any era would call a good place. Food was plentiful in the neighborhood—plenty of game, seeds, palm, fruit, berries, cattail roots, nearby saltwater fish, shellfish, manatees, turtles, freshwater snails—and there was no need to make frequent moves.

Most striking is the fact that these people buried their dead in the period from 7,000 to 7,300 years ago in a systematic and evidently reverent manner. At least 168 individuals are represented.

Of those, 47 are almost certainly adult male, 47 are female, and 7 are adults of indeterminate gender. Subadults represent the remainder of this remarkable population.

A total of 58 of the skeletons were completely articulated. Most of them were buried in a flexed position, heads to the west of the pelvis, with the majority oriented within the 298.5- to 241.5-degree compass arc defined by the summer and winter solstice positions of the sun at sunset.

The bodies were interred by securing them to the bottom of a mucky pond; in short, they were buried underwater. Enveloped in this completely anaerobic realm, the bodies and the grave goods accompanying them would remain mostly undisturbed (except by the occasional alligator) for the next seven millennia. Even though the external tissues had decayed shortly after interment, many of the skulls contained intact, albeit shrunken, brains sufficiently well preserved to enable useful DNA samples to be extracted. Collectively, these burials and their associated grave goods provide unprecedented and occasionally startling insights into the life and times of the populations who came to rest beneath the quiet waters of the Windover Bog.

The nature and distribution of the grave accoutrements is particularly revealing. For example, despite the emphasis of generations of lithocentric male scholars, stone tools are most notable at Windover by their near-total absence. Indeed, stone tools were of sufficiently reduced value in life that they are virtually unrepresented in death. The *entire* lithic assemblage from Windover Bog consists of seven items, only three of which were found directly associated with bodies. While it is true that these three were associated with males, the presumed artisans, their

low frequency and circumscribed occurrence does *not* support the long-advocated paramount position of stone tools as the be-all and end-all of hunter-gatherer existence.

In sharp contrast is the occurrence of both modified and unmodified floral material. Woven fabric and matting were recovered from 32 percent of the burials and according to the excavations may well originally have been in all of the Windover graves. The recovered sample derives from 24 percent of all adults and 45 percent of subadults, with a sex breakdown of 30 percent female and 20 percent male. The fabric, whether it was garments or shrouds, was carefully made of highly processed Sabal palm fiber, a minimum of four different twining techniques and one plain weave technique having been used. Additionally, the Windover weavers produced basketry and several types of string and rope-sized cordage.

Though there are no detectable gender differences in the occurrence of one or another type of basketry or fabric, there is a significantly greater incidence of fiber artifacts with subadults. Indeed, the importance of fabric is perhaps best illustrated by the fact that for 12 of the subadults, it is the *only* class of burial goods with which they are associated. For many of the subadult textile fragments, the degree of wear was so low as to suggest that they were specifically made to enwrap the deceased; that is, they were probably specially woven shrouds and not everyday clothes. Evidently, while it was apparently a small matter to be buried without a suitable stone tool, no one should be sent to the next life without appropriate covering. (Here it should be stressed that since most of the bodies were secured by fixing the shrouds/

The Invisible SEX

garments with wooden stakes, the woven fabrics served a doubly important role in interment rites.)

A quarter of the burials evidenced concentrations of edible seeds, occasionally intermixed with fish scales. David Dickel, one of the excavators of Windover from Florida State, found no distinctions in the distribution of these "caches" based on gender or age. From our perspective, it is notable that both the fabrics and the baskets, as well as the food offerings, most likely represent the obviously highly valued products of female labor—labor that, it appears from the grave goods, was more valued than the tool-making labors of the men, not only in life but in death.

In addition to artifacts fashioned from plant fiber, the Windover grave goods also included numerous items made of wood such as atlatl handles, mortars, pestles, cut and planed sticks, and perforated cylinders; antler-derived tools also in the form of parts of atlatls (spear-throwing devices), projectile points, and flakers; deer bone daggers, awls, pins, and projectile points; bird bone tubes; fish spines; modified animal teeth; and altered shell. One class of these remains, or more, was found in 110 burials, and their distribution is revealing.

Some individuals were buried with very few or even no items, but others of both sexes were interred with spectacular caches of funerary equipment. This suggests that status differences may have existed, and furthermore that high status was not gender specific. Moreover, though several classes of artifacts, notably antler-derived tools and atlatl-related paraphernalia, showed a strong statistical association with male burials, most kinds of grave goods were not gender specific. Besides showing

how unexpectedly complex were the lives and lifestyles of supposedly "simple" archaic hunters and gatherers in central Florida, the Windover cemetery also clearly demonstrates that many of our long-lasting stereotypes about the relative importance of various classes of equipment (for instance, fabric versus lithics) and, we suggest, the status of their respective makers, are seriously in error.

Another example of one's gender assumptions leading one astray occurred during the excavation of the major Archaic Indian burial ground in Indian Knoll in Kentucky. This is the best-known mound of several that flourished from about 6,000 years ago to 2,000 years ago at the confluence of the Ohio and Green Rivers. The mounds were essentially shell middens that grew over the millennia as successive groups of people enjoyed the richness of the land, its waters, and its resources. Indian Knoll itself was elliptical, eight feet deep at its deepest, and covered about two acres. Once excavations began early in the 20th century, archaeologists discovered about a thousand individual burials, many of which held gender-related objects. For example, men tended to be buried with axes, fishhooks, and stone tools, while women were buried with mortars, pestles, and beads. But 76 of these burials included beautifully made polished stone objects, which were puzzling in themselves, and all the more so since 13 of the graves with these stones contained females.

These carefully fashioned stones were symmetrical, with a single hole drilled with precision through them. They were mostly small, not much larger than two or three inches across. Whoever made them paid a great deal of attention to the "grain" of the stone, its color patterns. Whatever their function was, they were clearly

works of great craftsmanship, of artfulness. Since then, such stones have turned up in many sites east of the Mississippi River. Many, like those at Indian Knoll, tend to be rectangular, and many of those are diamond-shaped in cross-section. In other parts of the region, they came in more elaborate forms, like butterflies or bottles. Clearly they were highly esteemed objects, and by choosing certain shapes and certain kinds and colors of stone, individuals or families may have used them to distinguish themselves as to ethnic identity or rank within a society. But what where they?

The early excavators at Indian Knoll believed that they might have been used as net spacers, part of the gear involved in making nets. It was possible that both men and women made nets. Then "common wisdom" changed, and the stones, called bannerstones, were considered to be hair ornaments, so their presence in the female graves were still not a problem. But then it became clear that these beautifully crafted bannerstones were part of the weaponry of the hunt.

They were counterweights on spear-throwers, called atlatls, devices that were in use for about 7,000 years in Archaic Indian America (and elsewhere) and finally fell out of general favor after 1000 BC, when the bow and arrow gradually took over most hunting chores. An atlatl is a rod, typically of wood about half as long as the spear itself. At the back end of the rod is a hook, typically made of wood, bone, or antler. The hook fits into the back end of the spear shaft. Holding the front end of the atlatl, the hunter uses it to fling the spear forward, greatly increasing its speed if not its range. Sliding a bannerstone up the shaft of the atlatl so that it rested just below the hook improved the tool's surprisingly complex physics.

Out of functional need, the bannerstones had to be perfectly balanced and carefully finished. Out of some other urge—perhaps, as noted, to mark one's identity—they were also beautiful and specific to locale and even probably to families. And of the 76 burials at Indian Knoll where bannerstones were found, 13 were women who were presumably accomplished hunters. Were they seen as actual women, just like other women except that they hunted, or were they seen as some other additional gender? We will probably never know.

We do know that people were settling down in North and South America and in many other parts of the world. Women (almost certainly, and probably along with men) were now accomplished practitioners of the so-called perishable fiber arts. They had already begun producing the next world-changing revolution, the domestication of animals and plants. People in many parts of the world were forging an existence that relied on more reliable sources of sustenance. But with reliability would come intensity of, among other things, effort. For women—most of whom had spent the Pleistocene in small, family-based, egalitarian groups, undergoing a great deal of stress and hard work and also freedom of choice—the new world that was coming on strong would be a mixed blessing.

THE AGRICULTURAL EVOLUTION

In which we see how women invented agriculture and made food supplies more predictable, got even busier, and felt the consequences—good and bad—and including as well a diplomatic discussion of goddesses.

One of the more puzzling items that turned up during the excavations at the Windover site in Florida was the remains of a bottle gourd: a piece of its rind that was dated at about 7,000 years ago. This rather prosaic piece of plant life was puzzling because gourds were considered to be tropical or subtropical plants that grew and were domesticated in Mexico (gourds, squashes, and pumpkins are related and belong to a taxonomic group called Cucurbitaceae). It was widely assumed at the time that gourds made their way into the United States from Mexico as agricultural practices and products—corn, beans, and squash—spread northward into the American southwest and from there eastward. All this, it was supposed, took place over a period beginning sometime after corn was first domesticated near Tehuacan in central Mexico about 5,000 years ago. There is some evidence that squash was being domesticated on the shores of Ecuador about 9,000 years ago.

The Windover gourd called out for an explanation. Were the people growing gourds, or had some far-flung trade route brought this one to Florida? Or had it floated to Windover from Central America?

In fact, gourds were turning up at many archaeological sites of this time period in the eastern half of the United States, one such site being as far north as Maine. Before long, it was determined that a species of gourd grew naturally in a few spots east of the Mississippi River, and people had evidently learned to cultivate them as early as 7,000 years ago in Florida, Illinois, and elsewhere. Cultivating a plant is not the same as full-fledged domestication; it means just helping the plant along a bit, in the case of gourds simply reseeding them when they do not seed themselves, or clearing a place to seed them in areas where they do not naturally occur. Domestication, by contrast, implies an extremely active intervention in the plant's biology—such actions as selecting only bigger (and softer) seeds and planting them. Over time such artificial (as opposed to natural) selection processes will turn an unremarkable grass's seedhead into, say, the large-seeded ear of corn. Kernels of corn cannot of themselves fall off the ear but need humans to harvest them and plant them. Domesticated plants become annuals, in a sense, almost wholly dependent on humans.

We know that these early users of gourds were not actively domesticating them because the gourd seeds remained the same size (relatively small) and the walls of the gourds remained quite thin for another 3,000 years. The question remained, why were people cultivating gourds? Some speculated that they were used in some manner by shamans, who perhaps made vessels from them for administering herbal remedies. More prosaically, others

noted that they were just the right size for youthful hands to use them as projectiles to throw at each other. But then it was pointed out that people at Windover probably made nets, presumably for fishing, and the gourds were of a perfect size to be floats for the nets. Not only that, but virtually all the sites where archaeologists found traces of gourds were near places where rivers narrowed, making net fishing practical. So, Gayle J. Fritz of Washington University in St. Louis concluded, in a recent review of the matter, that people presumably passed gourds northward beyond their natural range as part of a fishing technology that came at about the time when river systems were becoming stabilized after their turbulent formation by the melting of the great Laurentide Glacier of the north. Gourds were easy to grow and required little or no tending, so they did not distract anyone from their normal hunter-gatherer chores and way of life.

Fritz opines that men may well have been the gourd cultivators, but this opinion, however plausible, is more iffy than the notion of net fishing, no nets having been recovered at Windover. But it could just as well have been women who cultivated the gourds (and even made the nets) for use by men. In the case of virtually all other plants that eventually came to be domesticated in various regions of the world, archaeologists now generally agree that women did the domesticating. But it was not always so. In fact, we have two quite different matters to dispose of before taking a closer and modern view of the coming of agriculture.

THE "NEOLITHIC REVOLUTION"

V. Gordon Childe was one of the giants of archaeology in the first half of the 20th century. Australian-born and educated in

Great Britain in the humanities, he eventually turned to archaeology, specifically that of Europe and the Middle East, coining the term "Neolithic Revolution" ("Neolithic" referring, of course, to a new Stone Age) to specify the toweringly important change from foraging to the domestication of plants and animals. Known as a great synthesizer, he attempted to bring to this study both the insight of the humanist and the care of the scientist. He postulated that this Neolithic Revolution took place beginning some 10,000 years ago in the Middle East, at a time when the glaciers had disappeared into the far north and global climatic changes were well under way, when many mid-latitude places saw the drying up of grasslands and the expansion of deserts. Meanwhile many of the great beasts had gone extinct, and the seeming chaos of Holocene weather was playing havoc with regional and even local ecosystems.

Childe hatched his Oasis Theory to explain why people had given up on the old foraging life and taken up the sedentary business of growing (and controlling) their own food. People were thus brought closer together—indeed, even crowded—into the few remaining "oases" in a drying land, the well-watered land around the ancient city of Jericho being one such oasis. Thus pushed into closer association with plants and animals than ever before, people found that their increased familiarity soon led to greater insight into plant and animal ways, leading to the domestication of both.

This was a perfectly reasonable notion at the time (the late 1930s and thereafter), but as so often happens as time passes and science progresses, oases are not where this happened. It seems now that agriculture began at several different times and in at

least seven different regions of the world, for the most part in marginal landscapes—places that were not so much oases as places where the resources of the wild were less than adequate.

The other wrong notion of Childe's in all of this will not come as a surprise to the reader: that men invented agriculture. After all, for millennia they had been the ones who brought home the real bacon, hauling dead beasts or slaughtered meat back to camp, where the women had gathered up enough plant life for a bit of wild salad. But when times got tough and hunting was poor, the men naturally enough sought a new source of reliable food and invented agriculture, domesticating both plants and animals at about the same time, some 10,000 years ago.

Actual proof of the women's role in domesticating plants in one area, the American southwest, was provided by the work of Marsha Ogilvie, a biological anthropologist who received her PhD from the University of New Mexico. Blinded by diabetes at age 27, Ogilvie earned her degree and became a forensic consultant in Albuquerque. For her PhD thesis she set out to find out just who exactly were the horticulturalists—men or women. The first task was to establish two baselines: a pure hunter-gatherer group and a pure agricultural group. She reasoned that the matter could be resolved by the subtle and not-so-subtle features of the femurs of people who had lived before, during, and after the shift to agriculture. People who are highly mobile develop a long ridge down the length of the femur: people who do not usually walk or run long distances do not develop the ridge.

Ogilvie studied the remains of people who in southwest Texas hunted the depauperate animal life of a rapidly drying desert

and who foraged for thousands of years for edible desert succulents like prickly pear, or yucca, and agave to make fiber artifacts. Both men and women and presumably children ranged far and wide gathering plants, firewood, and the rocks they used to line their hearths. The early Texans all had the distinctive ridge of the highly mobile. Next she studied the remains of people who lived in a large pueblo in New Mexico, abandoning it just before the Spanish conquistadores arrived in the 16th century. Agriculture was intensive here, many fields outside the pueblo being given over to the growing of corn, squash, and beans. There also, male and female thighbones were almost as lacking in signs of mobility. This was a sedentary way of life.

Having completed these baseline studies, Ogilvie was flown over by the wings of happy chance. Human remains came to light as a result of work on Interstate 10 where it goes through southeastern Arizona. Archaeologists were called in by the highway department and found that the remains were of people who were beginning, some 3,500 years ago, to make the transition from foraging to farming. Archaeologists refer to the early cultures in this area as Cochise. Ogilvie was summoned to the site and obtained tribal permission to examine the bones non-invasively. She made cross-sectional tomographic scans of the femurs (and other limb bones). As each scan was made the bone was taken off to be reburied by the local Indians in accordance with the Native American Graves Protection and Repatriation Act, which provides that tribes control the remains of their ancestral people when they are found on federal land.

Only the male femurs had pronounced ridges. The men

had continued to spend much of their time roaming the sur-
round, hunting (or goofing off?). Women's femurs did not have
the ridge and were less robust, clearly as a result of a more seden-
tary life. These Cochise women had given up the wide-ranging
life of the forager and remained near the settlements most of the
time, presumably tending the plants or, as one might say, invent-
ing agriculture.

In fact, as we now know, when (for example) Columbus
arrived in the New World, most of the native population in the
southwest and east of what is now the United States were villag-
ers practicing a modest horticulture or in many cases full-scale
agriculture. Indeed, active agriculture had been practiced east of
the Mississippi River for almost 4,000 years, and for much longer
in Central America and to the south. In all cases in that era except
among the Pueblo people of the American southwest, it was
practiced by women. Evidently, by about 1500 AD, the Pueblo
peoples' fields were so frequently raided—for both food and
women—by neighboring non-agricultural people that the men
had taken to doing the work in the fields.

In Childe's time and even up to the latter years of the 20th
century, age-old assumptions about the idea of men as the proac-
tive providers and women as the passive reproductive machinery
of society (and food preparers) prevailed. This led to the idea
that those wonderful figurines, the Venuses of Eurasia and the
ones found later in early farming villages, were fertility figures
created to insure the fecundity of the land and of women them-
selves. From there it was an easy step to the belief that they
represented the Goddess, the deity who many believe today had

presided over most of humanity's time on earth. And the Venus figurines of Eurasia were surely representative of Her.

THE GODDESS

The social anthropologist and Africanist Melville Herskovitz of Northwestern University is credited with taking a marginally insulting word, "myth," and turning it into a total pejorative. For most people the word "myth" is a slightly snobby word for somebody else's religion. To people who study comparative religions it is not at all snobby. Such scholars speak of the truths of the heart and spirit that are at the core of all mythology, and there is not much to complain about that, though science doesn't mix terribly well with such assertions. Herskovitz, however, a leading practitioner in his time of a social science, used the word "myth" to denote ideas that were simply and plainly false, however widely believed. An example would be that someone in a given tribe becomes terribly and inexplicably ill when he or she is bewitched by another person. Or that burying a ruby in your flesh will protect you from being wounded by an enemy (a Sanskrit notion). Or that women were created from a male rib. The net result is that people occasionally tangle up science and mythology. For example, it is popular in some circles to describe as myth what is a previous generation's science (now shown to be inadequate), and some go so far as to assert that *all* of what we think we know as a result of scientific inquiry is just more myth. Such assertions annoy the hell out of scientists, who, for example, can point to quantum mechanics, one result of which has been the laser, which in turn has permitted laser surgery to repair the eyesight even of those who call science just another kind of mythology. Equally

misguided are believers in a given religion or myth who often try to seek validation of their story in whatever bits and pieces of science they can cherry-pick. Both such efforts are what could politely be called cognitive fallacies, and it is with the latter one, cherry-picking science (in this case archaeology), that the Goddess would become embroiled.

The idea of the Goddess is intimately associated with the belief that until about 6,000 or so years ago, human society was matriarchal. The notion of the erstwhile matriarchy was given birth by a Swiss jurist and historian, Johann Jakob Bachofen, who proclaimed in the late 19th century that there were three "evolutionary" stages of human society: primitive promiscuity, followed by matriarchy, which was replaced by today's patriarchy. The idea, particularly the part about matriarchy, was taken up by Friedrich Engels and became a canon of Marxist thought. There it remained in central and eastern Europe until the end of communism but burst forth in the late 20th century in America and Europe, thanks in great part to the work of a Lithuanian expatriate, Marija Gimbutas.

Gimbutas, who died in 1994, had escaped from the Soviet Union as a young woman after having become a world expert on Lithuanian folkways, later extending her interests into the archaeology of Neolithic Eurasia. One of her achievements was to pin the origins of the Indo-European language on people she called Kurgans, who came into Europe from the Russian steppes north of the Black Sea about 5,000 years ago. A consummate scholar, she wound up teaching at the University of California at Los Angeles and came to the conclusion that the many figurines such as the Late Pleistocene Venuses, as well as other representa-

tions of females found in early farming villages, were evidence that people had worshipped a female deity, the Goddess. Gimbutas would go on to see ubiquitous representations of the Goddess in rock art. She saw the world (at least of Europe and the Near East—what she called Old Europe) as made up of female-centered, peace-loving, nurturing matriarchies, where the Goddess reigned in the human psyche. Neolithic settlements under the eye of the Goddess would be unfortified, so peaceful was Her world. There were no human or animal sacrifices. Matriarchy had prevailed in this large region until some 5,000 years ago when those Kurgan horsemen descended on these peaceful folk, bringing not only the Indo-European language, which all Europeans now speak (except Hungarians, Finns, and Basques), but patriarchy. The Goddess was demoted into minor goddesses of one thing or another like cereal or spinning, all now in the thrall of such beings as the outrageously sexist Zeus, and men took over the reins of economic, political, religious, and social power in the emerging urban societies.

Gimbutas soon became a darling—indeed, a living legend—among some feminists, especially those influenced by New Age precepts who wanted to revive or invent female-centered religious beliefs and practices such as Wicca. The Goddess re-emerged, backed by Gimbutas's archaeological support for what Goddess people had always assumed. Yet further archaeological evidence was also convincing. It was from an important site in Anatolia in Turkey, called Catalhoyuk, that an Oxford archaeologist, James Mellaart, had excavated over four years, beginning in 1961. Catalhoyuk was a huge conglomeration of houses all crammed together, something like the ancient pueblos of the American

southwest. As early as 8,000 years ago, possibly as many as 10,000 inhabitants went forth from this town to raise crops and to hunt in the surround and herd cattle.

From his excavations, Mellaart concluded that society at Catalhoyuk had been matriarchal. Goddess figures presided over the city's walls, over rooms in the houses, and elsewhere. Women were buried in special places inside their homes. It added up to a sure-fire home of Goddess worship, a place that fit perfectly into the notion of a female-centered, peaceful, nurturing society. Gimbutas and Mellaart became the twin pillars of archaeological authority that validated the existence of matriarchy and a world ordered by—indeed created by—a female deity-in-chief. The site soon became a major destination for women on Goddess pilgrimages, much to the delight of the Turkish officials in charge of promoting tourism. But mythology (a.k.a. religion) probably should not look to science for validation, since science is a self-corrective process and its findings are always subject to change.

Gimbutas's later work, as she fell more and more into the thrall of New Age feminism and spirituality, was regarded with deepening skepticism by her colleagues, even other feminist archaeologists. For example, a Cambridge graduate student (now a professor at Stanford University), Lynn Meskell, took issue with Gimbutas's assertion that the Venus figurines all meant the same thing: Goddess. In the first place, a great number of different peoples inhabited her Old Europe, and probably their figurines differed in meaning, particularly over the millennia. Gimbutas downplayed or ignored the many other figurines from the Neolithic—male, sexless, and animal. In looking at rock art figures, she assumed that virtually everything that was not obviously

phallic was a Goddess symbol, including "parallel lines, lozenges, zigzags, spirals, double axes, butterflies, pigs and pillars." Additionally, many archaeological sites in the region, Meskell pointed out, were indeed fortified. Various Balkan cemeteries showed signs of social hierarchies, not the egalitarianism Gimbutas asserted, and in at least one site, called Traian-Dealui, there were human sacrifices. Beyond that, Gimbutas wrote that the female figurines were found in practically every kind of situation: near hearths, inside, outside, even in refuse piles, which Meskell argued could more easily mean that they were toys. Archaeologists, Meskell wrote, would do more for the cause of feminism if they were to divorce their efforts from "methodological shortcomings, reverse sexism, conflated data and pure fantasy."

The next blow came when Ian Hodder, another Cambridge archaeologist now at Stanford University, led a large, modern multidisciplinary dig at Catalhoyuk beginning in the early 1990s. Mellart was able to excavate only a handful of the hundreds of residential rooms, and it was soon shown from other rooms, murals, other figurines, and burials that this city appeared to be quite egalitarian as to gender status. Much of the decorations pertained to bulls and hunting. Not only that, but Catalhoyuk did not even qualify as an early city, since it contained only residences but no monumental public buildings that would suggest an urban-style administrative component of its society.

How did Gimbutus and Mellart get it so wrong? Unstated unconscious assumptions were at the base of it. Both were operating on the Bachofen-type assumption of a lineal progression through universal stages of culture that led from matriarchy to patriarchy. Associated with these stages was the notion that in

deep time people recognized kin ties through the mother's line, while later (probably having something to do with the time that plants and animals came to be domesticated), humans began aligning themselves by paternal ties, and that soon led to a patriarchic social order. The problem with all this is that there is not yet any archaeological or ethnographic evidence anywhere of what could be called an actual matriarchy. Whether one aligns oneself with maternal or paternal ties does not bring about any particular political order. Indeed, to imagine that it does is simply to confuse matrilineality with matriarchy, and patrilineality with patriarchy.

Even the Kurgan hypothesis has taken a beating recently. Another hypothesis has been around for a while, suggesting that the Indo-European languages probably originated in Anatolia well before 5,000 years ago. Linguists and geneticists are coming to the conclusion that the Anatolia hypothesis is correct, at least in part. Anatolian farming began to spread to Greece and elsewhere in the region starting about 8,500 years ago—a date that accords better with linguistic dating of the spread of the original Indo-European language. And there is evidence that about 6,500 years ago, the region experienced a rapid divergence of Indo-European languages that gave rise to the Romance, Celtic, and Balto-Slavic languages. This is about the same time when Kurgans took up residence in the Russian steppe north of the Black Sea. Given the fairly imprecise nature of linguistic dating, it is possible that the Kurgans stirred up matters in eastern Europe sufficiently to bring about a sudden linguistic divergence.

All this, of course, is not to cast aspersions on the Goddess myth (religion), which many find to be a happy counterbalance

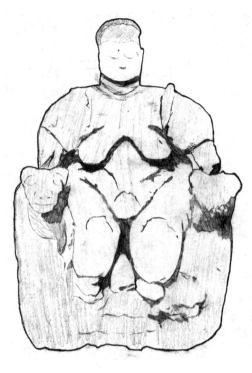

Figure 12-1.
*Artistic rendering of the
proto-typical mother-goddess
as found at Catalhoyuk.*
GINA ILLINGWORTH

to the rather remote male God of the so-called world religions. Of course, there *were* ancient societies that had very powerful female deities. For example, the Egyptians's Nut (or Neit) existed before the world; carried the earth, which she wove into being, between her thighs; and gave birth to the sun. Such entities are excellent fodder for those so inclined. But Late Pleistocene and Neolithic archaeology can no longer be called on for support.

One of the most significant challenges, in fact, to Gimbutas' tendency to see the same meaning in images and figurines that were created over a period of some 40,000 years is that it doesn't take into account the huge sea change in all manner of social features of life that accompanied the switch in many parts of the world from foraging, to cultivating, to the out-and-out domestication of plants and animals. Ultimately, the rise of agricul-

ture would lead to such things as state-level societies (civilizations, not to mention the internet), but its more proximate effects on both sexes and all genders were profound. Before we look at some of those effects, it is time to consider the process of domestication of plants (which we now believe was chiefly women's work) and the domestication of animals (probably men's work, at least in the case of the larger animals) which took place all around the world. It happened at different times, to be sure, but within an astonishingly short time worldwide, considering all the preceding millennia when every society of anatomically modern humans was out there hunting and gathering.

THE DOMESTICATION REVOLUTION

Suggestions abound to explain how and why certain plants came to be domesticated, but no single theory really explains each and every case. The same is true of domesticated animals. Indeed, particularly among animals, no single set of facts even describes what is meant by a domestic animal. With plants it is easier to explain. A domesticated plant is a cultigen, a plant that has become so altered by human intervention that it has become dependent on people to propagate. A domesticated animal can be as tame as a pet dog or as hard to handle as a bull. Some domesticated animal species could easily, if turned out, go happily back to the wild, and this happens often enough. There are plenty of places where domestic pigs have escaped back into the wild and formed permanent roaming herds that pose a good deal of danger. But in virtually all instances, domestication has necessarily been a two-way street. Most plants and animals, for various reasons, simply will not cooperate with efforts to domesticate them—

bison, for example, and tumbleweeds. Wolves and other canids around the world had it in them to be domesticated, and it is now thought that it was the wolves, not humans, who initiated this longest-term association of animal and human.

It is not hard to imagine that some wolves among those in the landscape would be more curious or just less shy than others, and these would come closer to human settlements, where they might gain by eating the less edible parts of game the humans had caught or, more likely, by foraging in the nearby garbage dump. In a playful manner, the humans then might even take to tossing bones and such out of the camp at the wolves, teasing them closer. This kind of situation would select for less shy animals, which would become increasingly dependent on scraps, which are much easier to obtain than wild game. Meanwhile, the people would note that these wolves hung about near camp at night and sounded the alarm when a dangerous predator approached, making "their" wolves valuable. The people would probably notice that, over the generations, the nearby (or commensal) wolves were now smaller as adults than their wild brethren, their ears becoming a bit floppy, their tails curving up rather than hanging down most of the time. In addition, "their" wolves were demonstrating submissive behavior even as adults. In any event, here was an emerging symbiosis, with the added benefit to the people of having an emergency food supply they didn't have to carry. It would simply follow along when they moved camp.

It appears that this process took place in China. It is fairly certain that dogs were the first animals to become widely domesticated. Archaeological evidence suggests that it might have happened as early as 14,000 years ago. By now, in any event, dogs are

the most domesticated of animals. Later, people would discover that dogs were helpful in hunting, and later in herding, even hauling.

In the case of plants, it is possible that true domestication came about for reasons other than feeding all the people. Some scholars have suggested that the domestication of wheat and barley (the first to be domesticated, some 10,500 years ago in the Near East) occurred for reasons we might not expect. One suggestion, following on the use of foraged wild grass seeds in Dolni Vestonice some 24,000 years ago, is that they were cultivated and then domesticated for use in making a mush for weaning children. Others have suggested that efforts to domesticate such plants were impelled by the discovery that one could use them to make fermented beverages for celebratory or ceremonial events. Scholars have argued, for example, that the first domesticated cereals arrived in the inhospitable climate of Scandinavia as late as 700 AD, not for their food value but because the Norse found that they could make intoxicating liquor from them. Yet others have suggested that the ability to supply delicious domesticated plant food for feasts (or beer, for that matter) might have been a sign of status or rank for the few big shots in a group.

At the same general time (10,500 years ago) in the Near East, people domesticated the goat, probably to achieve a relatively predictable supply of meat, though nobody caught on to the use of goat milk until much later. Domesticating goats was probably the men's job, since these animals, especially wild ones, are big and dangerous. Once they were under control, herding them would take the herder far from camp for most of every day, probably a task for children and old women and old men, as occurs to this day with Navajo sheep. The same would go for the

early domestication of sheep in the Near East (10,000 years ago), again for food. The soft undercoat (wool) came to be used as a source of clothing only much later—some 2,000 years ago.

The partial list that follows of plants and animals that humans brought into the fold shows the astonishing creativity that took place independently between 10,500 and 3,000 years ago in distinct parts of the world.

NEAR EAST

> **10,500 to 10,000 years ago**—wheat, barley, goat, sheep, lentil
> **10,000 to 8,000 years ago**—cattle, chick pea, pea, pig
> **8,000 to 4,000 years ago**—horse (?), date, pistachio

SOUTHERN ASIA

> **9,000 to 7,000 years ago**—millet, chicken, rice (rice may be far older)
> **3,000 to 2,000 years ago**—soybean, banana, orange

AFRICA

> **5,000 to 4,000 years ago**—musk melon, donkey, sorghum, millet, watermelon

MEXICO AND CENTRAL AMERICA

> **7,500 to 5,000 years ago**—squash, common bean, amaranth, chile pepper, maize (corn)
> **2,500 to 2,000 years ago**—cacao, avocado, turkey
> **date unknown**—tomato

SOUTH AMERICA

> **7,000 to 4,000 years ago**—lima bean, llama, sweet potato, chile pepper, manioc, potato, peanut, guinea pig

NORTH AMERICA

> **5,000 to 3,000 years ago**—gourd, sunflower, goosefoot, marsh elder, turkey

In the Americas, one sees a very limited amount of animal domestication, the simple reason being that the hemisphere provided very few animals that could have been domesticated. The turkey and the guinea pig seem fairly straightforward, and the llama, even in the wild, is a relatively gentle if skittish creature. The sheep that were tamed in the Near East were a much less belligerent kind than the mountain sheep of the Rocky Mountains, and the American bison, as Ted Turner and others have discovered, are much harder to handle than cattle. Horses had long since vanished from the American plains and pampas, to return only when the Spaniards arrived in the 16th century.

The sizable number of animals that could be domesticated in the Near East and thereabouts—notably goats, sheep, and cattle as well as horses—led to nomadic and seminomadic herding or pastoral societies that were probably like many that still roam that region. But as a rule, pastoral peoples generally survive via a symbiotic relationship with sedentary farming groups, exchanging grain for animal products as well as for other articles of value. One astounding theory about the domestication of animals belongs to the historian Phillip Van Doren Stern, who

straight-facedly suggested that men domesticated sheep and goats so they would become more pliable sex partners.

It does appear that the domestication of both plants and animals tended to occur about the same time as part of an ongoing process by which people slowly became more and more dependent on producing their own food. Later, what Andrew Sherratt of Oxford University characterized as a "secondary products revolution" occurred—the use of domesticated animals as beasts of burden capable of carrying a human rider and later of pulling a plow, or as sources of milk for making butter and cheese, or as producers of wool and a few other useful by-products. The use of animals to pull plows and chariots seems to have begun about 5,000 years ago, suggesting to the feminist prehistorian Margaret Ehrenberg of the United Kingdom that this may have been the time of the "male takeover"—shades of Gimbutus here, yet the use of the plow pulled by prehistoric cattle (or oxen) was almost surely a male affair, which might well have had some deepening effect on gender roles and social arrangements within and among families.

In fact, archaeologists and others have paid much less attention to exactly who domesticated animals in various regions than to who domesticated plants. But one thing is certain: domesticating animals would probably not have occurred if plants were not being domesticated at the same time in the same regions, and it appears to have taken a good deal of time for any of this activity to bear fruit. For most people in these regions, the plants that became the basis of agriculture almost surely were a minor part of the diet at first and remained so for various amounts of time. For example, in the eastern woodlands of the United

States, where sunflowers and a few other plants were domesticated, the natural bounty of the forest was of prime dietary importance for many centuries. Even after a form of maize reached the eastern side of the Mississippi, it received the same slow acceptance as it had received earlier in the American southwest.

Maize arrived in the American southwest about 3,200 years ago and made a very minor splash. It had, as noted, been grown in Mexico for at least twice that long and was a staple there along with squash and beans. This troika of staples would become the major feature of North American farms in due course, the beans being important because they provided an essential amino acid (lycine) missing in corn, and also resupplied soil with nitrogen. Early signs of maize in the southwest occurred at Bat Cave in central New Mexico. It was a puny strain with ears only a couple of inches long. The women there already had plenty of seed "technology" at hand—chiefly equipment for processing wild seeds, but also baskets for storing them. They planted these new seeds near the entrance of the cave and went off with their families to forage and hunt during the summer. Upon their return they harvested whatever maize had survived along with any other edible opportunistic plants (that is, weeds). Maize was, at best, a supplement. For another thousand years people could, and did, take it or leave it.

Some people in the southwest, however, most likely women, continued its use, probably plucking off those "ears" that had the larger seeds (kernels), eating some, and saving some to plant the following spring. This artificial selection was likely to have become deliberate and led to a new strain with larger ears and more rows of kernels, better adapted to arid conditions. This

formed the basis for several sedentary agricultural societies, among whom were the Hohokam people of Arizona, where a phenomenally sophisticated series of canals beginning about 2,100 years ago (or 100 BC) produced one of the longest-lasting irrigation cultures ever known. Within a few centuries of the Hohokams' florescence in Arizona, they began to make pottery, and with great certainty it was made by women. With pottery they had a far more effective means of keeping such things as kernels of corn safe from rodents, and for hauling water. For many people, now that they were sedentary, pottery (which is relatively heavy) could replace some kinds of baskets (which are light) for certain purposes. Like baskets, pottery provided its makers with a means of self-expression, and as its use spread, so did the variety of designs and techniques, providing archaeologists with one of their favorite ways of identifying cultures from one another and watching cultural change (and exchange) take place. North of the Hohokam, the people known as the Anasazi built monumental pueblos like Mesa Verde and Chaco Canyon, which again rested on the existence of maize, squash, and beans grown near small water sources or dry-farmed.

From the southwest, new strains of maize spread far and wide. Maize reached much of the eastern woodlands by 400 AD, again spending centuries as a supplemental foodstuff. By 900 AD it had come into its own as a major part of the diet in the east, making possible the great mound-building era called the Mississippian, when large aggregates of people created a highly complex, stratified, sophisticated agricultural world throughout much of the southeast. Maize also grew throughout the entire northeast and, surprisingly to some, on the plains.

Elsewhere in the world, of course, the stories vary to some degree, depending on a host of factors, including climate, availability of resources, and need. But wherever agriculture took hold there were some similar effects. For one thing, agricultural people by definition had to settle down. And pastoral herding people, as noted, depended on trade with their sedentary neighbors, thus losing some of the free-ranging mobility of the hunter-gatherer.

What was in store for people who finally committed themselves to agriculture?

For many, civilization and all its wonders and its discontents. But, as we noted in the preface to this volume, we are stopping this account on the far side of such phenomena, for with civilization comes writing in the form of cuneiform script or hieroglyphics and then letters as we conceive them—meaning that prehistory ends and history begins.

WAS INVENTING AGRICULTURE A MISTAKE?

Settling down in villages and institutionalizing the production of food had profound consequences for one and all. Their world shrank and their society became more complex. People had to redesign the way they spent their days and years. As agriculture took firm hold of people's lives, they had to change from focusing on large territories and meeting up occasionally with some loosely defined kinfolks. Instead, they lived year round in fixed areas with fixed personnel—whether it was a single family or an extended one, or a larger group that included yet more distant relatives or people who were not related at all. Of course, many people did not take up the sedentary agricultural life at all and, like the Australian Aborigines, remained hunters and gatherers

and provide many ethnologists today with their living. But with the move toward agriculture came the early glimmerings of what we today call property. The addition of beasts of burden, especially in the Middle East and western Asia—horses, donkeys, and so forth—permitted people to become migratory pastoralists and still accumulate material goods they could bring along as they moved their herds from one grazing area to another. But it would be people in the farming villages who would soon amass what we call "stuff."

Pottery and other items of storage, along with all kinds of tools for processing food—heavy grinding stones, for example. Tools for planting and harvesting as well as for hunting, for building and repairing homes. Fiber objects, including fabrics, sandals, floor mats, baskets. Increasingly elaborate ceremonial paraphernalia—masks, special clothes, amulets, and other objects for intervening in the spirit world. And of course, it was necessary to allocate the arable land in the vicinity (or its use) to individual families, or clans, or other groups within the group. People could accumulate what can be thought of as wealth, and did so. Status and social rank would emerge clearly, particularly as villages and then towns grew in size. This new system called forth, as well, the invention of new social arrangements, essentially new ways to deal over time and in day-to-day life with the increase in sheer numbers, social complexity, and proximity.

There comes inevitably some point (and it varies from society to society) in the aggregating of human beings when the categorization by rank or office of people takes place. Indeed, early feminists such as the late Michelle Rosaldo of Stanford University argued that once some notion of private property

arose, the category of people considered "women" could be and were seen as a form of valuable property in need of being controlled. There are many examples of this, one from the Inca civilization in Peru. Ironically, those female practitioners of the string revolution and of weaving—esteemed women like those we glimpsed at Dolni Vestonice some 26,000 years earlier—would be turned into what amounted to slave labor, churning out tapestries under the eye of a male master for the glorification of the Inca and his entourage. There are plenty of instances, as well, wherein status and rank were assigned within genders—powerful women indenturing female servants, for example. However, most if not all the developments in which people were treated as commodities seem to have come about only when what we are pleased to call civilization arose.

Even so, ill effects befell most agriculturalists right from the start. The very fact of gathering into villages where people could take advantage of the greatest potential—that is, the most arable land—led to declines in health from various infections and parasites, such as tapeworms, all rendered more viable by the closeness of people and poor sanitation. In the growing villages in Eurasia, people were also living cheek by jowl with their domesticated animals; beyond sanitation problems, they also suffered when viruses and bacteria leaped from the animals to humans, creating new infectious diseases like smallpox and measles. Before long, people in the Old World developed some immunity to such diseases and they became less lethal, but when they were brought to the New World by Europeans, beginning in the 16th century, they met virgin territory. Most if not all of the native populations of North America had arrived before the do-

mestication of animals in the Old World, so European diseases eliminated millions and millions of people almost overnight, especially those who practiced agriculture and lived cheek by jowl in towns. The native farming populations of the Americas had plenty of their own diseases and health problems before Columbus hove into view, some of them directly or indirectly as the result of the switch to agriculture.

Settling down to farming led to an array of new challenges. By about 1100 AD, maize had replaced most of the earlier domesticated crops of the eastern half of what is now the United States. It was the staff of life, and its cultivation gave rise to the complex societies of the Mississippi drainages, where paramount chiefs ruled from temples built on high mounds over satellite farming villages and outlying hamlets. Elaborate burials awaited leading figures (some of them women, at least in ethnohistorical times), who took astonishing riches with them into the next world. This was a period of grand religious ritual and social hierarchies worthy of European princedoms. The overall subsistence strategy was to produce reliable stores of food from the nearby rivers and from the cornfield. Thus, the burden of supporting all this activity fell mostly on the shoulders of women.

Skeletal remains, in fact, show that women grew more robust at this time, though shorter. The loss of stature is attributed to times—particularly in childhood and among women of about the age of 30—of malnutrition. In addition, those who farmed, prepared, and ate mostly this carbohydrate staple suffered from periodontal disease. Women farmers suffered a great deal of arthritis in the shoulders, arms, and legs. Men, who hunted deer in the surround, were much less afflicted, even though they

were presumably the ones who labored long and hard hauling dirt and building the mounds upon which the elites perched. In almost every instance where scientists have uncovered the remains of people who were engaged in agriculture in this Formative period (and the Neolithic, as it is called elsewhere), there are signs of reduced stature and malnutrition, especially among women and children, along with chronic disease, including iron deficiency anemia, and a great deal more physical labor. At the same time, such chronic problems as anemia are equal opportunity diseases and afflicted many men as well.

Settling down and relying on a secure (or what must have seemed a more secure) supply of stored foods than was available to foragers led, in virtually all such places, to a profound demographic revolution. It produced population explosions unlike anything seen up to that point in the human trajectory. For example, by the time Cortes arrived in Mexico in the early 16th century, as many as a million people lived in the capital city of the Aztecs, with other millions in the surround. Women began having more babies that survived as a result of many factors, including something as easily overlooked as the availability of rich soft carbohydrate weaning foods that resulted in turn in shorter periods of lactation. Since lactating women are much less likely to become pregnant, this natural form of birth control diminished. Also, in a settled agricultural world, the value of child labor shot up. In farming villages, children can be dragooned into weeding, hauling water and firewood, and tending to domestic animals, as well as their age-old job of tending smaller children.

With more pregnancies, women had to spend more energy on nurturing zygotes, fetuses, and helpless babies—a costly

enterprise indeed. As we noted long ago in the earlier part of this book, natural selection works on the individual, not the species or even the group. Therefore, it works somewhat differently on males and females—and even on mothers and babies. How natural selection has worked its stunning complexities over the eons on mothers and babies has never been discussed so fully and coherently as in the book *Mother Nature* by the primatologist and anthropologist Sarah Blaffer Hrdy. She discusses the sheer strain on a woman's physiology created by multiple births, but there is far more to the costs of childbearing than that. Pointing to numerous examples throughout history and prehistory of when the so-called universal maternal instinct fails and mothers abandon their babies, she writes that no one knows when females developed the capacity to distinguish between a baby that was a keeper and one that was not. Probably it arose when mothers were "faced with the prospect of provisioning a staggered clutch of slow-maturing, highly dependent offspring." Probably, she says, this took place some time before the Neolithic, and mothers would have become yet more discriminating once they lived in permanent agricultural settlements with decreasing intervals between births. In any event, Hrdy says, at times when survival was at stake, women would decide whether or not to keep a newborn based on a variety of contingent factors, ranging from her own age to ecological factors (such as a period of severe drought). To a mother giving birth in these early and quite perilous times, "it would have been critically important not to regard a neonate as having equal standing with older children."

This all seems desperately harsh to a society like ours, brought up in the belief that the maternal instinct is universal

and absolutely assures a strong bond between a mother and her newborn, but tell that to a social worker in the inner city. Natural selection has built in numerous physiological and psychological mechanisms that indeed push a mother to love her newborn, just as it has built in certain useful survival features in a newborn baby, such as big beautiful eyes and what, for lack of a better phrase, is "cuteness." But other contingencies can, and often have, overridden biology. This represents what may be thought of as a highly extreme response for a woman faced with the likelihood of becoming pregnant at least twice as often as in the past. The record of continuing population growth suggests that most babies were kept. No one knows, or ever will know, whether such choices back in the Neolithic were solely made by the women or whether men had a say in the matter. More than likely it was the mother who decided, perhaps in league with the other women attending her. Birth has typically been a female mystery, an event best unattended by men.

But what of such aspects of life as esteem, prestige, status, power? Did the agricultural life turn into a universal ironclad patriarchy? Were women doomed to a life of hard labor (of both kinds), little respect, and less control over their own destinies than they had enjoyed for more than 50,000 years as foragers? Except for what we have suggested above, few generalizations can safely be made. As sociologist Deniz Kandiyoti of Richmond College in the United Kingdom has pointed out, patriarchy comes in many flavors, as do the "negotiations" between men and women and other genders over who does what to whom. For example, the three-generation patriarchy of Islam and many parts of South and East Asia and the Middle East is far more

overbearing for women than are the more loosely configured patriarchies one can find in some polygynous African societies, where women have a great deal more bargaining power. And there can be considerable fluidity over time in whatever arrangements become negotiated.

A striking ethnohistoric example is the birth of the horse culture on the American Plains, which produced the iconic American Indian: the heavily feathered and decorated Sioux or Cheyenne warrior thundering across the Plains. In fact, the people who came to be known as the Sioux (or Lakota) and the Cheyenne started out as farmers in Minnesota. The women took care of the agricultural efforts, owning the fields and the crops, while the men hunted for the most part, supplementing the produce of the women. Gradually, beaver and deer having been significantly depleted in their territories, the Cheyenne moved out onto the Plains, where women in new villages continued to farm. As before, the women owned the fields and their fruits, the normal arrangement in the northeast. The Cheyenne were followed into the Plains by the Sioux.

Then, in the early years of the 18th century, horses came to the Plains, escapees from the Spanish southwest, and an entirely new and almost totally male-oriented world came into being. The Cheyenne and the Sioux stopped farming altogether, and the bison hunt on horseback became the central feature of life, along with the pushing and shoving between tribes that typified Plains life. Raiding, counting coup, and other daring feats became another major feature of Plains life, as did the accumulation (by men exclusively) of great wealth in the form of horses. Many women were largely disenfranchised, left with little economic power except

as employees charged with rendering the husband's bison skins into tradeable form. Indeed, many men were so successful at hunting bison that they needed several wives to handle all their booty.

There also arose, as part of this new world, figures called manly-hearted women. These were quite the opposite of the *berdaches* we discussed earlier—men who took on the clothing and roles of women. These Plains women continued to dress as women but engaged in the hunt and in raiding alongside the men, some rising to important political positions in the bands, and some so successful as hunters that they too needed to commandeer the services of several wives of their own. This all took place in a shadowy time when the European presence was little felt on the Plains—a time that is referred to sometimes as *proto*history.

For *pre*historians, however, interested in studies of gender during this Formative or Neolithic period, few places have provided as much information as the American southwest. Here, in what is now New Mexico, Arizona, and southern Colorado and Utah, one can hardly walk more than a few miles in the countryside without coming upon some ancient site, a few shards perhaps, or the ruin of a one-family dwelling, or more rarely the remains of large villages and monumental buildings like those still enigmatic and extremely complex architectural wonders of Chaco Canyon and similar places. It is a semi-arid region (the next driest type of place being classed as desert), where preservation of archaeological material is excellent, including the preservation of "perishable" artifacts. (While pottery types have been and still are critical in distinguishing cultures and cultural phases in the southwest, two entire periods of the past are known as Basket maker.) Over the past several thousand years there, in-

numerable cultures have arisen and faded from view as people took up farming and other activities common to such settlements. Plenty of variation exists in the arrangements that were negotiated among the genders.

Archaeologists have two advantages in this region. One is the richness of the archaeological record: the other is the existence of some of the descendants of the prehistoric people of the region. Today, the Hopi and Zuni as well as the 19 Rio Grande Pueblo people retain many presumably ancient ways and sensibilities that can provide the cautious archaeologist with useable insights into these older times. For these people are at least in part the descendants of the famed Anasazi and Mogollon peoples, and many of them are traditional in the extreme.

For example, among the Hopi today, the women own the fields, which are passed down through the woman's maternal clan. The women also own the fruits of the field, once they are delivered to her by her husband and sons, who work the fields. The husband moves into the woman's house, which she owns even if he built it for her, and if the marriage is, in her opinion, over, she simply puts the husband's belongings outside and he returns to his mother's house or village. There is no logical reason to imagine that this is something brand new. It is called matrilineality and matrilocality—not matriarchy—and it is one powerful way that has arisen in many places to check the tendency of men to take over if they are given the chance.

Similarly, among the Tewa-speaking pueblos of New Mexico (the 19 Pueblo people of the Rio Grande speak five separate languages, all of which are totally different from Zuni and Hopi),

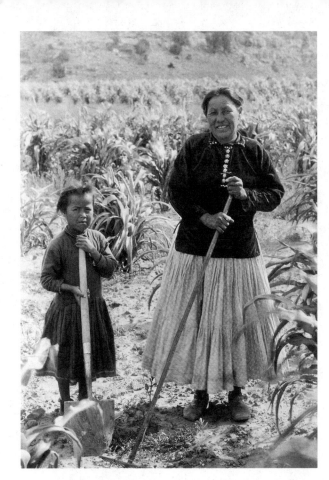

Figure 12-2.
Navajo mother and daughter tending a corn field in the southwestern United States. Women often provide much of the labor (and in some cases much of the political power) in agricultural societies.
BETTMANN/Corbis

the people have delineated three realms. First is the pueblo itself, where women are in charge of household duties such as cooking, child rearing, and making pottery, and the farmlands just outside the pueblo, where men do most of the work. Beyond lies a central realm marked by sacred landforms like particular mesas, where both men and women go for hunting and gathering. Far distant is the third realm, where only men go to hunt and to make pilgrimages to outlying shrines. Such arrangements do not prove

anything about the distant archaeological past, but they are sug-
gestive, even providing hypotheses an archaeologist can try to
prove or disprove about an earlier period.

Certain general trends, however, are apparent over the pas-
sage of time and as agriculture took firmer hold. Health declined
generally over time, for example, but it varied. In the so-called
Grasshopper Pueblo of western New Mexico, which finally gave
up the ghost about the time the Spanish arrived, men originally
ate a lot more meat, while women were mostly restricted to food
they grew or foraged, but over time this came to be equalized, in
part because of overhunting. Malnutrition continued to worsen,
however, and the pueblo was abandoned, the effort to eke out a
living there simply not worth it. Other trends in the region were
an increasing workload for both men and women as society and
its ceremonial and political makeup grew more complex.

These trends are not all that different from the trends one
finds in other parts of the world as people merged from a forag-
ing life into a pre-state agricultural world. But within these
trends, the negotiations and the bargains were probably endless,
and the outcomes were surely as various as were the numerous
villages and cultures here and there around the world.

CONCLUSION

NOT INVISIBLE AFTER ALL

A brief wrap-up in which we recount the major roles that females and women played in the trajectory of becoming and being human.

Most archaeologists now agree that the image of women in the past has been severely distorted or totally ignored by generations of male archaeologists. In recent decades, attempts have been made by many women and several male archaeologists to rectify this. Occasionally in the deep evolutionary past sex is discernible, but the gender status of humans—be they female, male, or gay—is much more opaque and probably will remain largely so even with expectable improvements in archaeological technique and coverage. But we do know that women were invented as a gender status in fairly recent times—at least by some 30,000 years ago—and this invention is a major signature or hallmark of *behaviorally* modern humanity.

One idea that those who study the lives of prehistoric people will have to get over is the notion of a worldwide monolithic patriarchy bent on oppressing women. We can now glimpse, looking back for thousands and even millions of years, that fe-

males and women were by no means ever invisible. It is simply we who have long been blind. Another indisputable perception we have now gleaned is that females and women have been as important as men, if not far more so, as the engines of our emergence as a species and of our success at colonizing and living on this planet. Yet another accomplishment of recent efforts in archaeology to probe the record for the signs of women is to show that for most of the human career in most parts of the world, in addition to the eternal war of the sexes there has been an ongoing effort by the sexes to accommodate each other, to collaborate. After all, what was at issue was survival.

With the invention of women, not only their status but their myriad roles and activities finally begin to become visible to us today, and the visibility increases as we reach more recent eras. We also can now look back on the origins of agriculture as bringing about not just the benefits of a settled life, with a relatively predictable food supply, but also—and ironically—in many instances the erosion of gender equality.

Even with all the efforts made so far to examine hitherto unnoticed information, including ignored or misrepresented artifacts like the impressions in clay from Dolni Vestonice and the clothes on the "naked" Venuses, we still do not know the personal identity of any one woman until about 2,300 to 2,400 BC, almost a thousand years after the invention of writing. The closest we have come in studying times before then is to perceive the unique styles of certain women's basketry techniques.

There are several candidates for the first live woman known to us by name. The evidence is pretty murky, but less so in the case of En Hedu'anna. She was the high priestess of the temple of

the Moon God in Ur, and arguably the first known poet and the first named author in all of literature. We have 48 of her poems, which were apparently highly popular in her day, many of them En Hedu'anna's personal songs to the Sumerian goddess Inanna. In one song the following line appears. We see it as a suitable salutation to all the individual and no longer altogether invisible women who preceded her:

My Lady, your greatness is manifest.

ACKNOWLEDGMENTS

Unlike Jim and Jake's first foray into writing a "popular" book, *The First Americans*, which went relatively smoothly with only a few low-order bumps along the way, this was an arduous and, at times, painful experience. Not only did the project take twice as long as any of us *ever* envisioned, its gestation and subsequent development were often quite trying, to say the least. Jim and Olga express their sincere gratitude for his collegiality and hospitality to Jiri Svoboda, under whose "roof" at the archaeological research facility in Dolni Vestonice they first "saw" Venus-wear from which much of this book ensued. They are also very grateful to Jake Page, who converted their often-arcane professional English argot into something akin to readable prose and who consistently comforted them with his version of "this too shall pass." All three of us are particularly indebted to Joe Regal, our agent, who persisted in finding a publisher for this book after a series of

editor changes no authors should have to confront, and to Elisabeth Dyssegaard, our wonderful editor, for actually wanting to publish this document. Jeff Illingworth assisted all of us by sorting out and organizing the critical illustrations "piece" of our volume, while Steve Holland took some key pictures, thereby making it a better book than it might otherwise have been.

We wish to acknowledge with gratitude the comments of several colleagues who read various drafts of this book and provided invaluable advice and observations. These include Jean Auel, Meg Conkey, Brian Fagan, Sarah Nelson, and Steve Leigh. We made every attempt to address their concerns and hope they are pleased with the product. Special thanks are also due to Judith Thomas, who read various drafts of this document and assured Jim that it was not as bad as it often seemed to be, as well as Mia Bruno, who kept the flood of correspondence between Jim and Jeff and the other authors, editors, and our agent organized and accessible.

SELECTED BIBLIOGRAPHY

Adovasio, J. M. et al., 2001, "Perishable Technology and Late Pleistocene/
Eary Holocene Adaptations in the Americas," Mercyhurst Archae-
ological Institute, Erie, PA

———, Olga Soffer, et al., 2001, "Perishable Industries from Dolni
Vestonice I: New Insights into the Nature and Origin of the
Gravettian," *Archaeology, Ethnology & Anthropology of Eurasia,* Volume 2,
Number 6

———, with Jake Page, 2002, *The First Americans,* Random House,
New York

Aiello, Leslie C. and Peter Wheeler, 1995, "The Expensive-Tissue Issue,"
Current Anthropology, Volume 36, Number 2

Allen, Jim and James F. O'Connell, 2003, "The long and short of it:
Archaeological approaches to determining when humans first
colonized Australia and New Guinea," *Australian Archaeology*,
Number 57

Allen, John s., et al., 2003, "Sexual dimorphism and asymmetries in the
gray-white composition of the human cerebrum," *NeuroImage 18*:
880–894

Almquist, Alan J. and Anne Manyak, 1993, *Milestones in Human Evolution,* Waveland Press, Prospect Heights, IL

Ambrose, S.H. and N.E. Sikes, 1991, "Fossil spils, grasses, and carbon isotopes from Fort Ternan, Kenya: grassland or woodland?" *Journal of Human Evolution,* Volume 21, pp. 295–306

Barber, Elizabeth Wayland, 1994, *Women's Work,* W.W. Norton & Company, New York

Barber, E.J. W., 1991, *Prehistoric Textiles,* Princeton University Press, Princeton

Bar-Yosef, Ofer, 1999, "Lower Paleolithic Sites in South-western Africa— Evidence for 'Out of Africa' Movements," *Anthropologie,* Volume XXXVI, number 1

Bedrman, Judith C. 1999, "Bad Hair Days in the Paleolithic: Modern (Re)Constructions of the Cave Man," *American Anthropologist,* Volume 101, Number 2

Bowdler, Sandra, 1976, "Hook, Line and Dilly Bag: An Interpretation of an Australian Coastal Shell Midden," *Mankind,* Volume 10, pp. 248–58

Bowdler, Sandra and Jane Balme, (In preparation) *Spear and Digging Stick: The Division of Labor and the origin of Gender,* Ms. in possession of the authors

Bruhns, Karen Olsen and Karen E. Stothert, 1999, *Women in Ancient America,* University of Oklahoma Press, Norman

Brunet, Michel, et al., 2002, "A new hominid from the Upper Miocene of Chad, Central Africa," *Nature,* Volume 418, July 11

Caspari, Rachel and Sang-Hee Lee, 2004, "Older age becomes common in late human evolution," *PNAS* 101:10895–10900

Claassen, Cheryl, 1997 "Changing Venue: Women's Lives in Prehistoric North America, in *Women in Prehistory; North America and Mesoamerica,* edited by Cheryl Claassen and Rosemary A. Joyce, University of Pennsylvania Press, Philadelphia

Crown, Patricia L. ed. 2000, *Women & Men in the Prehispanic Southwest,* School of American Research Press, Santa Fe

Diamond, Jared, 2003, "Evolution, consequences and future of plant and animal domestication," Nature, volume 418, Number 6898

Ehrenberg, Margaret, 1992, *Women in Prehistory,* University of Oklahoma
 Press, Norman

Ellison, Peter T. 2001, *On Fertile Ground: A Natural History of Human Reproduc-*
 tion, Harvard University Press, Cambridge

Eswaran, Vinayak, 2002, "A Diffusion Wave out of Africa," *Current*
 Anthropology, Volume 43, Number 5

Gamble, Clive, and Wil Roebroeks, 1999, "The Middle Paleolithic: a
 point of inflection," in *The Middle Palaeolithic Occupation of Europe,*
 edited by Will Roebroeks and Clive Gamble, University of Leiden
 Press, The Netherlands. Pp. 3–22

Gero, Joan M 1991 "Genderlithics: Women's Role in Stone Tool Produc-
 tion," in *Engendering Archaeology: Women and Prehistory,* edited by Joan
 M. Gero and Margaret W. Conkey. Basil Blackwell, Oxford

Gimbutas, Marija, 1982, *The Goddesses and Gods of Old Europe,* University of
 California Press, Berkeley

Goodison, Lucy and Christine Morris, eds., 1998, *Ancient Goddesses: The*
 Myths and the Evidence, British Museum Press, London

Hager, Lori D, ed., 1997, *Women in Human Evolution,* Routledge, New York

Hawkes, Kristen, 2003, "Grandmother and the Evolution of Human
 Longevity," *American Journal of Human Biology,*" Volume 15. pp. 380–400
——— and Rebecca Bliege Bird, 2002, "Showing Off, Handicap Signal-
 ing, and the Evolution of Men's Work," *Evolutionary Anthropology,*
 Volume 11, pp. 58–67

Hays-Gilpin, Kelley and David S. Whitley, eds., 1998, *Reader in Gender*
 Archaeology, Routledge, London and New York

Henshilwood, Christopher S. and Curtis W. Marean, 2003, "The Origin
 of Modern Human Behavior, *Current Anthropology,* Volume 44,
 Number 5

Hodder, Ian, 2004, "Women and Men at Catalhoyuk," *Scientific American,* January

Hope, Jeannette, l998. "Making up stories: Bias in interpretations of
 Aboriginal burial practices in southern Australia," In *Redefining*
 Archaeology: Feminist Perspective, edited by Mary Casey, Denise
 Donion, Jeannette Hope and Sharon Wellfare, ANH Publications
 RSPAS. The Australian National University. Camberra, Australia

Hrdy, Sarah Blaffer, 1999, *Mother Nature*, Pantheon Books, New York

Hyland, David C. et al., 2002, "Pleistocene Textiles in the Russian Far East: Impression from Some of the World's Oldest Pottery," *Anthropologie*, Volume 40, number 1, pp. 1–10

Jolly, Alison, 1999, *Lucy's Legacy*, Harvard University Press, Cambridge

Kamp, Katshryn A., 2002, *Children in the Prehistoric Southwest*, University of Utah Press

Kandiyoti, Deniz, 1988, "Bargaining with Patriarchy," Gender & Society, Volume 2, Number 3, pp 274–290

Kaplan, Hillard, et al., 2000, "A Theory of Human Life History Evolution: Diet, Intelligence, and Longevity," *Evolutionary Anthropology*, Volume 9 Issue 4

Klein, Richard G., 1999, *The Human Career: Human Biological and Cultural Origins*, University of Chicago Press, Chicago

Kolen, Jan, 1999, "Hominids without homes: on the nature of Middle Palaeolithic settlement in Europe," in *The Middle Paleolithic Occupation of Europe*, edited by Will Roebroeks and Clive Gamble, University of Leiden Press, The Netherlands

Kralik, Miroslav et al., 2002, "Fingerprints on the Venus of Dolni Vestonice I," *Anthropologie* XL 2, pp.107–114

Lancaster, Jane B., 1997, "The Evolutionary History of Parental Investment in Relation to Population Growth and Social Stratification," in Gowalty, *Feminism and Evolutionary Biology*, Chapman & Hall, New York

—— et al., 2000, "The evolution of life history, intelligence and diet among chimpanzees and human foragers," in Perspectives in Ethology, Volume 13, edited by Tonneau and Thompson, Kluwer Academic/Plenum Publishers, New York

Leonard, William R., 2002, "Food for Thought: Dietary change was a driving force in human evolution," *Scientific American*, December

Lewin, Roger, *Human Evolution*, 1999, Blackwell Science, Malden MA.

Lock Andrew and Charles R. Peters, 1996, *Handbook of Human Symbolic Communication*, Clarendon Press, Oxford

McBrearty, Sally and Marc Monitz, 1991 "Prostitutes or providers? Hunting, tool use, and sex roles in earliest *Homo*," *The Archaeology of Gender*, edited by Dale Walde and Noreen D. Willows. Proceedings of the 22nd Annual Chacmool Conference. The Archaeological Association of the University of Calgary, Calgary, Canada

McDonald, Kim A., 1999, "Citing the Rising Influence and Power of Women, 2 Anthropologists Ponder the Future of Men," *The Chronicle of Higher Education*, May 21, 1999

McWhortrer, John, 2001, *The Power of Babel*, Henry Holt and Company, New York

Meskell, Lynn, 1995, "Goddesses, Gimbutus and 'New Age' archaeology," *Antiquity*, Volume 69, pp. 74–86

Mithen, Steven, 1994, "From Domain Specific to Generalized Intelligence", in *The Ancient Mind: Elements of Cognitive Archaeology*, edited by Colin Renfrew and Ezra Zubrow, Cambridge University Press, Cambridge, UK

Morton, Eugene S., and Jake Page, 1992, *Animal Talk*, Random House, New York

Mulvaney, John and Johann Kamminga, 1999 *Prehistory of Australia*, Smithsonian Institution Press, Washington, D. C.

Munson, Marit K., 2000, "Sex, Gender, and Status: Human Images from the Classic Mimbres," *American Antiquity*, 65(1), pp. 127–143

Nelson, Sarah M., 1990, "Diversity of the Upper Paleolithic 'Venus' Figurines and Archeological Mythology," in Nelson and Kehoe, *Powers of Observation: Alternative Views in Archeology*, Archaeological Papers of the American Anthropological Association Number 2

Nelson, Sara M., ed., 2006, *Handbook of Gender in Archaeology*. AltaMira Press, Lanham, Maryland.

Noble, William, and Iain Davidson, 2001, "Discovering the Symbolic Potential of Communicative Signs: The Origins of Speaking a Language" in April Nowel, ed., *In the Mind's Eye*, International Monographs in Prehistory, Ann Arbor

O'Connell, J.F. et al., 2002, "Male strategies and Plio-Pleistocene archaeology," *Journal of Human Evolution*, Volume 43, pp. 831–872

Page, Jake, 2001, "Seeing Fingers Decipher Bones," *Smithsonian*, Volume 32, Number 2, May

Peterson, Jane, 2002, *Sexual Revolutions: Gender and Labor at the Dawn of Agriculture*, Altamira Press, Lanham, New York

Pringle, Heather, 1997, "Ice Age Communities May Be Earliest Known Net Hunters," *Science*, Volume 277, 29 August

Riel-Salvatore, Julien and Geoffrey A. Clark, 2001, "Grave Markers," *Current Anthropology*, Volume 42, Number 4

Rosenberg, Karen, 2004, "Living longer: Information revolution, population explosion, and modern human origins," *PNAS*, Volume 101, number 30

Rosenberg, Karen R., and Wenda R. Trevathan, 1996, Bipedalism and Human Birth: The Obstetrical Dilemma Revisited," *Evolutionary Anthropology*, Volume 4, Number 5

Schepartz, L.A., "Language and Modern Human Origins," *Yearbook of Physical Anthropology*, 36:91–126 (1993)

Shennan, Stephen, 2002, *Genes, Memes and Human History*, Thames and Hudson, London

Smith, Bruce D., "The Transition to Food Production," in *Archaeology at the Millenium: A Sourcebook*, edited by Feinman and Price, Kluwe Academic/Plenum Publishers, New York

Soffer, Olga, 1993, "Upper Paleolithic Adaptations in Central and Eastern Europe and Man-Mammoth Interactions," in Soffer and Praslow, *Paleolithic–Paleo-Indian Adaptations*, Plenum Press, New York

———, Pamela Vandiver, Bohushlav Klima, andf Jiri Svoboda, 1993, "The Pyrotechnology of Performance Art: Moravian Venuses and Wolverines," in Knecht, Pike-Tay and White, *Before Lascaux*, CRC Press, Boca Raton

———, J. M. Adovasio, et al., 1998, "Perishable Technologies and the Genesis of the Eastern Gravettian," *Anthropologie*, Volume 36, Number 1–2

———, and J. M. Adovasio, 2004 "Textiles and Upper Paleolithic Lives: A focus on the perishable and the invisible," in *The Gravettian along the Danube*, edited by Lenka Sedlackova and Jiri Svogoda. The Dolni

Vestonice Studies Vol. 11; Institute of Archaeology—Brno,
Academy of Sciences of the Czech Republic

———, and Margaret W. Conkey, 1997, "Studying Ancient Visual Cul-
tures, *Memoirs of the California Academy of Sciences*, Number 23

———, 2001, "Defining Modernity, Establishing Rubicons, Imagining the
Other—and the Neanderthal Enigma," Paper presented at the
CALPE 2001 Conference, Gibraltar

———, 1994, "Ancestral Lifeways in Eurasia—the Middle and Upper
Paleolithic Records, " in M.H. and D.V. Nitecki, *Origins of Anatomi-
cally Modern Humans,* Plenum Press, New York

———, J. M. Adovasio, and D.C. Hyland, 2000, "The 'Venus' Figurines,"
Current Anthropology, Volume 41, Number 14

———, 2000, "The Last Neandertals, *ERAUL*, Volume 92, pp 139–145

———, J.M. Adovasio and D.C. Hyland, 2001, "Perishable Technolo-
gies and Invisible People: Nets, Baskets, and 'Venus' Wear c.
26,000 B.P.," in Purdy (ed.), *Enduring Records,* Oxbow Books,
Oxford, UK

———, 2000, "Gravettian technologies in social contexts," in *Hunters
of the Golden Age,* edited by Roebroeks, Wil, et al, University of
Leiden

———, 2003, "Mammoth Bone Accumulations: Death Sites/ Kill Sites?
Dwellings?" in Vasil'ev, Soffer, Kozlowski, *Perceived Landscapes and
Built Environments*, BAR International Series 1122, University of
Liege, Belgium

Spielmann, Katherine A., 1995, "Glimpses of Gender in the Prehistoric
Southwest," *Journal Of Anthropological Research,* Volume 51

Stone, Richard, 2004, " A Surprising Survival Story in The Siberian Arctic,"
Science, Volume 303, 2 January

Sykes, Bryan, 2001, *The Seven Daughters of Eve,* W.W. Norton and Company,
New York

Taylor, Shelley E. et al., 2003, "Behavioral Responses to Stress in Females:
Tend-and-Befriend, Not Fight-or-Flight," *Psychological Review*,
Volume 107, Number 3, pp. 411–429

———2002, "Sex Differences in Biobehavioral Responses to Threat:

Reply to Geary and Flinn," *Psychological Review*, Volume 109,
Number 4, pp. 751–753

Tomasello, Michael, 1999, *The Cultural Origins of Human Cognition,* Harvard
University Press, Cambridge

Trevathan, Wenda R., 1987, *Human Birth: An Evolutionary Perspective,* Aldine
de Gruyter, New York

Turner, Alan, 1999, "Early Hominid Dispersions," *Anthropologie*, Volume
XXXVII, Number 1

Vandiver, Pamela B., et al., 1989, "The Origins of Ceramic Technology at
Dolni Vestonice, Czechoslovakia," *Science,* Volume 246, pp 1002–
1008

Verhoeven, Marc, 2004, "Beyond Boundaries: Nature, Culture and a
Holistic Approach to Domestication in the Levant." *Journal of
World Prehistory* vol. 18, no. 3. Pp. 179–282

WoldeGabriell, Giday, et al., 2001, "Geology and palaeontology of the
Late Miocene Afar Valley, Adar rift, Ethiopia," *Nature*, Volume 412,
12 July

Wolf, Arthur P., 2003, "Maternal Sentiments," *Current Anthropology*,
Volume 44 Supplement, December

Wong, Kate, 2003, "An Ancestor to Call Our Own," *Scientific American*,
January

———, 2003, "Stranger in a New Land," *Scientific American*, November

Wylie, Alison, 1992, "Feminist Theories of Social Power," *Norw. Arch. Rev.*,
Volume 25, Number 1

Zihlman, Adrienne, 1997 "The Paleolithic Glass Ceiling," in *Women in
Human Evolution,* edited by Lori D. Hager, Routledge, London, UK

———, 1981, "Women as Shapers of the Human Adaptation," in *Woman the
Gatherer,* ed., by Frances Dahlberg, Yale University Press, New Haven

———, "Natural History of Apes: Life History Features in Females and
Males," in Morbeck, Galloway and Zihlman, eds., *The Evolving
Female*, Princeton University Press, Princeton

INDEX